ON THE EVE OF THE FUTURE

OCTOBER Books

George Baker, Yve-Alain Bois, Benjamin H. D. Buchloh, Leah Dickerman, Devin Fore, Hal Foster, Denis Hollier, David Joselit, Rosalind Krauss, Carrie Lambert-Beatty, Annette Michelson, Mignon Nixon, and Malcolm Turvey, editors

Broodthaers: Writings, Interviews, Photographs, edited by Benjamin H. D. Buchloh

AIDS: Cultural Analysis/Cultural Activism, edited by Douglas Crimp

Aberrations: An Essay on the Legend of Forms, by Jurgis Baltrušaitis

Against Architecture: The Writings of Georges Bataille, by Denis Hollier

Painting as Model, by Yve-Alain Bois

The Destruction of Tilted Arc: Documents, edited by Clara Weyergraf-Serra and Martha Buskirk

The Woman in Question, edited by Parveen Adams and Elizabeth Cowie

Techniques of the Observer: On Vision and Modernity in the Nineteenth Century, by Jonathan Crary

The Subjectivity Effect in Western Literary Tradition: Essays toward the Release of Shakespeare's Will, by Joel Fineman

Looking Awry: An Introduction to Jacques Lacan through Popular Culture, by Slavoj Žižek

Cinema, Censorship, and the State: The Writings of Nagisa Oshima, by Nagisa Oshima

The Optical Unconscious, by Rosalind E. Krauss

Gesture and Speech, by André Leroi-Gourhan

Compulsive Beauty, by Hal Foster

Continuous Project Altered Daily: The Writings of Robert Morris, by Robert Morris

Read My Desire: Lacan against the Historicists, by Joan Copjec

Fast Cars, Clean Bodies: Decolonization and the Reordering of French Culture, by Kristin Ross

Kant after Duchamp, by Thierry de Duve

The Duchamp Effect, edited by Martha Buskirk and Mignon Nixon

The Return of the Real: The Avant-Garde at the End of the Century, by Hal Foster

October: The Second Decade, 1986–1996, edited by Rosalind Krauss, Annette Michelson, Yve-Alain Bois, Benjamin H. D. Buchloh, Hal Foster, Denis Hollier, and Silvia Kolbowski

Infinite Regress: Marcel Duchamp 1910–1941, by David Joselit

Caravaggio's Secrets, by Leo Bersani and Ulysse Dutoit

Scenes in a Library: Reading the Photograph in the Book, 1843–1875, by Carol Armstrong

On the Eve of the Future

Selected Writings on Film

Annette Michelson

An OCTOBER Book

The MIT Press
Cambridge, Massachusetts
London, England

This book was set in Bembo by the MIT Press. Printed and bound in the United States of America.

Library of Congress Cataloging-in-Publication Data

Names: Michelson, Annette, author.
Title: On the eve of the future : selected writings on film / Annette Michelson.
Description: Cambridge, MA : The MIT Press, [2017] | Series: October books | Includes
 bibliographical references and index.
Identifiers: LCCN 2016021257 | ISBN 9780262035507 (hardcover : alk. paper)
Subjects: LCSH: Motion pictures. | Art and motion pictures.
Classification: LCC PN1994 .M5157 2017 | DDC 791.43--dc23 LC record available at
 https://lccn.loc.gov/2016021257

10 9 8 7 6 5 4 3 2 1

For Rosalind Krauss, to whom I owe the stimulation of a constantly inquiring intellect that serves a writing rare in its persuasive clarity and force.

Contents

ACKNOWLEDGMENTS

It is to Jonas Mekas and P. Adams Sitney that I owe a significant part of my education in film, in particular that of a truly independent cinema emerging in the mid- and late 1960s. Their knowledge, deep and vast, of this cinema was offered with a generosity for which I shall always be grateful. And it is not for that alone, but for their installation of a larger, historical canon (established by vote from a community of filmmakers) that facilitated a deeper and more extensive study of film history through a recurrent screening of work from Lumière through Bresson. Access to the library established by Sitney has enabled the production of much scholarly work, and the welcome extended to researchers is remembered with especial gratitude by many among the successive generations of doctoral candidates with whom I enjoyed the hospitality extended over successive years in seminars held there; Anthology, under the directorship of John Mhiripiri, continues to encourage and assist scholarly research.

New York University's establishment in the late 1960s of a doctoral degree in cinema studies was a unique and courageous project. Like others of my fellow faculty members, I was recruited to this venture on tentative terms. Given its novelty, a certain *esprit de corps* of its faculty was required, and with them I shared the pleasure of experimenting,

establishing, enlarging, and refining a curriculum for this new field of study. In so doing, we had, together with our students, the sense of participating in the formation of a new discipline; generators of a fresh and refined literature soon to be established in part by the graduates of our own department. Among those (and there are many others) I count Federico Windhausen, Giuliana Bruno, Aparna Frank, Ismail Xavier, Paolo Levi, Tom Gunning, and Allen S. Weiss.

For their sustained interest in my own projects, I remain deeply grateful to Noël Carroll, Stuart Liebman, Malcolm Turvey, and Edward Dimendberg.

To Ann Harris, who has presided with patience and good humor over our department's technical and bibliographical services, I owe my deepest thanks. This is a debt I share with every other member, student and faculty, of our department.

William Simon, one of our early promising students, was to join our faculty and to serve eventually as chairman of the department and as a model for others beginning to lead new departments elsewhere in the country. His personal interest in the new cinema represented in this volume was an early source of stimulation and pleasure.

By faculty and students alike, William Everson is remembered for both his unequaled knowledge of the British and American film industries and the exceptional generosity with which he lent items from his own vast collection of 16 mm films. The late Robert Sklar brought to the study of American film history its social and political functions and their implications. To both of these colleagues I owe a sense of the larger cultural background within and against which the new American filmic ventures treated in this volume developed.

My debt to the Museum of Modern Art is that of a born New Yorker. Its film department had given me my first intimation of "other" films—many, perhaps most, of them made "elsewhere" or "differently." For myself and my students, the film department was hospitable, cooperative, encouraging. Among the curators, Laurence Kardish and Adrienne

Mancia gave outstanding support and practical assistance to special projects. Throughout my years of teaching, the museum's collections and schedule of exhibitions were the source of instruction and deep pleasure for my students. The library of film-related materials was chaired by Charles Silver, unfailingly generous with his knowledge and his time. And both collections and exhibitions were absorbed in our work on a new filmic Modernism.

Being somewhat in need of encouragement in what was for myself a new venture, I found it in the advice and reassurance of long-standing friends whose work, both critical and practical, I valued deeply: Manny Farber, Babette Mangolte, Robert Breer, Alain Robbe-Grillet, Chantal Akerman, André S. Labarthe, Jay Leyda, Marguerite Duras, Stan Brakhage, and Peter Wollen.

Together with my friends and colleagues at *October*, I have felt a strong but uninformed sympathy for recent research and analysis of current work on the moving image, exemplified in the publications of David Joselit.

For Malcolm Turvey's work as both contributor and editor, I want to express my deepest admiration, both for the depth and clarity of his editorial work—extending beyond his own chosen field of cinema—and for his brilliant contributions to a historically informed theorization of that field as a whole.

It is to Adam Lehner, *October*'s managing editor, that I owe thanks for the steady, indeed insistent encouragement for the publication of these studies.

Rachel Churner's huge role in the preparation of this volume I find difficult to define. She had served excellently some years ago as managing editor of *October*, and I welcomed her back to work on this project. At every step and on every parameter, she proved to be the editor one might dream of: offering suggestions for the text's refinement and clarification, securing illustrations and reproduction rights, offering ideas for design, fact checking, but much more. Entering upon this project conceived in

an earlier period of my work, I found her corrections and suggestions to be truly helpful and, more than that, instructive. For all of this, requiring more than usual time, energy, and patience, I remain moved and grateful. Indeed, without her, these texts, retrieved from a developing past, would not have reemerged in volume form.

In 1952 André Bazin undertook the charting of a new cinematic avant-garde, one founded on an endorsement of traditional narrative forms that were to be enlisted in a fresh conception of "advanced" cinema. This was to be established by young filmmakers and critics through the adoption of a "politique des auteurs":

> We may use the abandoned concept of the avant-garde if we restore its literal meaning and thereby, its relativity. For us, avant-garde films are those in the forefront of the cinema. By the cinema we mean, of course, the product of a particular industry whose fundamental and indisputable law is the winning, by one means or another, of public acceptance. This may seem a paradoxical statement to make, but it carries a corrective provided by the notion of public acceptance. The avant-garde of 1949 is just as prone to misunderstanding on the part of the mass public as that of 1925. ... This avant-garde arouses no less hostility. On the contrary, it elicits more, because not soliciting misunderstanding, attempting as it does to work within cinematic norms, it takes great risks: both misunderstanding on the part of the public and immediate withdrawal on the part of the producers.

This manifesto, published in the tenth issue of *Les Cahiers du Cinema*, was framed in reply to a short essay by Hans Richter on "Film as an Original Art Form."[1] Positing a future, a renewal for a tradition represented by the work of Viking Eggeling, Fernand Léger, Marcel Duchamp, Man Ray, Francis Picabia, Walter Ruttmann, and Jean Cocteau, and citing the work of Maya Deren, Frank Stauffacher, James Broughton, and Curtis Harrington, Richter might at that time have added the names, among others, of Kenneth Anger, Harry Smith, and Sidney Peterson. He had, nonetheless, an awareness of these and of other young filmmakers so that rather than accept that he was the sole survivor of a noble line, as Bazin had claimed with characteristic tact, Richter pointed, with discernment and generosity, to the existence of a generation of younger artists working to discover and create new options consistent with the aims, practices, and, ultimately, achievements in poetry, painting, music, and choreography that were continuing to redefine the nature and limits of their respective fields. We now correctly see these filmmakers as the cinematic inheritors of Modernism in a postmodern era, and their vision and practice as radically redefining and extending it.

Bazin's statement laid the foundations for a revision of the cinematic canon that was to animate a critical position of the postwar period through the recent past. It seemed a natural extension of the thought that cinema was no longer to be considered a field of practice inferior to an artistic canon; it could now take its place as equal to that of the novel—an evaluation made, however, in an era when creative energies at work in novelistic form were not at their height. (The *nouveau roman* of Alain Robbe-Grillet was not yet in the picture.) For those unconcerned with the important new developments in music, poetry, painting, and choreography, Bazin's statement was to afford a sense of ease and intellectual progress regained. One hears it in the sigh of relief publicly exhaled by Andrew Sarris, an important film critic of the time:

I have always felt a cultural inferiority about Hollywood. Just a few years ago, I would have thought it unthinkable to speak in the same breath of a "commercial" director like Hitchcock and a "pure" director like Bresson. Even today, *Sight and Sound* uses different type sizes for Bresson and Hitchcock films. After years of tortured reevaluation, I am now prepared to stake my critical reputation, such as it is, on the proposition that Alfred Hitchcock is artistically superior by every criterion of excellence and further, that film for film, director for director, the American cinema has been consistently superior to that of the rest of the world from 1915 through 1962. Consequently, I now regard auteur theory primarily as a critical device for the recording of the history of the American cinema, the only cinema in the world worth exploring in depth beneath the frosting of a few great directors on the top.[2]

The dramatically confessional tone, celebrating a shift of perspective and power, brings to mind Pound's reevaluation of the canon of Western literature, beginning with that of classical antiquity:

I took my critical life in my hand, some years ago, when I suggested that Catullus was in some ways a better writer than Sappho, not for melopoeia, but for economy of words. I don't in the least know if this is true. One should start with an open mind.

　　The snobbism of the renaissance held that all Greek poetry was better than ANY Latin poetry. ... I doubt if Catullus is inferior to Sappho. I doubt if Propertius is a millimetre inferior to his Greek antecedents; Ovid is for us a store-house of a vast mass of matter that we cannot NOW get from the Greek ...[3]

The rhetorical strategies strike one as similar; the difference lies partly in the functional, practical nature and historical depth of Pound's remarks, and in the slant of his concern as a poet for the future, practical utility of the bodies of work under discussion.

Bazin argued for a cinema of transparency, for the production of a spatiotemporality that would further develop and fulfill the aesthetic promise of a powerfully mimetic instrument. It was precisely against such a prospect that Adorno was to protest that film, being primarily representational, is not a medium of subjectivity and therefore is not amenable to radical intervention and construction. Nor could it create "purely aesthetic" values. From this view followed the somewhat heavy *bon mot*: "I love to go to the movies; the only thing that bothers me is the image on the screen."[4]

There was most certainly a body of crucially important French film work (that of Robert Bresson, Jacques Tati, Alain Resnais, for example) and of American film criticism and film work that argued against the threat, implicit in Sarris's declaration, of a new orthodoxy through the imposition of *la politique des auteurs*. A visibly stronger resistance did exist to renew and extend the medium through the work of a younger generation that was largely, although not wholly, American. This renewal required, however, the definitive shift of filmmaking from a system of industrial production to an artisanal mode. It required the renunciation of capital investment and of industrial methods of production, publicity, and distribution. It would involve as well a renewal of critical and theoretical method and, ultimately, the provision for a new public and the invention and acceptance of new forms of cinematic pleasure. Richter spoke for the renewal of energy and of invention that had characterized the work of those earlier filmmakers of the 1920s and '30s to whom he and Bazin, each in his own way, referred.

The European systems of film production in France, Italy, Germany, and Sweden were differently and somewhat more flexibly organized than those of the United States. They were, in many cases, partly financed by

the state, which thereby sustained some capacity for entry by young and independent filmmakers. And it was indeed the very success of American industrial production (the cinema of Hitchcock, John Ford, Howard Hawks, Vincente Minnelli, among others) that impelled the French industry to open the way to a younger generation of filmmakers, possibly capable of drawing a larger number of young people into film theaters in the later 1950s and '60s. Those young men (and they were almost exclusively men) who composed the New Wave were eventually to become the senior statesmen of an industry newly subject to the double threat of television and the wide distribution of American film, leading to its dominance of the international market.

Central to the renewal by the postwar generation of Independents was their keen awareness of the significant production of the 1920s and 1930s. They worked to develop radically new terms, techniques, and strategies of production and distribution. Their work tool was the 16 mm camera inherited from its service in World War II. It was soon clear, however, that this generation of independent filmmakers were the inheritors of Modernism in the various forms that characterized the significant work of a still recent past. And one could see clearly, as well, the fresh, new ways in which this younger generation made of that heritage the basis of new forms of spectatorship and of cinematic pleasure.

For Robert Breer, it was Dada's alliance of abstraction and wit, of linearity and collage that inspired his radical renewal of animation in film. For Stan Brakhage, it was the encounter with the rhythmic energy of Expressionism. For Maya Deren, it was both the freedom and the ritualistic sources of "modern dance." One particularly striking piece of evidence of the Modernist heritage in the work of this generation of filmmakers declares itself in the surprising recurrence in their work of the *empty screen*: a recurrence, maximally varied in form, function, and impact—dramatic, rhythmic, political—as in the production of Paul Sharits, Peter Kubelka, Bruce Conner, and Breer, among others. Observing this development, one thought back to the interesting debate

between Malevich and Eisenstein on the aesthetics of cinema, in which antithetical notions centered on questions of abstraction or representation passed between them in a dialogue of the deaf. (Malevich's position, however, is, as one might expect, far more hospitable to a development of filmic imagery in the direction of an "abstraction" that Adorno denies.) For Brakhage, however, a contemporary filmic Expressionism required the radical revision of the filmmaking process through the destruction of the camera's mechanics and the revision of the established industrial system of processing, with particular attention focused on color.

Within this era of renewal and invention, the work of Maya Deren was and remains central. Deren provided a model of filmmaking for several generations of workers in the field, and it is through this model rather than those of formal "influences" that we can define and assess the nature of her contribution to the cinema of the twentieth century and beyond. A theoretician of originality and power, she assumed early on the responsibility of providing informative, critical work on the new cinema. Of the filmmakers represented in this volume, Deren and Hollis Frampton produced the most powerful bodies of theoretic work of the period. And it was rapidly understood that the work of this new generation of filmmakers would require as well a new system of distribution. Therefore, anticipating by two decades Jean-Luc Godard's declaration that the urgent need was not for political films but to make films politically, they formed cooperatives, new forums of discussion, new venues of distribution, and, throughout the country, new spectators.

★

The title of this series of studies, written over a span of thirty years, has a double source. It is drawn from that of the volume's first entry, written as a gesture of homage to Villiers de l'Isle-Adam, who created in *L'Ève future* (1886) one of the most witty and sumptuous erotic texts in Western literature. It is the tale of the scientific creation of a "live" woman whose body is the object of obsession of the English nobleman who had

commissioned her fabrication and who now comes to Thomas Edison, *le papa du phonograph*, in quest of a process to alter the bourgeois narrowness, the offensive stupidity of her thoughts and desires.

Upon rereading the Villiers text after an interval of some decades, it struck me as powerfully suggestive, anticipating a tenet now central within the literature of film studies: the effect of the frequent shooting and editing of the female actor—largely in close-up—as the object of the male gaze. Central to Villiers's tale is the rapturous description of the Eve of the Future by her owner as he catalogs at great length both the delights of her body and his disgust for her mind, bringing home, as he does so, the negative sense of the French idiom *toiser d'un regard* (to look over, from head to toe).

It pleases me, as well, to title this volume with a sense of its double relation to its field of study, for the film work to be considered was (with one exception, that of Martha Rosler) shot in 16 mm film, which is to say, prior to filmmakers' almost universal adoption of video. It represents, therefore, a historic and recent avant-garde on the eve of the future.

NOTES

1. Hans Richter's "Film as an Original Art Form" was reprinted in translation *Les Cahiers du Cinéma* 10 (April 1952). It had first appeared in an issue of the *Art Journal* (Winter 1951), and somewhat later in *Film Culture* (January 1955). It is more easily accessible in *The Film Culture Reader*, ed. P. Adams Sitney (New York: Praeger, 1970), pp. 15–20. Bazin's response, "L'Avant-garde nouvelle," is found in the April 1952 issue of *Les Cahiers du Cinéma*, pp. 16–17.

2. Andrew Sarris, "Notes on the Auteur Theory in 1962," *Film Culture* (Winter 1962–1963); reprinted in Sitney, *The Film Culture Reader*, pp. 121–135.

3. Ezra Pound, *ABC of Reading* (New Haven: Yale University Press, 1934), p. 48.

4. Adorno's statement is noted in Klaus Eder and Alexander Kluge, *Ulmer Dramaturgien: Reibungsverluste* (Munich: Hanser, 1981), p. 48.

PART I

ON THE EVE OF THE FUTURE: THE REASONABLE FACSIMILE
AND THE PHILOSOPHICAL TOY

In preparing these first, tentatively framed reflections on that intersection marked by the invention of the toy termed "philosophical," I have had quite constantly in mind my friend, the late Hollis Frampton, to whom they are dedicated.

It is, of course, the cinema, and particularly its prototypes—the phenakistoscope, most notably—which were referred to as toys both philosophical and scientific. These terms, and their conjunction, are the product of an era in which science and its technological applications could still be identified with philosophy, and the scientist held to be the natural philosopher. For an early and significant text, for the *locus classicus* on the scientific toy, I turn, therefore, to Baudelaire's "La Morale du joujou" (The ethics of toys), written in 1853:

> I think that children generally do exert influence on their toys, that their choice is directed by inclinations and desires, which, however vague and unformulated, are nevertheless, very real. Still, I would not deny the contrary, that is to say, that toys act upon the child, particularly upon one with literary or artistic inclinations. One would hardly be surprised to

Georges Méliès, *L'Éclipse du soleil en pleine lune*, 1907.

see a child of that sort, whose parents take him to the theater, already coming to consider the theater as beauty in its most entrancing form.

There is a kind of toy recently on the increase, and upon which I shall pronounce no judgment of value. I mean the scientific toy. Its principal defect is its high cost. But it can provide extended amusement and develop within the child the taste for surprising and wonderful effects. The stereoscope, which renders a flat image in depth, is of this sort. It has been around a few years now. The phenakistoscope, which is older, is less well known. Let us suppose that a movement of some sort—that of a dancer or tumbler, for example—is divided and decomposed into a certain number of motions. Suppose that each of these motions—twenty in number, if you like—be represented by a single figure of juggler or of dancer, and that they are all drawn around a circle of cardboard. Adjust this circle, and that of another, pierced with twenty small windows, equidistant from each other, to a pivot at the end of a handle, which you hold as you might a screen before a fire. The twenty little figures, representing the decomposed movement of a single figure, are reflected in a mirror placed opposite you. Set your eye at the level of the little openings, and turn the circles rapidly. The rapidity of the rotation transforms the twenty openings into a single circular one, through which you see reflected in the mirror twenty dancing figures, all exactly alike and executing, with fantastic precision, the same movements. Each small figure has benefited from the nineteen others. On this circle it turns, and its rapidity renders it invisible. In the mirror, seen through the turning window, it stays in one place, executing all the movements distributed amongst the twenty figures. The number of pictures that can be thus created is infinite.[1]

Such was the prototype of the cinema, that toy Baudelaire termed scientific, and others, philosophical, in an era prodigal of natural philosophers, among them the magi of electricity: Ampère, Faraday, Coulomb, Clerk Maxwell, Edison.

Science, then, as natural philosophy and the inventions of technology as philosophically inspired are the ground of our concern. And our protagonist is Edison, the central figure of a fable composed over a century ago, by Villiers de l'Isle-Adam, the student of Baudelaire and the master of Mallarmé. *L'Ève future* is a late work, written between 1880 and 1886, published three years before Villiers's death in 1889, the year of Edison's visit to the great Exposition Universelle, organized in celebration of the centenary of the French Revolution.

In proposing a reading of this text, I am well aware that it has not gone wholly without mention within the cinematic context. Its place, however, and its force as epitomization of the dynamics of representation issuing in the invention of the cinema have been neglected. For Bazin, whose single allusion to it in *The Myth of Total Cinema* is laconic, it is a merely peripheral and curious episode in the evolution of realism. My project is genealogical, and I will claim for the text the status of a greatly privileged instance in the formation of our theorization of mechanical reproduction, initiated, as it were, by photography, extended by telegraphy, phonography, cinematography, holography, television, and the computer. Its fuller understanding will demand, however, that we locate its anticipatory instances, embedded and dispersed within the epistemophilic discourse which traverses the art of the Renaissance and of the Enlightenment until the crisis of modernity. The poetics and metaphysics of Symbolism which articulate that crisis mark, as well, the point of cinema's invention and of the inscription, within its invention, of desire. To speak of that inscription is, of course, to speak of the perversion at its source. But it is this perversion—characterized as fetishistic—which informs Symbolism in its highest and most seminal instances, that of

Mallarmé, as that of Villiers, guardians of the Orphic in the era of industrial capitalism, Hegelian idealists in the parish of Auguste Comte.

Our protagonist is Thomas Edison, the Faust of industrial capitalism, the wizard of Menlo Park. He is already, when the tale begins, "le Papa du phonographe."

But let Villiers set the scene:

> Edison is a man of forty-two. … As for Edison's face, when compared to old prints, it is the spitting image of Archimedes, of the Syracusan medallion. …
>
> On this particular evening, the engineer had dismissed his five acolytes, his foremen—devoted, learned, and skilled workers whose rewards were princely and whose silence he commanded. Alone, seated in his American armchair, leaning on his elbows, a Havana cigar between his lips—he is little given to smoking, the tobacco transforming his virile projects into reveries—legs crossed beneath his ample black silk gown with violet tassels (already legendary), he appeared lost in the depths of meditation. He was staring off into space. …
>
> Here and there, piled upon the tables, were the outlines of precision instruments, of unknown wheel mechanisms, of electrical equipment, telescopes, reflectors, enormous magnets, piped receivers, bottles filled with mysterious substances, blackboards covered with equations. …
>
> Under the subtle action of this atmosphere, the dreamer's thought, usually vigorous and lively, relaxed and gave itself up to the seduction, to the pull, of reverie and of dusk.[2]

Into this Faustian sanctum steps Lord Celian Ewald, an old friend of Edison. He is in love with Miss Alicia Clary. Although a mere "virtuoso" (or, as we would say, performer), she is of the most unique and exquisite beauty. Let us attend to the particulars of her description:

Miss Alicia is barely twenty. She is svelte as the silvery aspen. Her movements reveal a slow, voluptuous harmony. The lines of her body form an ensemble such as one finds in the greatest sculpture. ... Here is truly the splendor of a humanized *Venus Victrix*. ... Her face is a most seductive oval. Her cruel mouth blooms like a bleeding carnation drunk with dew. ... A warm fragrance issues from the breast of this human flower, its perfume that of a meadow; its scent is burning, intoxicating, ravishing. The timbre of Miss Alicia's speaking voice is so penetrating, the inflections of her singing voice are so vibrant, so profound, that whether in tragic or noble recitation, or in superb song, she makes me shudder in spite of myself with an admiration which is, as you shall see, strange indeed. (pp. 31–32)

Such is the catalog of Miss Alicia's beauties. And yet, and yet ... Lord Ewald cannot rid himself of the awareness of that indelible, essential inner life which confers upon every creature its character, which governs its details, impressions, whether sharp or vague, which shapes experience and reflection. To this substratum of sentience he gives the name of "Soul."

Now, between Miss Alicia's body and soul, he perceives no mere disproportion, but an overwhelming, total disparity—as if her beauty, which he terms "divine," were alien to her self. Her inner being proclaims a contradiction with her form, so that he finds himself inclined to wonder if, in that which he calls "the Limbo of Becoming" (yes, Villiers has a Hegelian past, but that is still another story), if then, in the Limbo of Becoming, this woman had somehow strayed into a body which did not belong to her.

Lord Ewald goes on to speak of his sense of that body as a temple (it is Greek, no doubt) profaned by the spirit that now dwells within it. And that spirit, how is it to be described? Its description answers exactly

to that of the Absolute Bourgeois, detailed in other of Villiers's polemical tracts, most particularly the portrait of Tribulat Bonhommet, Villiers's own compiler of a Dictionary of Received Ideas, first cousin to Monsieur Homais, to Bouvard and Pécuchet.

Looking at and listening to Miss Alicia, Lord Ewald has the impression of a temple profaned, neither by rebellion nor the bloody torches of the barbarian invader, but rather by calculating ostentation, a hard insensitivity, an incredulous superstitiousness. She is, as it were, the priestess of bourgeois positivism, of that belief in progress founded in the materialism of a rising middle class, with its eye to advantage, its meanness and intolerance of excess, its philistinism: the ideology, in short, of commodity fetishism against which Villiers shored up defense together with Baudelaire, his master, and those to whom he was master, Mallarmé and the Symbolists.

For Miss Alicia is afflicted with reason. Were she unreasoning, Lord Ewald could understand and accept.

> The marble Venus, after all, has made no compact with reason. The goddess is veiled in mineral and silence, and her aspect seems to proclaim her beauty incarnate, to declare, "I think only with the mind of the beholder. In my absolute state, any concept is self-cancelling, any limit is dissolved. All limits collapse, intermingled, indistinct, identical, like waves of a river entering the sea. For the man who reflects me, I am of such depth as he can bestow upon me. (p. 45)

It is Lord Ewald's lament which impels Edison to hasten to completion the great work upon which he has been engaged lo! these many years. And Villiers's tale becomes the narration of the creation—the fabrication—of a simulacrum, an android in which Miss Alicia's beauty, reproduced in accurate and complete detail, is informed with mind, with spirit. The simulacrum's name will be Hadaly—Arabic, we are told, for

"Ideal." Lord Ewald, in the climactic passage of the tale, will come to mistake her for Miss Alicia, and his rapture at this fusion of body with spirit is ended only by the destruction of Hadaly in a storm at sea, as they journey to a life of secluded bliss on his ancestral estate in England.

The text is organized on two parameters: the narrative of Lord Ewald's plight and of its resolution, and that of Edison's discourse on method. And this discourse serves persuasion, elaborated in the register of casuistry, all enveloped in a paean to electricity as the Promethean fluid of vivification, pitched to an extremity of lyricism that borders on the pastiche. Tale and discourse converge in the climactic moment of induction of misprision, followed by Lord Ewald's acceptance of the simulacrum for the model.

To pursue our reading, we return to the manner of Villiers's rendering of the female body in its glory of perfection, to its particulars of description. Composed, as one notes, of details, it proceeds, one also notes, downward, from shining tresses to elegant feet, rather like the male glance of inspection which, as in French, *toise d'un regard*, takes the measure or stock of its object. Detailing, inventorying, cataloging the body with, of course, the lingering, descending glance at not only the Venus Victrix (as the Venus de Milo, thought to be a figure of Victory, was then known), but also, by inference, at the Venus of Botticelli, her hair swirling about her shoulders as she rises from the sea. The sculptural ideal of Greece and the pictorial paradigm of the Italian Renaissance are fused in the canonical stereoscopy of this living Venus.

For the rhetorical model of this litany (and it is one of many which punctuate the tale at regular intervals), for the sources of its syntax, we do well to press somewhat further on toward the anticipatory instance generated by the sixteenth century, in that moment marked by erotic art of the high Renaissance in France, in both its poetic and pictorial instances: that of the school of Fontainebleau under François I. For it is here that the notion of the erotic assumes, with a paradigmatic power, a distinctly fetishistic aspect, in its analytic view of the female body. One sees this

in the celebrated double portrait of *Gabrielle d'Estrées and the Duchess of Villars in Their Bath* (c. 1594)—itself a reference to those of Venus and of Diana—in which the Duchess, naked, like her sister, points to and encircles the nipple of her sister's breast. "What," an old friend asked many years ago as we strolled through the Grande Galerie of the Louvre, "is the Duchess doing to her sister?" She announces, the iconographer tells us, Gabrielle's coming maternity, confirmed by the allusion to the coming birth of the Duc de Vendôme, for whom, in the painting's furthest plane, a nurse prepares a layette. But that ostensive gesture, indicating, pointing, and marking off, is, in its ambiguity, deeply consonant with Fontainebleau's eroticism: one which marks, dissects, delimits the body, charting, mapping the zones of pleasure. It is thus that the cultural order is inscribed on the body, through clothing, jewels, cosmetics, and, in other civilizations, through scarring, tattooing, extension or binding of the body and its members. This is the work of fetishization, of the mapping of the body in parts, of *la carte du tendre*. Its expression in the sixteenth century of the high Renaissance in France will find poetic instantiation in the invention of a new and highly developed, scandalous, controversial genre: the *blason du corps*, the blazon or escutcheon of the female body, in which the poets—among them Clément Marot, its inventor, Michel d'Amboise, Gilles d'Aurigny, Estorg de Beaulieu, Antoine Héroet, François de Sagon, Lancelot de Carle, and the foremost of them, Maurice Scève—will fragment and glorify the body of woman. *Blason des cheveux, du front, blason du sourcil, blason de l'oeil, blason de l'oreille, blason du nez*, and, in Clément Marot's celebrated founding work, *Le blason du beau tétin* or *Blazon of the Comely Tit*.

A glance at that founding instance will repay our attention. The blazon as a form originates during Clément Marot's exile from Fontainebleau. Finding refuge at the court of the Duchesse Renée in Ferrara, he devoted himself, far from the court of François I, to the composition of apologetics and the translation of the Psalms.

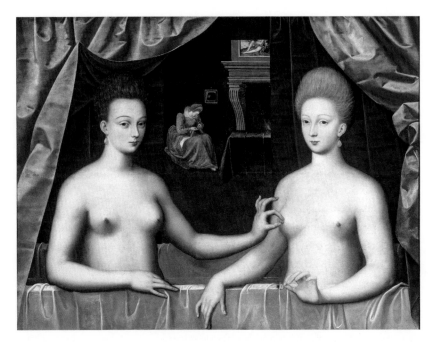

School of Fontainebleau, *Gabrielle d'Estrées and One of Her Sisters* (also known as *Gabrielle d'Estrées and the Duchess of Villars in Their Bath*), c. 1594. © Musée du Louvre, Réunion des Musées Nationaux.

The Psalms, lyrics of perpetual praise, articulate, in their enumerative structure and cumulative metaphors, the rhetoric of the Old Testament. Marot, then, impelled by his study of the Psalms, composes his own, but they are secular, to say the least. They are, as we should say, profane. Such was the *Blazon of the Comely Tit*, and the success of this form at the court of François I was such, it is recounted, that not only poets such as Scève, but also the lettered members of the court, the magistrates, the booksellers—and many of the clergy—produced blazons. And their subject was single, central; it was woman, her body already denuded by the artists of Fontainebleau, her seduction evident, her charms half-hidden, her force secret. The tradition of sacred poetry was, then, redirected in the service of the most profane of subjects, for *la femme blasonnée* was not spiritual but carnal, and each member, every part of her body, was precious, venerable. For the fetishistic veneration of the holy relic, the *blasonneurs*, as they were known, substituted the cult of the living detail. Or, one might say, for *le corps glorieux*, the glorified body of Christ, they substituted the female body—an eroticism in the mode of castration and veneration, fragmenting and glorifying. Woman, subjected to the analytic of dissection is then reconstituted, glorified in entirety and submission: as Marot says in his *Blason du beau tétin*, "He who shall with milk make you swell, makes of a virgin's tit that of a woman, whole and fine."

We have seen that body, a conflation of Greek sculpture and Renaissance painting, generated in conformity with the aesthetic canons of the nineteenth century, submitted to inventory by the lover's eye. Let us now consider how it is constituted, simulated by Edison in the fabrication of Hadaly, the android.

We are told in chapter one of Book V, entitled "The First Appearance of the Machine in Human Form." Edison speaks:

The Android is subdivided into four parts:

———

1. The live, internal System, which includes Balance, Loco-
motion, Voice, Gesture, the Senses, possible facial Expres-
sions, the inner action regulator, or if you prefer, "the Soul";

2. The plastic Mediator, which includes the metallic enve-
lope insulated from the epidermis and the flesh tint, a sort of
armor with flexible articulations to which the internal System
is firmly attached;

3. The Carnation (or properly speaking, artificial flesh), su-
perimposed upon and adhering to the Mediator, which (pen-
etrating and penetrated by the animating fluid) includes the
traits and lines of the imitated body, with that body's par-
ticular personal emanation reproduced, the responses of the
skeleton, the modeling of the veins, musculature, the model's
sexuality, all bodily proportions, etc.;

4. The Epidermis or human skin, which includes and con-
trols the Complexion, Porosity, Features, the sparkle of the
smile, the imperceptible creases of Expression, the precise
labial movements of speech, the hair and the entire pilose
system, the ocular set, together with the individuality of the
Glance, the Dental and Ungular systems. (p. 145)

We are reminded of those medical drawings and anatomical models
with layered articulations of nervous, digestive, and circulatory systems,
among which those commissioned by the naturalist Felice Fontana in the
eighteenth century for the Royal Cabinet of Physics and Natural His-
tory in Florence are preeminent. It was the close collaboration of Fon-
tana with designers and modelers, the mobilization of the extraordinary
technical prowess of Clemente Susini, which produced, in an era increas-
ingly bent on the scrutiny of the female body, the Waxen Venus.[3] Here is
the fastidiously and voluptuously modeled woman in the flesh of youth,
nude, recumbent, suave and tender of aspect, her digestive, pulmonary,

circulatory, and genital systems revealed and resolved into detachable elements. Her balance, her posture, her ever slightly parted lips, her long, gleaming tresses, her pearl necklace, the tasseled silken coverlet upon which she lies—these and the presence of pubic hair (none of these indispensable for the purpose of anatomical demonstration)—fashion an object of fascinated desire in which the anatomist's analytic is modulated by the lambent sensuality of Bernini. This Venus yields, responds, one feels, to the anatomist's ruthless penetration with the ecstatic passivity of Saint Theresa or the Blessed Ludovica Albertoni to the ministrations of the Holy Spirit.

"But," says Edison, "the Android presents nothing like the frightful spectacle of our own vital processes. In her everything is rich, ingenious, and somber. Look!" And he presses his scalpel on the central apparatus riveted to the level of the android's cervical vertebrae.

> "Here [he continues] is the locus of Man's vital center. One prick here and we die instantly. … You see that I've respected nature's example here. These two inductors, insulated at this point, match the play of the Android's golden lungs. … It is due to the mystery generated in these metal disks and emitted by them that warmth, movement, and strength are distributed through Hadaly's body via this intricate mesh of shining wires, exact replica of our nerves, arteries, and veins. …
>
> "This spark, bequeathed by Prometheus, harnessed to flow around this truly magic wand, produces respiration. …
>
> "These two gold phonographs on an angle inclined towards the center of the chest are Hadaly's two lungs. Between them pass the metallic leaves of her harmonious, I might say, celestial chatter. … [S]even hours of speech … have been composed by our greatest poets, our subtlest metaphysicians, the deepest novelists of our century—geniuses—upon my commission. These never-to-be published marvels are worth

15

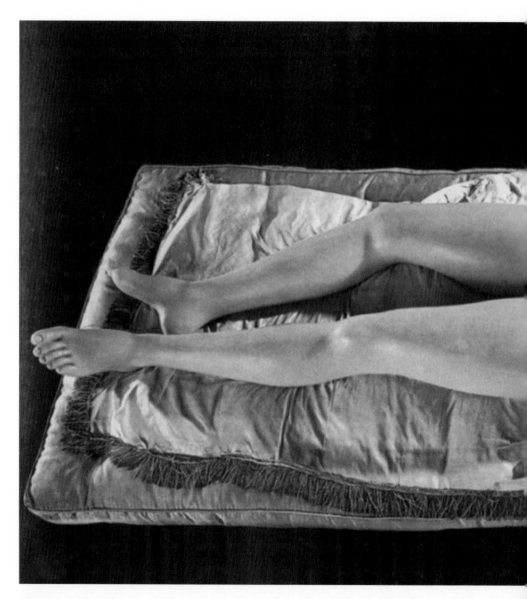

Clemente Susini, *Venus*, c. 1790. Courtesy La Specola, Museo di Storia Naturale, Florence.

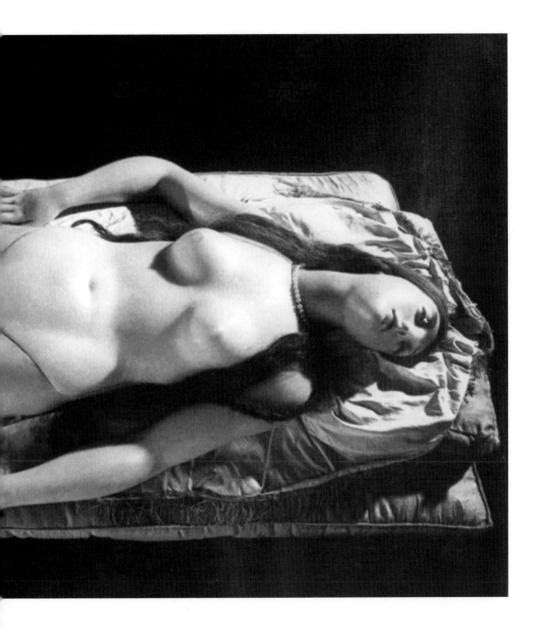

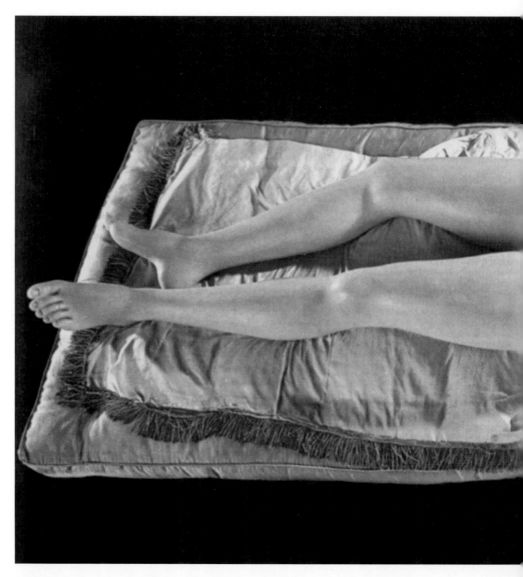

Clemente Susini, *Venus*, c. 1790. Courtesy La Specola, Museo di Storia Naturale, Florence.

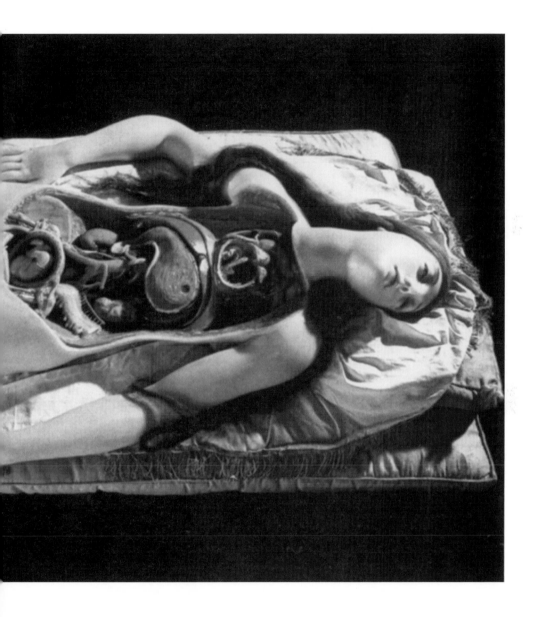

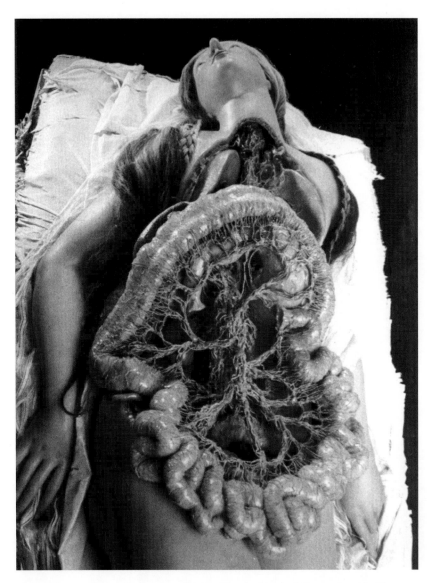

Clemente Susini, *Venus*, c. 1790. Courtesy La Specola, Museo di Storia Naturale, Florence.

their weight in diamonds. I therefore claim that in Hadaly Intellect is replaced by Intelligence." (p. 147)

We might say, then, that Hadaly has intelligence of the corpus of occidental culture. She is a palimpsest constituted in a synthetic text of Edison's inscription.

After Villiers's description of other recording devices for gesture, speech, labial movements, balance—and for all the modulated depths of subtle expression, regulated with perfect precision—Hadaly's scenes, so to speak, are set in place. Hadaly becomes that palimpsest of inscription, that unreasoning and reasonable facsimile, generated by reason, whose interlocutor, Lord Ewald, has only to submit to the range and nuance of mise-en-scène possible in what Edison calls the "great kaleidoscope" of human speech and gesture in which signifiers will infinitely float. "And never will her speech deceive your expectations. It will be even as sublime as your inspiration to elicit it. With her you need never, as with the live model, fear misunderstanding. You will have only to remember the rests engraved between the words. Nor need you even articulate the words yourself. Hers will reply to your thoughts and to your silence" (p. 149).

It is a comedy for all time that Ewald is asked to rehearse, and it will take the shock of direct and inadvertent encounter with the completed and perfected android to change his horrified refusal into eager, ardent acceptance, to transform his rejection of mimesis into assenting seduction by the simulacrum.

If, then, Miss Clary is but an empty vessel, Edison's text, whose complex articulations, fine tolerances, and inscriptions will fill that vessel, vivifies the statue's body, fragmenting, analyzing, then restoring, through inscription, this body. We have seen that impulse animating the *blasons d'amour*, the erotic poetry of the high Renaissance, denuding, fragmenting, restoring the painted body of Venus. Where, however, shall we find the model of its inspiriting? Where but in the celebrated image of that statue which founds the epistemology of the ideologues of the

21

Enlightenment, in that statue which Condillac proposes as the sentient, knowing subject in *The Treatise on Sensations* (1754)?

Let us recall something of Condillac's project. It was generated by his need to trace knowledge back to its first elements, employing not direct observation, but a hypothetical and analytic construction. Condillac had, prior to its publication, worked to systematize and popularize Locke's theory, holding that nothing inheres in the intellect which is not given in and by the senses. The source of knowledge was twofold: sensation and reflection. It was by sensation that we apprehend external phenomena, and by reflection, internal phenomena. In *The Treatise on Sensations* we have the completed and definitive exposition of Condillac's epistemology. Departing from Locke, he maintains that there exist not two sources of ideas, sensation and reflection, but one only, sensation. From this he derives the activity of mind. His critique of Locke centers on what he considers to be an insufficiently radical deployment of the natural methods of analysis. If knowledge is sentience, we must trace the process of its generation to its source. We must first resolve it into its elements. Next we must show how these elements will account for the activity of the human soul in all and every form. The faculties of the soul are not innate; they have their origin in sensation itself.

For his analysis of the genesis of our faculties, Condillac, as is quite generally known, made use of a fiction, a fantasy wholly in keeping with the sensibility of the time. He imagined a marble statue (it was Greek, no doubt) with the complete organic structure of the human body, but insentient. He then proceeded to analyze the knowledge such an imaginary being would develop were its senses to be awakened one at a time. He began by allowing it smell. Here is the initial stage of this awakening:

> Our Statue being limited to the sense of smell, its cognitions cannot extend beyond smells. It can no more have ideas of extension, shape, or of anything outside itself, or outside its sensations, than it can have ideas of color, sound, or taste.

If we give the statue a rose to smell, to us it is a statue smelling a rose, to itself it is the smell of this rose. The statue therefore will be the smell of rose, the smell of carnation, the smell of jasmine, the smell of violet, according to the flower which stimulates its sense organ. In a word, in regard to itself, smells are its modifications or modes. It cannot suppose itself to be anything else, since it is only susceptible to sensations.

Let the philosophers, to whom it appears so evident that all is material, put themselves for a moment in its place, and then imagine how they could suspect the existence of anything which resembles what we call matter.[4]

Condillac, in a systematic strategy of *ascription*, then successively endows his statue with taste, hearing, then sight, and so on, with touch the last of the senses. Sensations themselves are referred to that which is external to ourselves. It is something like a theory, say, of intentionality, and our sensations become our ideas of things. Attention, memory, judgment are produced by these sensations, in their interrelations; the emotions and passions—hope, fear, love, hatred, volition—are sensations transformed. For Condillac, the nature of thought was wholly unproblematic; it followed from sensibility. Sense is sensibility. *To feel is to think*.

We had recognized in Alicia Clary the lineaments of Venus Anadyomene. Do we, as well, discern in Hadaly, the subject formed by Edison's textual inscription, that marble statue endowed by Condillac's systematic ascription with the parameters of sentience?

We will want once more to note that assiduous, relentless impulse which claims the female body as the site of an analytic, mapping upon its landscape a poetics and an epistemology with all the perverse detail and somber ceremony of fetishism. And may we not then begin to think that body in its cinematic relations somewhat differently? Not as the mere object of a cinematic *iconography* of repression and desire—as cataloged by now in the extensive literature on dominant narrative in its major

23

genres of melodrama, film noir, and so on—but rather as the phantas-matic ground of cinema itself.

We will then wish to consider once again, and somewhat differently, those acts of magic perpetrated upon the female subject, as by Edison and Méliès in the films of the primitive period (1900–1906), for the mutilations, reconstitutions, levitations, and transformations performed upon her body are to be read not, as has been suggested, as instances of male envy of the female procreative function.[5] We may rather understand them as the obsessive reenactment of that proleptic movement between analysis and synthesis which will accelerate and crystallize around the female body in an ultimate, phantasmatic mode of representation *as* cinema.

The female body then comes into focus as the very site of cinema's invention, and we may, in an effect of stereoscopic fusion (like that of the two Venuses, like that of Edison and Doré, artist and natural philosopher) see the philosophical toy we know as the cinema as marked in the very moment of its invention by the inscription of desire.

For the moment of Lord Ewald's surrender to his Eve-to-be is that of a world, assenting, on the eve of its future, to that synthesis of the parameters of mechanical reproduction figured as simulacrum of the female body, for whose interlocutor (or spectator) the scene is already set. And this world, assenting, murmurs, "I know, but all the same …"

Notes

First published in *October* 29 (Summer 1984): 3–20. Minor corrections have been made for consistency.

1. Charles Baudelaire, "La Morale du joujou" (1853), in *Oeuvres complètes*, ed. Y.-G. Le Dantec (Paris: Gallimard, 1961), p. 525 (translation mine). The English translation, "A Philosophy of Toys," is found in Baudelaire, *The Painter of Modern Life and Other Essays*, ed. and trans. Jonathan Mayne (London: Phaidon, 1964).

2. Auguste Villiers de l'Isle-Adam, *L'Ève future* (Paris: Editions Jean Jacques Pauvert, 1960). I have used, with minor modifications, the excellent English translation *Eve of the*

Future Eden, trans. Marilyn Gaddis Rose (Lawrence, Kans.: Coronado Press, 1981), pp. 3–4. Subsequent citations of this translation appear parenthetically in the text.

3. I have consulted Maria Luisa Azzaroli Puccetti, Benedetto Lanza, et al., "La Venere scomponibile," *Kos* 4 (May 1984): 65–94.

4. Étienne Bonnot de Condillac, *Traité des sensations*, in *Oeuvres philosophiques*, ed. Georges Le Roy, vol. 1 (Paris: Presses Universitaires de France, 1947), p. 2 (translation mine).

5. See Lucy Fisher, "The Lady Vanishes: Women, Magic, and the Movies," *Film Quarterly* (Fall 1979): 29.

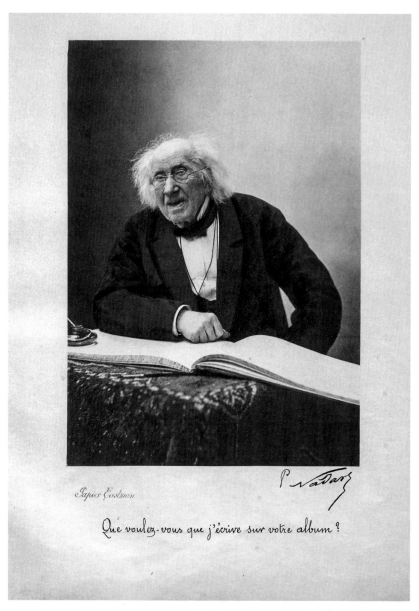

Papier Eastman

P Nadar

Qué voulez-vous que j'écrive sur votre album ?

"What do you want me to write in your album?" Paul Nadar, *Michel-Eugène Chevreul*,
September 1886. Courtesy George Eastman House. (Translations mine.)

A still photograph is simply an isolated frame taken out of the infinite cinema.

—*Hollis Frampton*

Cinema is simply a branch of photography.

—*Louis Lumière*

The old gentleman, seated and in animated conversation, is more ancient than he appears; born before the French Revolution, he is, in fact, a centenarian. Michel-Eugène Chevreul (1786–1889) is being interviewed by Nadar on the eve of his 101st birthday, while their conversation, photographed under the direction of Nadar's son Paul, is recorded by a stenographer. Of the series of twenty-seven images, thirteen, with accompanying captions, were published on September 5, 1886, in *Le Journal Illustré* under the title "The Art of Living One Hundred Years: Three Interviews with Monsieur Chevreul."[1]

Among the caption texts preserved in the collection of the George Eastman House are the following:

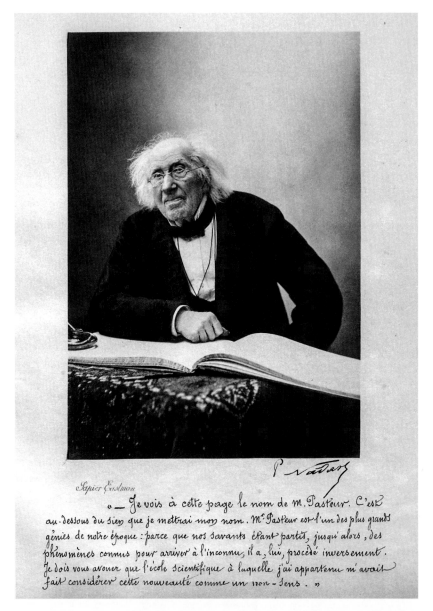

Papier Eastman

« — Je vois à cette page le nom de M. Pasteur. C'est
au-dessous du sien que je mettrai mon nom. M. Pasteur est l'un des plus grands
génies de notre époque: parce que nos savants étant partis, jusqu' alors, des
phénomènes connus pour arriver à l'inconnu, il a, lui, procédé inversement.
Je dois vous avouer que l'école scientifique à laquelle j'ai appartenu m'avait
fait considérer cette nouveauté comme un non-sens. »

"I see Monsieur's Pasteur's name on this page. I shall put my name under it. Monsieur
Pasteur is one of the greatest geniuses of our time; for until then, our scientists had
started from known phenomena so as to arrive at the unknown, whereas he proceeded
in the opposite manner. I must admit that the scientific school to which I belonged had
led me to consider this innovation as nonsensical."

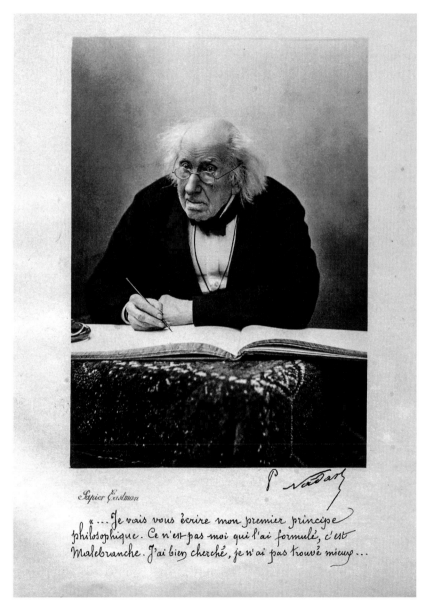

Papier Eastman

« ... Je vais vous écrire mon premier principe
philosophique. Ce n'est pas moi qui l'ai formulé, c'est
Malebranche. J'ai bien cherché, je n'ai pas trouvé mieux ... »

"... I am going to write down my prime philosophical principle. It was not I who put it
into words, it was Malebranche. In casting about, I've found nothing better than this
..."

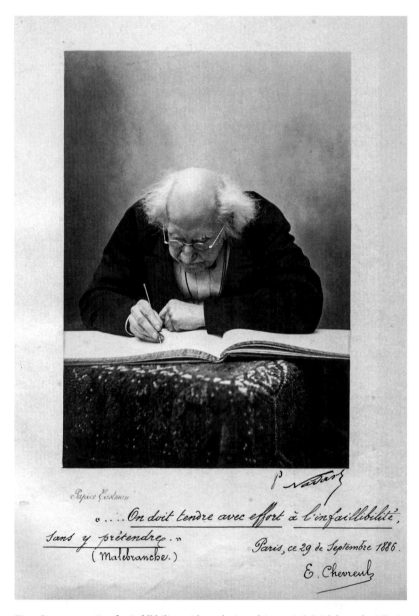

"'… One must strive for infallibility without laying claim to it.' (Malebranche.) Paris, September 29, 1886. E. Chevreul."

Now look carefully at this: I am going to spin this red and white disk, and you will have the impression of … green …

I ran into Monsieur Hersent, the painter and academician in the court of the Institute in 1840 … and I told him that yellow placed next to blue produces an orange color, and that blue next to yellow turns violet. …

Monsieur Hersent, somewhat upset by our talk, replied: "Had anyone but Chevreul told me that, I would say he was lying! But since Monsieur Chevreul has said so, I wish to see it to believe it." So I invited him to come to my laboratory at Les Gobelins, where I would prove it to him.

He died twenty years later, without ever having come to see me at Les Gobelins, as I had asked him to do.

Chevreul's appointment to the Royal Tapestry Manufacturer of Les Gobelins had been as supervisor of color-dyeing processes, and it was there, convinced of the need for a firm and scientifically sound basis for their improvement, that he conducted his research into color perception. The central importance of this work for the entire range of an era's industrial production is articulated in the full title of the pathbreaking treatise, *On the Law of Simultaneous Contrast of Colors and on the Matching of Colored Objects Considered According to the Law in Its Relation to Painting, to the Tapestries of Les Gobelins and to Those of Beauvais for Furniture, to Rugs, Mosaics, Stained Glass Windows, Printed Textiles, Printing, Illuminated Design, Architectural Ornament, Clothing and Horticulture.*[2]

If Monsieur Hersent persisted in his resistance to Chevreul's research, the same is not to be said of those artists whose names, unlike Hersent's, endure as Chevreul's truly distinguished contemporaries and vital posterity. Baudelaire, writing of Delacroix, who was, indeed, acquainted with the color theorist's investigations, tells us, in his account of the artist's works on view at the Exposition Universelle of 1855, that "even when seen at a distance too great to allow for analysis or even

31

comprehension of the subject, a picture by Delacroix already produces an impression that is rich, cheerful or melancholy, as though a painting such as this can, like a sorcerer or mesmerist, project its thought at a distance." This singular phenomenon derives, says Baudelaire, "from the colorist's power, from a perfect tonal harmony (preestablished in the painter's mind) between color and subject." And he then declares that "it seems as though this color … thinks for itself, independently of the objects clothed in it."[3]

It is, in fact, the rethinking of color, of the dynamics of its perception, that will effect pictorial Modernism's revision of representational practices. If, for Delacroix, acquainted with Chevreul's research, it is already an increasingly expressive element of composition, the Impressionists and Postimpressionists will, through independent and parallel analytic efforts, radically redefine the dialectic of form and color. Representation will, as in the art of Monet, tend toward the sovereignty of optical sensation.

The editorial introduction to Nadar's photographic reportage anticipated the imminent capture and preservation of human speech by "the wondrous invention" of the phonograph, thereby "eliminating all possibility of error and omission." M. Paul Nadar has managed, as it were, through these prodigious improvements, "to complete in advance the task of the phonograph which will soon be preserving articulated sound." And for the editor, the fifteen-minute pose required by Niépce or Daguerre is a thing of the past: "Photography has now, through Eastman's efforts, captured images in one two-thousandth of a second. … Monsieur P. Nadar has [thereby] instantaneously reproduced all the gestures of the illustrious scientist, his many faces, as it were, the changes and metamorphoses which, depending on the subject under discussion, transformed his countenance and his general aspect."[4]

When one remembers, as well, that Jules Marey (1830–1904), seeking, in his proto-cinematic analyses of movement, to perfect the darkroom constructed for his "chronophotographic" apparatus, adopted Chevreul's formula for the production of "absolute darkness," we have an

intimation of the centenarian's place at the point of intersection, within the nineteenth century, of photography, painting, and cinema.[5] Or rather, we may see him as that locus from which we can trace the radiating developments of those practices of representation.

Nadar's photographic reportage, produced just ten years prior to the Lumières' first public demonstration of cinema in the Grand Café, marks a limit, the visible trace of the instant that precedes the eruption of the still image into movement, the moment in which, as Louis Lumière will claim, photography appears to "branch out" into cinema.

For it is in 1906 that Maxim Gorky informs us that

Last night I was in the Kingdom of Shadows. …

If you only knew how strange it is to be there. It is a world without sound, without color. Everything there—the earth, trees, human beings, air and water—is dipped in monotonous grey. Grey rays of the sun across the grey sky, grey eyes in grey faces, and the leaves of the trees are ashen grey. This is not life but its shadow, it is not motion but its soundless spectre. …

When the lights go out in the display room for the Lumière Brothers' invention, there suddenly appears on the screen a large grey picture. A street in Paris—shadows of a bad engraving. As you gaze at it, you see carriages, buildings and people in various poses, all frozen into immobility. All this is in grey, and the sky above is also grey; you anticipate nothing new in this all too familiar scene, for you have seen pictures of Paris streets more than once. But suddenly a strange flicker passes through the screen and the picture stirs to life. Carriages coming from somewhere in the perspective of the picture are moving straight at you, into the darkness in which you sit; somewhere from afar people appear and loom larger as they come closer to you; in the foreground children

are playing with a dog, bicyclists tear along, and pedestrians cross the street picking their way among the carriages. All this moves, teems with life and, upon approaching the edge of the screen, vanishes somewhere beyond it. … Before you a life is surging, a life deprived of words and shorn of the living spectrum of colors. … Suddenly something clicks, everything vanishes and a train appears on the screen. It speeds straight at you—watch out! … But this, too, is merely a train of shadows. … Three men, seated at a table playing cards. Their faces are tense, their hands move swiftly. … It seems as if these people have died and their shadows have been condemned to play cards in silence unto eternity.[6]

Gorky's text, which continues with a review of the program of films (among them, *Workers Leaving the Lumière Factory* and *Watering the Gardener*, both now enshrined within the canon of the primitive period), bears the traces of the persistent fascination and discomposure that have in large part generated the theoretical literature accompanying the cinema's development. Gorky has chronicled the instant of revelation that is even now available to us. For to watch a film move between freeze frame and motion is to relive cinema's generative moment, its opening of a paradigm shift.

To understand the discomposure of that moment, that shift, we must take some account of cinema's "spectral" quality in the full range of that term's meaning. Ghostly, insubstantial, unreal, the spectral is defined, also, as that which is produced by the action of light upon the eye or other sensitive medium. Deriving from the notion of an object or source of dread or error, it pertains, as well, to the spectrum. It may be an unreal object of thought, a phantom of the brain, an apparition, or yet again, a faint shadow or imitation of something. And for the school of Epicurus, a spectre was an image or semblance supposed to emanate from corporeal things, those that assail the soul when she ought to be at rest. The simulacral, ever recurrent, always disturbs.

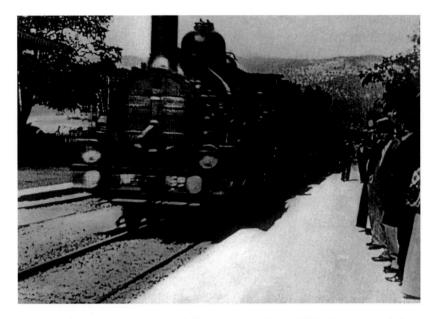

Auguste and Louis Lumière, *Arrival of a Train at La Ciotat*, 1900. Courtesy Anthology Film Archives.

Gorky, however, was of a generation long acquainted with photography's world in gray. It is, rather, the grayness of a suddenly animated, mute world that newly perturbs; the sense of beings "eternally condemned" is attendant upon and indissociable from the impression of mute "life" in cinema.[7] If, as we know, photography had from the first a perturbing effect, the advent of the motion picture intensified this perturbation; its effect of spatial depth and temporal flow may truly be said to have complicated the nexus of jubilation and discomposure that had characterized, from its earliest period, the reception of photography. To photography's indexical "certificate of presence," to its ostensive declaration that "this has been,"[8] cinema brought the edge of actuality, the warrant of the present, the claim that "this is."

<p style="text-align:center">*</p>

A body in motion moves neither in the space in which it is, nor in that in which it is not.

—*Zeno of Elea*

It was in the decade following the First World War and the October Revolution, during an era of revival and consolidation of the film industry, that the spatiotemporality of cinema became, for a generation of European intellectuals, the object of a general and lively theorization. In this period, the revival of the film industry went hand in hand, as it were, with speculation on cinema's multiple possibilities as artistic practice, historical archive, and as a new, uniquely powerful instrument of analysis. This generation looked upon the dazzling promise of cinema with a wild surmise.

Albert Einstein, speaking in 1920, saluted film, predicting "its triumphal march … into pedagogic regions," anticipating, with remarkable precision, the project of a revolutionary filmmaker such as Dziga Vertov. Einstein outlined the manner in which

it would be possible … to infuse certain subjects with pulsating life.

And the lines on a map will gain an entirely new complexion in the eyes of the pupil, if he learns, as if during a voyage, what they actually include, and what is to be read between them.

An abundance of information is imparted by the film, too, if it gives an accelerated or retarded view of such things as a plant growing, an animal's heart beating, or the wing of an insect moving.[9]

Among the most important of early writers on film was Jean Epstein, whose critical work, coextensive with his filmmaking career, remains unexcelled in its originality, imaginative power, and the vivacity of its rhetoric. Epstein was intent upon situating his speculation within a larger philosophical context, that of contemporary theoretical developments, and to clarify thereby the status of film in relation to that of other artistic practices. Like most theorists of cinema, especially those of this early period, he worked toward the constitution of a filmic ontology. In so doing, he was concerned to account for and to preserve the initial sense of wonder elicited by the appearance of the medium. He thus became the advocate of those specifically cinematic techniques and optical processes that had so intrigued Einstein. Sharing in the general epistemological euphoria that characterized the theorists of the time, he saw the spatiotemporality of cinema as the way to disclose the immanent structure of the phenomenal world. Film was to be philosophical, or it would not fully be. Epstein wrote: "Little or no attention has been paid until now to the many unique qualities film can give to the representation of things. Hardly anyone has realized that the cinematic image carries a warning of something monstrous. That it bears a subtle venom which could corrupt the entire rational order so painstakingly imagined in the destiny of the universe."[10]

In this passage Epstein located a principal source of the spectatorial discomposure attendant upon film's emergence. His intuition as to the import of cinematography as a radical intervention within Western culture is grounded in the knowledge that discovery involves, inevitably, an abandonment of epistemological certitude. Citing his own use of the specifically optical properties of cinema (slow motion, freeze-frame, superimposition, and the like), he suggested that they may serve to clarify "that terrible underside of things … terrifying even to Pasteur, the pragmatist. … Now, the cinematograph seems to be a mysterious mechanism intended to assess the false accuracy of Zeno's famous argument about the arrow, intended for the analysis of the subtle metamorphosis of stasis into mobility, of emptiness into solid, of continuous into discontinuous, a transformation as stupefying as the generation of life from inanimate elements."[11]

To slow motion, in particular, Epstein attributed the possibility of disclosure that might regain for us a degree of certitude. For him (and in this belief, he is by no means alone), cinema in slow motion is a truth machine: "If a slow motion film were made of an accused person during his interrogation then, from beyond his words, the truth would appear, evident, fully inscribed upon his face, so that there would be no further need of indictment, or of any proof beyond that provided by the deep images."[12]

In his questioning of the Eleatic paradox,[13] Epstein had, with his extraordinary acuity, also seen the particular interest of the role of the still photograph within the flow of cinematic temporality. He had seen that the still photograph cuts into time, that the instant of arrest produces a kind of gap, and that cinema, grounded in the persistence of vision, has hypostatized our inability to think a gap in time. The filmic "frame" or single image, abstracted from that flow, becomes that which Philippe Dubois has, in an extremely interesting study, termed "thanatography."[14] One can, then, say that the photograph inserts, within our experience of lived time, the dimension of "extratemporality." It is this dimension that gives to the freeze-frame, and to cinematic forms of temporal variation

and digression, their particularly striking effects. Within the flow of cinematic representation, that semblance of temporality itself, we can produce an arrest. The image, released from that flow and from that of the narrative syntagma, is thus invested with an extratemporal dimension. That arrest, that extratemporality, figures mortality.

The theorization of photography has not developed in a steady, systematic fashion; rather it has been hesitant, sporadic, charged with tension and with contradiction. It may well be that the West has been reluctant to confront squarely and in full the early intimation of the thanatographic function of these processes of chemical and mechanical reproduction. That theorization, long deferred, began with the discourse on the spectral and the disquiet elicited by it. To this discourse, Epstein and his contemporaries brought the intimation of a boundless promise contained within the cinema. The anticipation of a new episteme is evident in the proliferating literature on the silent film, and in the general and predominant euphoria that never quite dispels the disquiet of cinema's earlier reception. This spirit lingers until the eve of the Second World War, for Walter Benjamin, in the most celebrated and influential of his essays,[15] speaks of the way in which slow motion reveals qualities hitherto concealed within familiar gestures. It is as though the nature that now "opens itself to the camera" differs from that which is accessible to the eye, "if only because an unconsciously penetrated space is substituted for a consciously explored one."[16] For Benjamin, as for Epstein, it is cinema, with its mobile frame and play with scale, its temporal variation, that will newly instruct us in the particularities of motion, of gesture, and of subjectivity's fluctuations. "The camera introduces us to unconscious optics as does psychoanalysis to unconscious impulses."[17]

For Dziga Vertov, working within the exceptionally fertile period of postrevolutionary Soviet cinema, latent truth was similarly susceptible to filmic inscription upon the human face. He recounts, in a text that closely parallels that of Epstein, his own initiatory glimpse of the cinematic potential. Early in his career he had beheld upon his own face,

filmed in slow motion during a perilous leap across Moscow rooftops, the successive expressions of fear, hesitation, resolution; he had seen the strain of effort, shock, and adjustment of the body in that leap and final landing.[18] Paul Valéry, writing in 1927, offers an interesting parallel account of the unsettling revelation produced by the subject's sight of self in cinema: "Saw myself in film. Odd, seeing one's self as a puppet. Heightening of mirror effect. Narcissus stirs, walks, sees himself from the back, as he cannot see and could not imagine himself. Becomes aware of a whole area indissociable from him, a host of hidden bonds, a whole Other sustaining the Same. Receives the invisible self. One is cast out of one's self, changed into another. One passes judgment upon one's self—If it could see or perceive, through this artifice, the mind thus externalized, and from forbidden angles—what awareness would one have? What effect on one's sense of self? To see one's self thinking, responding, sleeping."[19]

The sense of an expanding horizon of inquiry, of film as a philosophically charged medium, informs, as well, the film practice of the early years. The films of Méliès, Keaton, René Clair, Vertov, Epstein (to name but a few) celebrate, in narrative and in the deployment of optical processes, the passage from photography to cinematography. In so doing, they install early on within the history of the medium the metacinematic discourse that will insidiously and intermittently traverse the development of the medium down to our time. Within this discourse the relation between the still and moving image has a place of privilege.

Thus in René Clair's *Paris qui dort* (*The Crazy Ray*, 1924), the city, arrested by the action of Dr. Crase's time machine, lies suspended in sleep. The squares of the Opera, of Concorde, and of the Madeleine are silent; the streets of Chaillot and of the sixteenth arrondissement are emptied and quiescent, as in the photographs of Atget, with here and there a lone *figurant* (extra), a street cleaner or cab driver, transfixed in the post of the *petits métiers*. Only Dr. Crase's machine (within which we sense the presence of the camera of Mr. Clair, the filmmaker) can release the still picture (the stilled city) into the temporality of cinema (the flow of life).

———

René Clair, *Paris qui dort*, 1924.

This modest comedy, an early example of the "city film," is a philosophical fable in which the theme of the urban metropolis as the seat of capital, and the notion of time as money, are intertwined with the jubilant celebration of cinematic temporality, the passage from still to moving picture and back again.[20]

Vertov's *Chelovek s'kinoapparatom* (*The Man with the Movie Camera*, 1929), undoubtedly the most ambitious metacinematic effort within the history of the medium, is constructed through the analysis of the harmonious interrelationships of production processes with a socialist society. Filmmaking as one form of labor among others provides the central axis of the work, and the production of this very film generates the demonstration of editing and projection processes by which, in a series of brilliant variations, the dialectic of still and moving image is proposed.[21] This celebrated reflexive parameter of the film is, moreover, initiated by the sequence of a family on holiday excursion in a horse-drawn carriage, during which a freeze-frame in close-up of the cantering horse suddenly, startlingly disrupts the flow of action, precipitating the spectator back toward the editor's work on the strip of still images.

Two masters of the silent cinema have, from within their respective political cultures, set forth the terms for a reading of cinema and photography as the terms of a dialectic operative within mechanically reproductive processes. Muybridge and Atget preside, as it were, over the initiation of the metacinematic discourse. Cinema, that spectral form, will in turn be haunted by still photography.

*

Simulation tends toward a limit which is contradiction.

—*Paul Valéry*

The role and status of both freeze-frame and still photograph within the flow of cinematic narrative were initially enlisted in the celebratory rehearsal of cinema's genesis. Their use, developing over time, was extended, varied. Vertov himself, in *Three Songs of Lenin* (1934), was to set his film oscillating between action and freeze-frame in the articulation of the mourner's obsessive desire to retain a loved object, to recapture a historical moment, to memorialize a departed leader.[22]

This oscillation, when more generally considered, constitutes the "ostensive declaration" to the spectator that not only is cinematic representation composed of multiple images, but that it is a representation.[23] It is this awareness, basic to Clair's analytic irony and to Vertov's revolutionary commitment, which, together with evidence of the labor processes and material conditions of film production, was systematically excised from cinematic representation. Such were the consequences of the development within the dominant system of production of a narrative form construed as a "classical mode."

André Bazin remarked of that excision, beginning in 1932, of optical effects such as superimposition and the "wipe" that it entailed "even, especially in the United States, [the rejection of] the close-up, the too violent impact of which would make the audience conscious of the cutting." These devices and processes, together with those of slow motion and the freeze-frame and still image, had characterized a period of "associative montage" with its stress on the symbolic interrelation of images. The system of classical film narrative established within the American film industry between 1917 and 1940 called for modifications such that these processes would come to represent anomalies within the construction of the spatiotemporality of industrial production.[24]

Although more detailed and precise accounts of these developments have brought to view the variations and contradictions within the system, there is no doubt of its rapidly established hegemony, not within American production alone, but in that of the European, Soviet, and Asiatic industries as well.[25] The setting of norms and standards for

Dziga Vertov, *Chelovek s'kinoapparatom*, 1929. Courtesy the Museum of Modern Art, Film Stills Archive, New York.

all parameters of production—lighting, editing (match cutting and cross cutting), the composition and use of music, among others—was designed to insure a generalized clarity, coherence of psychological motivation, and narrative closure. For those who, like Bazin, saw realism as "cinema's vocation," the desired "continuum of reality" necessarily entailed the rejection of metaphor and symbol and their enabling devices as the price for an illusion of a transparently objective presentation. The consequence of these developments was a qualification, a diminishing, of the cognitive aspect of film viewing. A cognitive spectator was succeeded, as it were, by a desiring spectator.

A critique of cinematographic representation and its conditions of production would in the 1960s produce within American and European cinema the reinsertion within the film strip of the still and stilled image. This development began, however, in this country in the aftermath of the Second World War, through the emergence of a generation of filmmakers seeking, through an artisanal mode of production, greater autonomy and control. The material circumstances of independent production at that time allowed for a relative expansion based on recent experience with 16 mm technology, used in the Army Signal Corps, and the engagement of personnel from the film industry (including directors such as John Huston and Frank Capra, among others) in documentary work for the war effort. At the other end of the cultural spectrum, in both New York and Los Angeles, distinguished émigré representatives of the European avant-gardes had provided an important stimulus to independent production. Alternative models of representative models of representation (those of the Dadaists, Surrealists, and Expressionists) were reexamined.

Within this period, the figure of Maya Deren is especially salient, for it was she who located and defined many of the principal issues, options, and contradictions of filmmaking conceived as an artistic practice. Deren's formulation of aesthetic principles and social goals, as well as her career as filmmaker, writer, and organizer, epitomizes, in a clear and prescient manner, the central and unresolved tensions that continue to

inform the relations between technology and artistic practice, between first and third world cultures, and that characterize both the tasks and the predicaments of the woman artist. A theoretician of originality and power, she formulated in her writings of the 1950s and 1960s the tenets and the program of a cinematic avant-garde. If these efforts developed the impetus of a "movement," this was due largely to Deren's ability to articulate the claims of the filmmaker within the larger context of cultural production. Her example and influence, her concrete programs, formed a model of filmmaking practice for several generations of workers in the field, and it is in terms of that model (rather than through formal "influences" or morphological parallels) that we can define and assess the nature of her contribution to the culture of our time. Her writings demonstrate a renewed preoccupation with the relation of filmmaking to other artistic practices within a specifically Modernist tradition. Adopting as a basis for both film theory and practice a linguistic model, articulated in terms analogous to the model then in the process of elaboration by Roman Jakobson, she proposed a dialectic centrality of metaphor and metonymy, of "vertical" and "horizontal" axes, which provides the structural principle of her mature work.[26]

Ritual in Transfigured Time (1946) traces the labyrinthine negotiations and cyclical repetitions of the urban cocktail party, offering a rhythmically and spatially complex choreography developed through assertive editing, loop printing, the mismatch within a synthetic continuity of tracking shots, and freeze-frame. It reintroduced, as well, superimposition through the slow dissolve, which also stresses the still photographic dimension of cinematography insofar as movement within the composite image is thereby qualified. Presenting, as well, in the concluding sequence, the literal transfiguration, by passage from positive to negative image, of the female body and countenance, she amplified the deployment of optical processes, emphasizing a renewed potential of the photographic within cinema.

Maya Deren, *Ritual in Transfigured Time*, 1946. Courtesy Anthology Film Archives.

During the next two decades, independent production in this country centered on a project of transgression, doubly defined as such: the sustained celebratory discourse of the erotic, and the production, hitherto suppressed, of film outside the industrial system and its narrative codes. These two transgressive impulses, confirmed in the theoretical production of that period, are to be understood as intimately, indissociably linked. It is in the 1960s that independent filmmaking shifted focus from that of the erotics of the body to another prime object of desire: the body of cinema itself. The result is the intensified reflexivity of that period's production. In this period, that of the maturity of Michael Snow, Hollis Frampton, Stan Brakhage, Ernie Gehr, and Ken Jacobs, among others, the reinsertion of the still image emerges as a generalized deconstructive strategy of cinematic representation. This is the period of metacinema. The price extracted for its subtlety and refinement has been the sacrifice of access to advanced, industrial technology. An assertion by Frampton, poet, photographer, and filmmaker, whose originality and intellectual grace established him as the preeminent theorist of the movement, epitomizes its character:

> Cinema is a Greek word that means "movie." The illusion of movement is certainly an accustomed adjunct of the film image, but that illusion rests upon the assumption that the rate of change between successive frames may vary only within rather narrow limits. There is nothing in the structural logic of the film strip that can justify such as assumption. Therefore we reject it. From now on we will call our art simply: film.[27]

Snow explored, with a notable consistency, the function and status of the still image within the moving picture. *One Second in Montreal* (1969), which followed the celebrated *Wavelength* (1967), represents an attempt to construct, in film, a purely temporal structure. It presents a serially composed succession of still photographs animated only by the

flicker of projection. The images of public squares and parks at that time under consideration as possible sites for a monument in Montreal succeed one another in a series of expanding and contracting length. The main compositional parameter is that of duration, and the work consequently offers, with unadorned intensity, the tension inhering between the still photograph and filmic image.

The reinsertion of the still image within European cinema was heralded in magisterial fashion by the production of Chris Marker's *La Jetée* (1961). This remarkable instantiation of the catastrophic imagination projects in still images the posterity of nuclear destruction, a world in which the memory of the past is, with difficulty and in pain, by strenuous effort, only partially retrievable. The narrator, speaking from beyond a civilization's entombment, recalls the fragile, vivid images of that past, whose climax is a single instant of movement: the flicker of an eyelid, that of a woman known within that past or future life, remembered as awakening from sleep at the dawn of a summer's day. In that instant of passage from still to moving picture is contained the promise of joy.

It was Jean-Luc Godard, however, who, within the European context, initiated, in the mid-1960s, the systematic and consequential analysis of cinematic representation and its narrative system. Beginning with *A Married Woman* (1964), produced at the moment of pop imagery's insurgence through the work of Warhol and of Lichtenstein, Godard commenced his analysis of the culture of consumption, which had generated the proliferating imagery of advertising, packaging, and printing techniques that now emerged in the iconography of painting. This analysis was tellingly amplified in *Two or Three Things I Know about Her* (1967), in which the theme of prostitution, subject to successive and obsessive variations, also entered Godard's production. Photographs, posters, advertising slogans, book covers, newspaper clippings, street signs, traffic signals began then to fill Godard's screen.

The political crisis of the late 1960s finally impelled an intensified interrogation of the sound-image relationship as the nexus of cinematic

representation and its ideology. Godard's analysis of the culture of the consumer society became directed against "cinephilia," against the cinema as object of desire, and there followed a period of intensive assault upon cinematic representation as the instrument forged by the bourgeoisie for the imposition of its own vision of the world, rigorously determined by class interest. Godard's increasingly violent attack upon the cinema is not, as in the case of the Americans, wholly focused on the constitution of a filmic ontology; rather, its deconstruction of the codes of sound-image relationships is aimed at the creation of a foundation for another, oppositional cinema, a militant cinema destructive of bourgeois ideology.

Godard drew support for these efforts from a larger, developing current of opposition to a system of pictorial representation that was then, somewhat tardily, revealed to have provided the presuppositions for photographic and cinematic practices. Thus:

> It is interesting to observe that it is the very moment when, for Hegel, the history of painting is ended, at the very moment of growing awareness of the manner in which the scientifically established perspective which determines painting's relation to figuration derives from a given cultural structure …
> it is interesting to observe that at this very moment Niépce invents photography. Niépce (1765–1833), the contemporary of Hegel (1770–1831), is enlisted in the reinforcement of the Hegelian closure for the mechanical production of the ideology of the perspective code, its norms and effects of censorship.[28]

And the indictment of the photographic origins of the cinema was then, from time to time, reinforced by the evocation of the consolidation of international banking as providing the third term of this ideological hegemony. Niépce, Hegel, and Rothschild are then cited as the trinity

Jean-Luc Godard, *Letter to Jane*, 1972. Courtesy the Museum of Modern Art, Film Stills Archive, New York.

presiding over its installation. *Letter to Jane* (1972), which takes place in Godard's sustained response to the war in Vietnam, and presented a critical analysis of a single still image, subjecting the photograph to an intensive ideological interrogation, completes a historical cycle. In so doing, it once again framed the question: When is a film a movie? Or: What is cinema?

NOTES

First published in the exhibition catalog *The Art of Moving Shadows* (Washington, D.C.: National Gallery of Art, 1989), pp. 13–29. Minor corrections have been made for consistency.

1. These are reprinted, with captions in a translation slightly different from my own, in Beaumont Newhall, *The History of Photography* (New York: Museum of Modern Art, 1964), pp. 181–182.

2. Michel-Eugène Chevreul, *Da la Loi du contraste simultané des couleurs et de l'assortiment des objets colorés, considérés d'après cette loi dans ses rapports avec la peinture, les tapisseries des Gobelins, les tapisseries de Beauvais mosaïque pour meubles, les tapis, la mosaïque, les vitraux colorés, l'impression des étoffes, l'imprimerie, l'enluminure, la décoration des édifices, l'habillement et l'horticulture* (Paris, 1839).

3. For this account of Delacroix's work, see *L'Exposition universelle de 1855* in Charles Baudelaire, *Oeuvres complètes*, ed. Jean Hytier (Paris: Gallimard, 1961), pp. 972–973.

4. Editorial introduction to "L'art de vivre cent ans: trois entretiens avec Monsieur Chevreul," *Le Journal Illustré*, September 5, 1886, p. 282 (translation mine). I am indebted to Molly Nesbit for bringing this text to my attention.

5. Marey recounted the manner of his installation as follows: "My experiments revealed the defects in construction of the screen in my present installation. As the exposures were quite long, the slightest bit of light produced a very noticeable effect. I therefore decided to replace the inclined screens with a kind of shed, deep and completely dark inside." Cited in Jacques Deslandes and Jacques Richard, *Histoire comparée du cinéma*, vol. 1: *De la cinématique au cinéma: 1826–1896* (Paris: Casterman, 1966), p. 120. The shed in Marey's "station physiologique" measured three meters deep, fifteen meters long, and four meters high. The walls were smoked black and the floor was tarred so as to limit, as far as possible, the reflection of light. In 1884, Marey had the shed's walls covered in black velvet. See also the description of Edison's first production studio, the celebrated "black Maria," in Matthew Josephson, *Edison: A Biography* (New York: McGraw-Hill, 1959), pp. 393–394.

Peter Kubelka's design for the Invisible Cinema theater at Anthology Film Archives, constructed in New York in 1971, represents a recent variation of this model.

6. I. M. Pacatus (pseudonym of Maxim Gorky), in *Nizhegorodski listok* (July 4, 1896), cited in Jay Leyda, *Kino* (London: Allen and Unwin, 1960), pp. 407–409.

7. This image of a machine-generated life perpetuated in silence is central to the cinematically inspired theme of the novel *The Invention of Doctor Morel*, by Adolfo Bioy Casares, the friend and collaborator of Jorge Luis Borges. The notion of the "spectral" within the early reception of photography is epitomized in Balzac's speculations upon the medium, as reported by Nadar in "My Life as a Photographer," trans. Thomas Repensek, *October* 5 (Summer 1978): 7–28. For elucidation of this discourse within the early theorization of the medium, see Rosalind Krauss, "Tracing Nadar," *October* 5, pp. 29–47. Its revival is central to the work on photography of Roland Barthes in *La Chambre claire: Note sur la photographie* (Paris: Editions du Seuil, 1980), pp. 23–24.

8. These pervasive themes are developed in Barthes, *La Chambre claire*, pp. 119–126.

9. Cited in Alexander Moszkowski, *Conversations with Einstein*, trans. Henry L. Brose (New York: Horizon Press, 1970), pp. 69–70.

10. Jean Epstein, "The Universe Head over Heels," trans. Stuart Liebman, *October* 3 (Spring 1977): 21.

11. Ibid., p. 23.

12. Jean Epstein, "A Conversation with Jean Epstein," *L'Ami du peuple* (May 11, 1928), trans. Robert Lamberton, Anthology Film Archives, undated, unnumbered.

13. Epstein, "The Universe Head over Heels," pp. 18–25.

14. Philippe Dubois, *L'Acte photographique* (Paris: Nathan, 1983), pp. 111–148.

15. Walter Benjamin, "The Work of Art in the Era of Mechanical Reproduction," in *Illuminations*, ed. Hannah Arendt, trans. Harry Zohn (New York: Schocken, 1969), pp. 236–237.

16. Ibid., p. 236.

17. Ibid., p. 237.

18. Dziga Vertov, "*Three Songs of Lenin* and Kino-Eye," in *Kino-Eye: The Writings of Dziga Vertov*, ed. Annette Michelson, trans. Kevin O'Brien (Berkeley: University of California Press, 1984), pp. 123–124.

19. Paul Valéry, "Ego," in *Cahiers*, 2 vols., ed. Judith Robinson (Paris: Pléiade, 1973), vol. 1, pp. 107–108 (translation mine).

20. For a fuller consideration of this work and of its theoretical implications, see my "Dr. Crase and Mr. Clair," *October* 11 (Winter 1979): 31–33. This text also discusses in

some detail the relations (historical, semantic, and formal) between *Paris qui dort* and Dziga Vertov's *The Man with the Movie Camera*.

21. This film is analyzed in considerable detail in my "'The Man with the Movie Camera': From Magician to Epistemologist," *Artforum* 10, no. 7 (March 1972): 60–72. For a more extensive consideration of its place within the totality of Vertov's production and within that of the Soviet Union in the postrevolutionary era, see Vertov, *Kino-Eye*, pp. xxxxii–lxi.

22. These aspects of the film are discussed in an unpublished essay of my own, "The Kinetic Icon in the Work of Mourning." [This essay was subsequently published as "The Kinetic Icon in the Work of Mourning: Prolegomena to the Analysis of a Textual System," in *October* 52 (Spring 1990): 16–39.]

23. The status of the photographic image is discussed in detail in Noël Carroll, *Mystifying Movies* (New York: Columbia University Press, 1988), pp. 106–127.

24. These developments, central to Bazin's defense and illustration of a cinema of "realism," are outlined in "The Evolution of the Language of Cinema," in André Bazin, *What Is Cinema?*, ed. and trans. Hugh Gray (Berkeley: University of California Press, 1967), pp. 23–40.

25. See David Bordwell, Janet Staiger, and Kristin Thompson, *The Classical Hollywood Cinema: Film Style and Mode of Production to 1960* (New York: Columbia University, 1985), pp. 1–69.

26. These principles are set forth in Deren's contribution to "Poetry and the Film: A Symposium with Maya Deren, Arthur Miller, Dylan Thomas, Parker Tyler, Chairman, Willard Maas. Organized by Amos Vogel," in *Film Culture Reader*, ed. P. Adams Sitney (New York: Praeger, 1970), pp. 171–186.

27. Hollis Frampton, "For a Metahistory of Film," in *Circles of Confusion* (Rochester: Visual Studies Workshop, 1983), p. 111.

28. Marcelin Pleynet, cited in Jean-Patrick Lebel, *Cinéma et idéologie* (Paris: Éditions Sociales, 1971), p. 22 (translation mine).

Gnosis and Iconoclasm: A Case Study in Cinephilia

I love to go to the movies; the only thing that bothers me is the image on the screen.

—*T. W. Adorno*

Anniversaries are of dual nature, impelling rituals of celebration and of commemoration, and such was most evidently the case for cinema's centenary—understandably so, for now, in the age of the digitized image, we begin to construe the notion of cinema in a considerably extended fashion. That step was not easily taken, for it strains with a certain violence an internalized sense of an ontology generated by a century of engagement with practice and theory, formal and improvised. The festivities of 1995 were thus commingled with expressions of mourning. Solicitations for the work of mourning were heard both here and abroad for the death of the medium and of its devotees, for the end of cinephilia. Since there exists, however, no one such thing as cinephilia, but rather forms and periods of cinephilia, its complex history over its first century suggests, in fact, that cinephilia may indeed have a future within the framework of its expanded construction.

Andy Warhol in the Invisible Cinema at the Anthology Film Archives, 1970. Courtesy Anthology Film Archives.

I shall be considering a form of cinephilia as it developed within a
very particular milieu, that of American filmmakers of independent per-
suasion and production, sustained through half a century by the devel-
opment of a movement known as the New American Cinema for the
dissociation of filmmaking from the norms and constraints of industrial
production.[1]

Consider, then, an image—not of a film, but of a theater for film
exhibition: a projective and spectator *dispositif*, generated by a move-
ment's radical revision of the cinematic institution and apparatus. Specta-
torship is traditionally organized within a framework such that the basic
structural components of theatrical exhibition (as against its decorative
aspects) vary but slightly over the range that extends from the neighbor-
hood theater to the *cinémathèque*, film club, the cinema of repertoire, and
the first-run theater. They vary little, too, in their derivatives, the multi-
plexes, hewn from those earlier, grander structures, formerly known as
"movie palaces." In all these, open seating plans prevail, with the specta-
tors enfolded within the mantle of a darkness often qualified or bro-
ken by intermissions, the glare of reflective wall surfaces, the flashlights
of "usherettes." Edward Hopper's canvas *New York Movie* (1939) docu-
ments this tradition, antithetical to the project under consideration. In
this country, the sale of sweets, popcorn, and soft drinks is traditionally
available in the lobby before the spectator reaches her seat (rather than, as
in France, within the projection space proper), and it is generally believed
to exceed in profit that of ticket sales.

In the theater under consideration, no form of supplementary, oral
gratification was offered. Here, the spectator sat solipsistically positioned
by partitions erected in an interior wholly sheathed in light-absorbing
fabric. Here, indeed, was the architecture of the Velvet Light Trap. And
one wants to note that even the minimally luminous Exit signs were an
unwilling concession to the fire department's strictures. Isolated visually,
the viewer could establish minimal tactile contact with her neighbor's
hand, but aurally, one was well insulated, with structure and materials

inhibiting conversation and effectively muffling all sound from sources other than that of the screen. It was this isolation that was assumed to enhance one's sense of Vision. I must add that it was these very features, while conceived as a means of sacralization of the filmic object and essential in the conception of a temple for the ritual celebration of cinema as an artistic practice, that had, from the first, alternatively suggested this structure as an ideally appropriate site for the viewing of pornographic film.

In this theater, devoted to the constitution, preservation, and exhibition of a canonically conceived history of the cinema generated in the continuity of an international cinematic avant-garde, subtitles were not used. For foreign-language films of both silent and sound eras, translations of titles and of dialogue were available in print, for no extraneous element, either visual or aural, was permitted to intrude upon the pristine integrity of the image. Moreover, the current vogue of musical accompaniment for silent film involved in the search for a restored historical "authenticity" of projection was here banned on the grounds that such accompaniment—including that of specially or originally commissioned scores—had been primarily the response to the demands of exhibitors, and not necessarily structurally intrinsic to the author's filmic project.

For this cinema was conceived preeminently as the movement's militant gesture toward the establishment of a *politique des auteurs*, conceived not as an instrument of validation within the system of industrial production, such as that of *Les Cahiers du Cinéma*. Rather, this notion of the Author was tied to that of a film practice underwritten, most importantly, by an *artisanal ideal*, adopted in opposition to the principle of division of labor that animates industrial production. The movement offered a challenge to the dynamics of entrepreneurial capital and management that regulated access to advanced technology while defining the role of director as that of foreman subject to managerial surveillance and corporate control.

The Invisible Cinema at Anthology Film Archives, 1970. Courtesy Anthology Film Archives.

The canon constructed by the founders of the Anthology Film Archives—filmmakers all but one—articulated the felt necessity of a *policy* of production and exhibition to support a reconfiguration of film history—one that would take account of the intensive development of independent and oppositional practice developed largely, though by no means exclusively, within the United States over the three decades following World War II. This canon was grounded in the defense and illustration of the production by the postwar generations of those film-makers of independent persuasion following in the wake of Maya Deren's epochal achievement in both practice and theory.[2] This perspec-tive entailed the reassessment of past production, and it was thus that these successive new waves of Independents found entrance into the company of the Lumières, of Eisenstein, Vertov, Cocteau, Vigo, Bresson, Murnau, Renoir, Keaton, Rossellini, and Dreyer, among others, within the institution's newly formed collection and programming policy. This canon quite evidently overlapped with that established by *Les Cahiers du Cinéma*. However, its opening to an artisanal production grounded in the high Modernism of American painting, music, poetry, and performance was its distinguishing feature.

Finally, the exhibition principle of this theater adopted the form of the loop (subject to amplification if not to fundamental revision), designed to unwind and rewind year after year for the edification of successive gen-erations, ever recommencing the canonical series of films presented in the alphabetical order of the filmmaker's name. Thus, Bresson and Buñuel, following upon Brakhage, were all equally implicated in a continuum that respected neither chronology nor hierarchy of age or reputation—a continuum within which, it must be observed, history was elided in a step propaedeutic to its critical reconfiguration. Conceived as the museologi-cal arm of the movement, this archive provided another demonstration of the manner in which museology traditionally shapes knowledge.

This principle of the loop as the ideal form of the canon's exhibition was, like other important aspects of the institution's aesthetic, designed in

analogical relation to the work of one of the institution's founders and animating spirits, that of the Viennese filmmaker Peter Kubelka, whose own practice as archivist and programmer in the Vienna Cinémathèque, located on the very premises of the Albertina Museum (whose situation within the Ringstrasse suggests the morphological determinant of his practice as filmmaker and curator) was museologically oriented. Kubelka had composed, through the loops of *Adebar* (1957) and *Arnulf Rainer* (1958–1960), his radically minimalist alternations of black-and-white screen and of "white noise" with silence, an essentialist project of maximal intensity and purity. Here, in fact, were films composed as if to order for Adorno's iconoclastic cinephilia, purged of any trace of the mimetic, realized (*réalisés*) at last.[3] Here was a project analogous in its iconoclasm to that of Suprematism as promulgated by Malevich, beginning in 1915. "Until now we have had realism of objects, but not of painted units of color," Malevich had declared.[4] And one recalls that, anticipating Adorno in expression of his own disdain of the mimetic, he had engaged in a debate (a true *dialogue de sourds*) with Eisenstein through two polemical essays of 1925 and 1926, "And Images Triumph on the Screen" and "Artists and the Cinema."[5] If we may say that Malevich was to find his posterity a half-century later (in the painting of Robert Ryman, Ad Reinhardt, Yves Klein, and Agnes Martin), Kubelka, working within the accelerating history of the New York avant-garde, found his within a decade— that of the late 1960s and the early 1970s in the climate generated by "minimalist" sculpture and painting and the film production for which P. Adams Sitney enlisted the somewhat problematic term "structural."[6]

Such, then, was the project of the Anthology Film Archives, established in 1970 under the direction of Jonas Mekas. It offered, through the intensity of its commitment to preservation and documentation of film work, through a fastidiousness of projection technique enhanced by the absorptive properties of its setting, a repertoire, determined by a committee of filmmakers, a canon, conceived, as noted above, for the edification of succeeding generations. It articulated a prescriptively utopian and

redemptive version of cinephilia, and it is this version, frequently attacked as a perversion of cinephilia, that I shall be considering.

Unlike their European contemporaries, who tended to label this cinema "perverse," "chaotic," "futile," or "irrelevant," American filmmakers had been denied access to the economy and technology of a studio system modeled upon that of the automobile industry.[7] European systems of production, differently and somewhat more flexibly organized, were in many cases subventioned by the state, thereby sustaining a margin of possible entry for the ambitious young Independent. And it was, of course, the threat posed by the very success within the international market of American industrial production, so deeply admired abroad (the cinema of Hitchcock, Hawks, Ford, Lang, Ray, Minnelli, among so many others) that impelled the French industry to open the way to a younger generation of filmmakers, capable, in the dawn of the television era of the early 1960s, of drawing younger, larger audiences into the film theaters. (The members of that generation, represented in part by what became known as the New Wave, are now, of course, the senior statesman of a newly threatened industrial production in Europe.)

The strength of this perverse and highly productive cinephilia laid in its oppositional, indeed, its transgressive impulse, in the drive toward a cinema of difference. Its advocates were, of course, the inheritors of a mass film culture, but animated as well by that of high Modernism, and the tension between the two cultures will be played out within the larger development of this movement of Independents. Briefly put, it will, on one level, animate the debate between the projects of Brakhage and Deren on the one hand and of Warhol and Jack Smith on the other. In both instances, however, the general project was, in its nature, deeply transgressive. We do well to pause at this point to inquire into the nature and implications of this perverse and obviously fetishistic cinephilia, literalized, reified, as it were, through the project of the Anthology Film Archives. To

do so, I turn to the published series of exchanges on the themes of desire and perversion, organized and edited in 1965 by Guy Rosolato.[8]

Rosolato designated fetishism as a privileged point of departure for these exchanges, linking, in a manner that appears particularly appropriate for consideration in the present context, the structures of fetishism, gnosis as redemptive knowledge, and perversion. Thus: "It really does seem that perversion is to gnosis what obsessional neurosis is to a religion of ritualized tradition."[9] And Piera Aulagnier-Spairani in reply pointed out: "If it be true that the perverse act consists in a sacralization of the fetish, it seems equally important to remember that this *requires* a permanently immutable ceremony, forms of regulation, and that the meaning of this requirement should not be underestimated."[10]

We must understand this perverse cinephilia as oppositional, and its transgressive impulse as that of a movement's drive toward a cinema of difference. The first object of this transgressive impulse was the mystique of professionalism. A full understanding of this would require consideration of the rejection—critical, systematic, and categorical in the case of Stan Brakhage—of existing codes and techniques of cinematic representation.[11]

A second focus of this drive was that which had been repeatedly repressed within standardized production: the erotic, the body in its fullness of being.

The poet Robert Kelly, an early advocate of the new and independent American cinema put the case as follows:

> I rejoice in the existence of soul. … I will praise accordingly, but will likewise insist that Shechinah walks only in the house of flesh, and that spiritual entities shall be predicated on visible phenomenal bodies. … [F]ilm has consistently avoided dealing … with the human body with the wholeness that man is in the only dimension in which the screen can make that wholeness apparent.[12]

In this respect, the early work of collaboration by the filmmaker Willard Maas and the British poet George Barker takes on special significance. *Geography of the Body* (1943) is entirely composed of shots for which Maas, together with his wife, filmmaker Marie Menken, and Barker filmed details of each other's bodies. I have, in another context, noted

> the succession of extreme close-ups in which skin, fold, membrane, hair, limb, and member are transformed into plateaus, prairies, pools, caves, crags, and canyons of uncharted territory. The film develops the grand metaphor of body as landscape. Estranged, the body appears as "an America, a Newfoundland," its lineaments suffused with the minatory thrill of exploration. Through close-up, magnification, and patterns of editing as well as text, this film works to disarticulate, to reshape and transform the body into landscape, thereby converging, in a manner that is both curious and interesting, with the filmic microscopy which now offers us passage through the canals of the reproductive and cardiovascular systems.[13]

And the newly forming independent cinema becomes one in which desire and its fulfillment—a desire linked with anguish and the pleasures of the perverse—are first articulated as in the work of Maas, Menken, and Deren. These inheritors of the hyperbolic editing tradition of an older avant-garde are celebrants of "the whole man." Promulgators of a gnosis, a redemptive carnal knowledge of "the whole man," their work, grounded in a montage tradition, centered nonetheless, on an erotics of part objects—of a body in pieces.[14] It would be Warhol and Jack Smith (whose debt to Sternberg is evident in *Flaming Creatures* and in other works of film and of performance) who would reintroduce into a homoerotic cinema of the early 1960s a cult of the performer at the center of a cinephilia that has rejoined and revalidated the popular, industrial

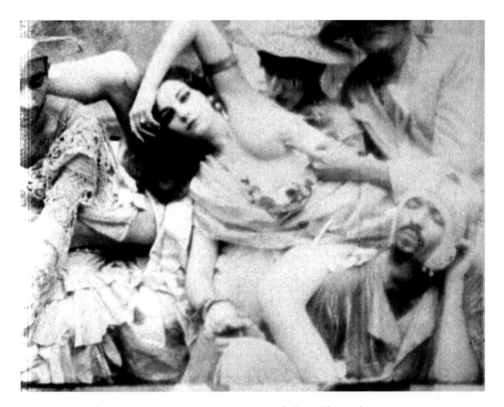

Jack Smith, *Flaming Creatures*, 1962. Courtesy Anthology Film Archives.

cinema. This is a cinema that anticipates the movement for gay liberation and that articulates to the full Whitman's affirmation: "I sing the body electric. And if the body be not the soul, what is the soul?"

If gnosis is, as Rosolato has proposed, "a permanent contestation of the Law, with no recourse to mediation," one does well to note, as well, that

> it forms a sort of state of proliferation, of fermentation within which discovery, unveiling, finds fertile ground and necessary conditions for invention that provide the foundation for the sacred or the aesthetic. The perverse subject thus finds himself well situated for the sorts of reversals and revolutions that propel cultural choices. They provide a context for the clarification of the mechanisms of sublimation. But the energy of obsession will be devoted to the establishment of detailed research, legal procedure, and ritual obedience, the fixing of liturgy and of necessary constraints.[15]

Such are the elements that we find embodied at the level of theory and of practice extensively articulated in the textual production of what was termed the New American Cinema. And they found a further, strikingly concrete embodiment in Anthology Film Archives—in its architecture, in the structure of its exhibition policy and its surrounding rituals, as well as in its radical reconfiguration of film history.[16]

It was, of course, the cinephilia of Jack Smith and of Warhol—with its emphasis on the star performer—that was to reinstall and celebrate the literally visible "whole man," through the restoration of the establishing shot, long take, through action in real time and task performance. Works of the 1960s, such as *Haircut, Eat, Blow Job, Sleep,* and *The Chelsea Girls* are paradigmatic in this regard. It is, of course, Warhol as well who, in a series of moves too widely known to recapitulate here, reinstalled the elements of industrial production in the studio known as the Factory,

with its division of labor, its superstar system. And Warhol's celebration in a series of dazzling portraits of the Star (Elizabeth Taylor, Marilyn Monroe, Elvis Presley, among others) within the tinfoil-lined precincts that in their creation of a reflective surround, fostered, articulated and reified the narcissism of its denizens. The Factory, when scrutinized as site of production is, as I have suggested at some length elsewhere, the elaborately carnivalesque version of an industrial production unit, with its division of labor, office of public relations, marketing strategies, etc.[17] Its carnivalesque nature, involving tactics of inversion, hyperbolization, and desacralization, formed part of Warhol's larger, brilliant strategy of reassessment and revalorization of mass production and its entrepreneurial base. The object of Warhol's cinephilia is the cinematic apparatus and institution as a whole. And Brakhage's vehemently expressed opposition to Warhol, his insistence that the long take, systematically used, contravenes the poetic function of cinema, represented an attack on precisely a restoration of those elements generated by the cinematic institution that were central to Warhol's cinephilia.

This confrontation is intensified, epitomized in the two productions that stand as epic instances of their respective aesthetics: *The Art of Vision* (1965) and *The Chelsea Girls* (1968). And it is as though the extremity of these two ultimate efforts is such as to exhaust the space of confrontation, generating what may be described as *a displacement of cinematic desire*. We locate it partly and centrally in the use of found footage, increasingly frequent in the 1970s. Its paradigmatic expression is the film by Ken Jacobs, *Tom, Tom, the Piper's Son* (1969). This work most intensively exemplifies the manner in which the filmmaker's cinephilia, a desire for cinema as such, mediated until then by the expressive erotics of the human body, is now deflected, reoriented, sublimated, articulated through the body, the corpus, of film itself. And cinephilia will now assume the guise of meta-cinema.

Tom, Tom, then, is centered on the projection of a film made in 1905 (possibly by Bitzer, Griffith's cameraman) on the narrative of the nursery

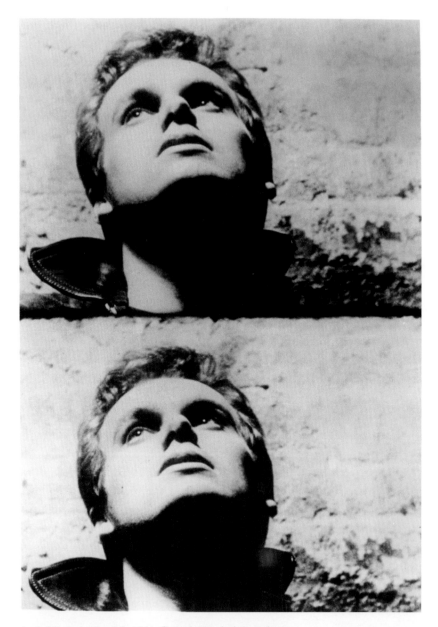

Andy Warhol, *Blow Job*, 1964. © Andy Warhol Foundation.

———

rhyme ("Tom, Tom, the Piper's son, stole a pig and away he run"). Jacobs, rescuing the film from the ashcan of history to which it had been consigned,[18] first offers the film *in extenso*, then proceeds, with the use of an analytic projector, to reshoot the film for one hour, with what one can only describe as a loving, indeed, an amorous caressing and exhibition of the film's hitherto obscured, intimate parts.[19]

Of his project, Jacobs has this to say:

> The staging and cutting is pre-Griffith. Seven infinitely complex cine-tapestries comprise the original film, and the style is not primitive, not uncinematic but the cleanest, inspired indication of a path of cinematic development whose value has only recently been rediscovered. My camera closes in, only to better ascertain the infinite richness (playing with fate, taking advantage of the loop-character of all movies, recalling with variations some visual complexes again and again for particular savoring), searching out incongruities in the story-telling (a person, confused, suddenly looks out of an actor's face), delighting in the whole bizarre human phenomena of story-telling itself and this within the fantasy of reading any bygone time out of the visual crudities of film dream within a dream![20]

This film thus represented the displacement to another site of desire. *Tom, Tom* is, in fact, a demonstration of the amorous caress of this early object of desire, the cinema, through the use of close-up, slow motion (combined with panning and changes of angle), masking, and freeze-frame. Its framing and reframing evoke with singular force the way in which Christian Metz had described filmic framing through the metaphor of the striptease that provokes and renews provocation through a kind of hide-and-seek:

Ken Jacobs, *Tom, Tom, the Piper's Son*, 1969. Courtesy Anthology Film Archives.

> The way the cinema, with its wandering framings (wandering like the look, like the caress), finds the means to reveal space has something to do with a kind of permanent undressing, a generalized strip-tease, a less but more perfected strip-tease, since it also makes it possible to dress space again, to remove from view what it has previously shown, to take back as well as to retain.[21]

And indeed, when, after an hour of this caressing penetration of the filmic object, Jacobs restores and offers once again the film in its pristine entirety, one has the sense of *re-dress* through a permanently altered view of the object.

This displacement, marking the high point of a celebratory cinephilia provided the point of departure, as it were, for a final, sublimatory moment of this movement's cinephilia. It is coincident with another particularly interesting moment of *radical ascesis*; that of Kubelka's posterity, when the screen is *wholly cleared* of images.

I can find no better way of describing or analyzing this period of visual ascesis than by offering the following anecdote, drawn from personal experience. In 1974, while preparing a catalog for a retrospective exhibition in Europe of the American Independent cinema, I was puzzling over the choice of an image to reproduce on the cover.[22] My reflection produced a rapid montage of appropriate single frames in untold numbers, each one when a friend suggested—not, perhaps, without a trace of malice—"Why not an empty screen?" To which my immediate response was, "But *whose* empty screen? That of Brakhage, Sharits, Breer, Kubelka, Conner, Frampton, or Conrad?" For indeed, the screen voided of images seemed to be developing as an important feature of this cinema. One saw it sometimes in color, more frequently as the pristine white radiance of the projector lamp in alternation with the blackness of the screen in the darkened theater. Quite evidently, Kubelka's posterity had arrived, and his prophet was named Tony Conrad.

71

And within this development, one discerns two emerging trends. The first was a growing tendency toward systematicity, in an era when a notion of structure is seen to predominate over the projection of subjectivity. This followed upon the advent of Minimalism in painting and sculpture, and shares with them the deployment of monochrome, of patterns of repetition and the concern with coherence of the compositional gestalt.

And it is at this time that the vacuum of the formerly image-crowded screen is filled with the return of the linguistic sign. We may regard Bruce Conner's remarkable film on the assassination of John F. Kennedy, *Report* (1967), as an anticipatory instance; in it the image track comes entirely to be replaced by the anguish and disorientation of the on-the-spot report of catastrophe over the empty, dark screen. It is, however, *made visible* in the work of the filmmaker Hollis Frampton, of whom Stan Brakhage once remarked, "he strained cinema through language."

Frampton opened a new era in the production of the cinema of independent persuasion. He created in *Poetic Justice* (1972) a film which is, in fact, wholly and radically textual, its screen filled with the successive shots—one to each page—of a film's handwritten script. To read the text requires the integral repositioning of the spectator, whose projection of the imaginary film, the narrative of an apparently triangular series of erotic transactions within a house and garden, is conveyed by descriptions of still photographs. The deictic promise held out is, however, constantly, relentlessly deferred, and the confusion of spatial coordinates and the systematic use of the pronominal shifter work to dissolve and defeat the construction of a coherent narrative.

Adorno, as noted, had objected not to movie going, but to what he saw as the inevitably mimetic nature of the film image.[23] Like Adorno, Barthes was a celebrant of the ritual of filmgoing, and, at the same time, a deeply resistant spectator—resistant to the fullness of the image, its plethora of information imposed upon the spectator.[24] It was, in effect, the tact and economy, the discretion, the reserve of the linguistic signifier

that Frampton offered in *Poetic Justice*, so that there would now exist a cinema invented as if to order for them both. Frampton's sublimation of filmic mimesis and information through textual reduction would complete and intensify the iconoclastic ascesis introduced by the emptying of the screen, postulating, as the ultimate object of cinephilia, one that was wholly eidetic.

NOTES

First published in *October* 83 (Winter 1998): 3–18. Minor corrections have been made for consistency.

1. Although the movement under consideration was largely generated by natives of the United States, the roles of artists of the wartime emigration and of members of a younger generation such as the Austrian Peter Kubelka and the Canadian Michael Snow, among others, have been determinant in its maturation. Jonas Mekas, its indefatigable animator, began his work as an immigrant freshly arrived from Lithuania.

2. Maya Deren's major theoretical texts are collected in *Film Culture* 39 (Winter 1965). The evolution of her career is traced in VéVé A. Clark, Millicent Hodson, and Catrina Neiman, ed., *The Legend of Maya Deren: A Documentary Biography and Collected Works*, vols. 1 and 2 (New York: Anthology Film Archives, 1980). See also Alain-Alcide Sudre, *Dialogues théoriques avec Maya Deren: Du cinéma expérimental au cinéma ethnographique* (Paris: L'Harmattan, 1996).

3. For an outline of Kubelka's own aesthetic, see the collection of interviews with the filmmaker and essays on his work, *Peter Kubelka*, ed. Gabriele Jutz and Peter Tscherkassky (Vienna: P.V.S. Verleger, 1995).

4. This claim is extensively developed in "From Cubism and Futurism to Suprematism: The New Realism in Painting," in K. S. Malevich, *Essays in Art*, vol. 1, ed. Troels Andersen (Copenhagen: Borgen, 1968), pp. 19–21.

5. In Malevich, *Essays in Art*, vol. 1, pp. 226–238.

6. See P. Adams Sitney, *Visionary Film: The American Avant-Garde, 1943–1978* (New York: Oxford University Press, 1979), pp. 368–397. In the pages of a penultimate chapter, Sitney develops what he terms "the most significant development in the American avant-garde cinema since the trend toward mythopoeia … the emergence and development of the structural film." He goes on to define it as one "in which the shape of the whole film is predetermined and simplified," and which generates "the primal impression of the film."

7. Thus Agnès Varda, in conversation, in 1966 on the cinema of Robert Breer; or Jacques Aumont remarking on "the optical mincemeat" of the American avant-garde in his introduction to Dziga Vertov, *Écrits* (Paris: Union Générale de l'Edition, 1970).

8. See Piera Aulagnier-Spairani, Jean Clavreul, François Perrier, Guy Rosolato, Jean-Paul Valabrega, *Le Désir et la perversion* (Paris: Seuil, 1967).

9. Ibid., p. 33.

10. Ibid., p. 47.

11. The textual *locus classicus* is Stan Brakhage, *Metaphors on Vision* (New York: Film Culture, 1963), n.p. Brakhage's radical critique of prevailing theories of visuality and of standard film equipment and technology antedates by approximately a decade that of Godard offered in the wake of the events of 1968.

12. Robert Kelly, "The Image of the Body," in *The Film Culture Reader*, ed. P. Adams Sitney (New York: Praeger, 1970), p. 395.

13. See my "'Where Is Your Rupture?': Mass Culture and the *Gesamtkunstwerk*," *October* 56 (Spring 1991): 42–55; reprinted in this volume.

14. The work of Harry Smith represents a particularly interesting variation on these themes. See his *Heaven and Earth Magic*, also known as *The Magic Feature*, produced, according to Sitney's informed account, during the 1950s. I deal with *The Magic Feature* in "The Mummy's Return: A Kleinian Film Scenario," in this volume.

15. Rosolato, in Aulagnier-Spairani et al., *Le Désir et la perversion*, p. 33 (translation mine). The productive forms of these traits involved, among other things, the Anthology Film Archives' careful documentation of the movement's development. Its files and the Archives' library are the primary source in this country for research in the history of Independent cinema of the postwar period. Its conception of "necessary constraints," whether of exhibition policy or of its architecture, aroused lively debate.

16. The sort of fetishization involved in its archival function is, of course, inherently and universally inscribed in that very practice.

17. A Bakhtinian reading of Warhol's site of production, the Factory, is offered in my essay "'Where Is Your Rupture?': Mass Culture and the *Gesamtkunstwerk*."

18. Recent developments in film history centered on the period formerly termed "primitive" have animated a more general interest in this example of early narrative.

19. This formulation is here offered as an instantiation of the claims made by Christian Metz as to the erotic dimension of cinematic framing and reframing. See Metz, *Le Signifiant imaginaire* (Paris: Union Générale d'Éditions, 1977), pp. 105–106; English translation as *The Imaginary Signifier: Psychoanalysis and Cinema*, trans. Celia Briton et al. (Bloomington: Indiana University Press, 1982), p. 77.

20. Cited by Sitney in *Visionary Film*, p. 406.

21. Metz, *The Imaginary Signifier*, p. 77.

22. The exhibition "New Forms in Film" was held in Montreaux, August 3–24, 1974.

23. See Theodor W. Adorno, "Transparencies on Film," trans. Thomas Y. Levin, *New German Critique* 24–25 (Fall/Winter 1981–1982): 199–205.

24. Roland Barthes, *Roland Barthes par Roland Barthes* (Paris: Seuil, 1975), p. 59.

PART II

I

[O]n its own ground, within its own terms of debate, ratio-
nalism sees the cinema as the dissolving agent of absolute
rules and fixed definitions. For visual representation, given
fresh life through an accustomed cinematic spectatorship,
tends to introduce or reintroduce its higher realism within
the most static verbal concepts through multiple truths sub-
ject to constant variation—even to the point of contradic-
tion, because they are alive.

—*Jean Epstein*

The four decades following World War II saw the emergence of an Amer-
ican cinema of independent persuasion and production, distinguished by
its range (extending from documentary to narrative and lyric forms),
its internationally recognized quality, and its accompanying theoretical
literature. Within the larger landscape of our culture, significantly altered
and enriched by this development, Maya Deren stands as an especially
salient figure, the pioneer who located and defined the issues, options,

and contradictions of filmmaking as an artistic practice. In its formulation of aesthetic principles and social tasks, Deren's career as filmmaker, writer, and organizer epitomizes, in a clear and prescient manner, those tensions, central and unresolved, which continue to inform the relations between art and technology, First and Third World cultures, and the tasks and predicaments of the woman artist.

Thinking of Maya Deren, I begin, as I often have in the past, with an image that documents and emblematizes her project, her role, and the manner in which Deren laid the groundwork for the theorization of an American cinema of independent persuasion and production, one of a deeply transgressive nature. By the latter I have in mind the multiple challenges launched by three generations of filmmakers in defiance of the established codes of industrially produced cinema, the conventions of professionalism, and the constraints of censorship.

Deren's film work of the twenty years following World War II, when casually surveyed, offers evidence of her presence within the intellectual milieux of New York and Los Angeles. John Cage, Anaïs Nin, and Erick Hawkins, to name only a few, were chosen as collaborators in her major films. And her writings demonstrate her familiarity with the poetry, choreography, and music of the period's avant-garde. Her theorization of a cinematic grammar demands analysis in relation to the linguistic model then being developed by Roman Jakobson.

The extensive documentation now available informs us of Deren's political commitments in her student days at Smith College, the University of Syracuse, and New York University.[1] It was, arguably, that same impulse that spurred her to action as theorist, polemicist, propagandist, and animator of the early collective efforts among independent filmmakers in this country. If, in fact, these developments assumed the dynamism of a "movement," this was in large part due to Deren's ability to articulate and promote these efforts, to act as spokeswoman for the filmmaker as artist within our culture. Her example, her influence, her concrete programs were to define a model of filmmaking practice for several

generations of workers in that field, and it is in terms of that model—rather than through formal influences or morphological parallels—that we can locate and assess the nature and the quality of her contribution to the larger culture of our time.

I return, therefore, to a photograph, a group picture made at Cinema 16, a pioneer film society dedicated to the presentation to New York audiences of work by artists of the American avant-garde. The occasion here documented was a symposium held in October 1953, "Poetry and the Film." The proceedings, published in somewhat abridged form in Jonas Mekas's review *Film Culture*, constitute a document of high interest.[2] Rereading them now, one is startled by an intensity and level of exchange among working artists to which we are no longer accustomed. The scene is that of the early 1950s, and here, gathered by Amos Vogel, the director of Cinema 16, in addition to Deren, are its players. Parker Tyler, a poet and film critic already distinguished, had been actively involved with the Surrealists during their wartime exile in New York. Another member of this group is Willard Maas, filmmaker. The others are Arthur Miller, then the white hope of a certain native theatrical realism, and Dylan Thomas, poet and a frequently visiting star performer of that period. These latter two are undoubtedly there to represent, respectively, prose and poetry. With Maas acting as chairman or moderator, cinema and poiesis are most strongly represented by Deren, herself.

This occasion unites not only varying conceptions of film, but also deeply contradictory notions as to what the nature of such an occasion might be, antithetical presuppositions about the conventions of possible discourse on film. And inscribed within it is the clear evidence of the status of a woman as independent filmmaker—one doubly marginalized, and exposed to the lordly contempt affected by intellectuals for seriousness in film and for the female subject as theoretician. Thomas's coarse and derisive wit and his grandstanding joviality are thus directed against the seriousness of a woman filmmaker's attempt to define the subject about which they might profitably converse.

Cinema 16 Symposium, "Poetry and the Film," October 28, 1953. Left to right: Dylan Thomas, Arthur Miller, Willard Maas, Parker Tyler, Amos Vogel, and Maya Deren. Courtesy Amos Vogel.

Miller, whose discourse is less narcissistic and more interesting than Thomas's, has obviously given somewhat more thought to the topic at hand, and there is, near the end, one remarkable moment, when he suddenly declares, "I think that it would be profitable to speak about the special nature of any film, of the fact of images unwinding off a machine. Until that's understood, and I don't know that it's understood (I have some theories about it myself), we can't begin to create on a methodical basis, an aesthetic for that film. We don't understand the psychological meaning of images—any image—coming off a machine. There are basic problems, it seems to me, that could be discussed here."[3]

These remarks are apparently offered as antidote to what Miller obviously considers to be the questionable rhetoric of Deren's poetics, but that challenge and its invocation of "basic problems" will, of course, nevertheless later come to figure in subsequent attempts at an aesthetic and an ontology of cinema undertaken by American Independents and their European colleagues through the reexamination—twenty years later, in fact—of the materiality, the conditions, and the empirical contingencies of filmmaking and exhibition as their movement develops. The theory and practice of Stan Brakhage, Paul Sharits, Hollis Frampton, Peter Kubelka, Malcolm Le Grice, and Peter Gidal, among others, we may now see as an extraordinarily powerful and proleptic corpus of what one might term *une pensée sauvage*, the product of a brilliant *bricolage* accomplished within the general framework of a Modernist aesthetic. It is as such that I shall consider Deren's major theoretical text, *An Anagram of Ideas on Art, Form and Film.*[4]

II

[P]recisely because film, like language, serves a wide variety of needs, the triumphs which it achieves in one capacity must not be permitted to obscure its failure in another.

—*Maya Deren*

———

What was it that Deren was on this occasion proposing? And what did it signify for those who followed in her wake?

Deren spoke for a cinema of poetry and a poetics of cinema, representing an approach to experience as distinguished from that of "drama." Elaborating and further focusing on this question, which had already engaged a tradition of film-theoretical debate around the issue of medium specificity, she now presents a new set of terms for its consideration, describing her approach as "vertical" in structure, as

> an investigation of a situation, in that it probes the ramifications of the moment, and is concerned with its qualities and its depth, so that you have poetry concerned, in a sense, not with what is occurring but with what it feels like or what it means. A poem, to my mind, creates visible or auditory form for something that is invisible, which is the feeling or the emotion or the metaphysical content of the statement. Now, it may also include action, but its attack is what I would call the vertical attack, and this may be a little bit clearer if you will contrast it to what I would call the horizontal attack, to drama which is concerned with the development, let's say, within a very small situation from feeling to feeling.[5]

She continues with a consideration of the relation in Shakespeare's work of the lyric to dramatic form, allowing for the possibilities of varied combinations: "You can have operas where the 'horizontal' development is virtually unimportant—the plots are very silly but they serve as an excuse for stringing together a number of arias that are essentially lyric statements. Lieder are, in singing, comparable to the lyric poem, and you can see that all sorts of combinations would be possible."[6]

Deren is on this occasion arguing passionately and prophetically for something fundamental: a recognition *for* cinema, *in* cinema, of the duality of linguistic structure, that very duality which Jakobson was to

propose, through his study of aphasia, as the metonymic and metaphoric modes, upon which contemporary film theory will eventually build.[7] The subsequent development within academic cinema studies of the syntagmatic chain as the principal axis of film analysis and scholarship was indeed to strengthen and confirm the hegemony of the coded narrative structure within both industrial film production and academic film theory. (André Bazin's defense of the metonymic mode as the epiphanic celebration of the world's flesh would, of course, work toward a confirmation of this structure.)

It was against this hegemony and in validation of a commitment to the substitutive metaphor as an essential constructive element that Deren spoke, and the set of formal strategies entailed by this position, deeply grounded in montage, was to generate an entire rethinking, not only of composition and production, but, eventually, of distribution, exhibition, and reception as well.

Deren's intervention at Cinema 16 was by no means her first effort at a "defense and illustration of a poetic cinema." It stands, nonetheless, as a dramatic moment of crystallization in the theorization of the New American Cinema, that of the period following World War II. It spoke to her contemporary Independents and to the next two generations of filmmakers with a force that can be compared only to the early manifestoes and theoretical texts of Eisenstein. Indeed, we must read her work as reopening, within the context of postwar America, questions posed by the direction, shape, and scale of Eisenstein's project, which had by that time acquired canonical status within the history of cinema.[8]

What, most generally and strongly, might impel one to make such a claim? The sense of a constant and intimate articulation of theory with practice, a relentless concern with systematization, the determination to ground innovative practice in theory. And, of course, the manner in which both practice and theory stand in a relation of fruitful, unresolved tension, at variance with those of industrial production in her time. Tracing the development of Deren's work and of her role, one discerns a logic

that solicits comparison, in some detail, with that of Eisenstein in the construction of a New Cinema—in their insistence on the grounding of this cinema in a solid basis of theory, in their reference to other disciplines and forms of artistic practice. Of major importance, as well, was their grounding in theatrical (and choreographic) movement and gesture, their adventurous forays into other cultures, their interest in ritual, and the manner in which their production is crowned by ambitious and uncompleted ethnographic projects—Eisenstein's in Mexico, Deren's in Haiti. To the consideration of those projects I shall return.

I want, however, at this point, to stress their shared desire for a systematicity that could provide the solid basis and legitimatization of their radically innovative practices. Eisenstein's theory and practice are, as we know, marked, like Deren's, from the first by the contrasting strains of a desire for systematicity and for an organicity of structure. And there is ultimately a sense in which the theoretical productivity of both may have been, at least in part, stimulated by and compensated for, the frustrations encountered in practice.

Anagram, Deren's major text of 1946, forms an early, ambitious, and nearly definitive statement of her poetics. More than this, it sets the tone and largely defines the terms of what came to be the movement of the New American Cinema over the four decades following the war. *Anagram* is, in fact, the hitherto unprecedented attempt, within the United States, on the part of a twenty-six-year-old woman, to propose an ontology, an aesthetic, and an ethos of cinema. Although its density and scope defy the possibility of complete analysis within the constraints of a single essay, I shall want, nonetheless, to convey something of the text's general contours and, in passing, something of its points of convergence with the work of European theorists.

Deren's table of contents for this discursive text is presented as informed with the dynamic play of horizontal and vertical axes in violation of univocal linearity. Central not only to her poetics, such play will become the central line of attack for succeeding generations of the

CONTENTS OF ANAGRAM

	A THE NATURE OF FORMS	B THE FORMS OF ART	C THE ART OF FILM
1 THE STATE OF NATURE and THE CHARACTER OF MAN	**1A** Page 7	**1B** Page 18	**1C** Page 30
2 THE MECHANICS OF NATURE and THE METHODS OF MAN	**2A** Page 11	**2B** Page 21	**2C** Page 37
3 THE INSTRUMENT OF DISCOVERY and THE INSTRUMENT OF INVENTION	**3A** Page 14	**3B** Page 26	**3C** Page 44

Table of contents from Maya Deren, *An Anagram of Ideas on Art, Form and Film* (Yonkers, N.Y.: Alicat Book Shop Press, 1946).

American avant-garde in their struggle against the hegemony of narrative codes and conventions. *Anagram* is a concrete, visual form of presentation, offered together with the following introductory explanation of her strategy:

> An anagram is a combination of letters in such a relationship that each and every one is simultaneously an element in more than one linear series. This simultaneity is real, and independent of the fact that it is usually perceived in succession. Each element of an anagram is so related to the whole that no one of them may be changed without affecting its series and so affecting the whole. And, conversely, the whole is so related to every part that whether one reads horizontally, vertically, diagonally or even in reverse, the logic of the whole is not disrupted, but remains intact.[9]

Deren's triple project is, as a close reading of the text reveals, the construction of an ethos (in the three texts of column A), general aesthetic (elaborated in the three texts of column B), and a cinematic ontology (adumbrated in column C). And all three sections are informed by a critical analysis of developments in contemporary film production seen within the general sociopolitical context. One notes, however, that the project of an ontology is fused, and to some extent confused, with an aesthetic, itself presented as a poetics.

It was, as noted above, in 1946—that is to say, in the climate of malaise created by Hiroshima—that Deren undertook this project of theorization. The cinema of the American avant-garde has been frequently accused of apoliticism, a wholly unjust accusation, as an attentive review of the work of Brakhage, Sharits, Baillie, and Conner, among others, reveals. The movement that was to come to full maturity in the late 1960s was founded by a woman who opened her onto-aesthetic text with an analysis of the American citizenry's passive response to the deployment of

the atom bomb. She sees this as an extension of the nation's sense of the inevitable domination by a science and technology that escape comprehension or control, domination by the industrial and military complex that was shortly to emerge in the "reconversion" period after 1945. Her analysis of what she characterizes as "the schizoid nature" of the social formation within modernity is conveyed in terms familiar to her generation that recall T. S. Eliot's observations on "the dissociation of sensibility," whose origins both Eliot and Deren locate in the seventeenth century—an epistemological break that Europeans will more readily identify with the advent of Cartesianism.[10]

It is this analysis that generates Deren's ethos, expressed in her conviction that it was the artist's role, even morally incumbent on the artist, to confront and address the forces threatening a generalized anomie, to address them in one's art, "not literally, of course, but imaginatively." For Deren, artistic practice is, then, the most powerful antidote to what she sees as an atrophy of consciousness.

And it is, curiously and interestingly enough, in the name of the struggle against this *anomie* that she launches her project with an attack on Realism and on the "romantic realism" of Surrealism. She appears to have in mind the figurative Pictorialism through which Surrealist painting was largely represented and known by the time of her writing. She rejects, moreover, what she terms Surrealism's ecstatic elimination of the "functions of consciousness and intelligence."[11]

It is in the alignment of these two factors that we can see something of the contradictions that inform her categorical rejection of Surrealism. Breton had early on marked out two possible paths for the movement's development of painting. The first, adumbrated in a tribute to Cézanne, proposed the locus of signification in compositional form—the "metaphysics" that transpired through the folds of a curtain within a painted portrait. The second path was that of graphic elaboration and illustration of an iconography of dreams. It was that second path—taken by Dalí, Tanguy, Ernst, and Matta—that she condemned. What Deren did

———

not perceive and understand, however, was the extent to which a free, gestural play, as in the work of André Masson (sanctioned by a tradition of experimentation in automatic production), was to play a role in the maturation of American painting. We do well to remember that Deren's theory and practice are exactly contemporary with the development of Abstract Expressionism—with the work of Pollock, Rothko, Kline, de Kooning, and Motherwell. Deren's strategy, involving the rejection of both unconscious processes as operative in artistic production and the primacy of the mimetic-figurative, was aimed at the establishment of a cinematic specificity and at the institution of the filmmaker as "artist," a status that is repetitively, indeed, obsessively invoked on every occasion of presentation of her work, in both theory and practice.

Presented as an ontology of cinema, *Anagram* offers, rather, an aesthetic and an ethos. Deren sees the aesthetic as predominantly moral in essence. Her critique of contemporary documentary cinema proceeds from the observation that "they stand on moral grounds which are ostensibly impregnable. Yet it is my belief, and I think that I am not alone in this, that the documentaries of World War II illuminate precisely how such a failure of form is a failure of morals, even when it results from nothing more intentionally instructive than incompetency, or the creative lethargy of the 'achieved' professional craftsman. Surely, the human tragedy of the war requires of those who presume to commemorate it—filmmaker, writer, painter—a personal creative effort somehow commensurate in profundity and stature."[12]

The "commensurate effort" of documentation is defined throughout Deren's discourse in terms of a resolutely Modernist tradition founded on a crisis of the referent. It is a crisis that enjoins upon the artist what Deren, in the idiom of her time, calls "the renunciation of the natural frame of reference." This renunciation is not, she says, an escape from "the labor of truth."[13] On the contrary, it places upon the artist "the entire responsibility for creating a logic as dynamic, integrated and compelling as those in which nature abounds." Deren eventually takes

care, however, to reassure her reader: "Everything which I have said in criticism of film may create an image of severe austerity and asceticism. On the contrary, you may find me many evenings in the motion-picture theater, sharing with the other sleepers (for nothing so resembles sleep), the selected dream without responsibilities."[14] One notes the allusion to a signal work of the time, Delmore Schwartz's early story, "In Dreams Begin Responsibilities," that begins with a vision of his parents presented as if on a film screen.[15] Deren came to insist that above all, "it must never be forgotten" what film owes to D. W. Griffith and Mack Sennett, to Murnau and Pabst, Méliès and Delluc, Stiller and Eisenstein.[16] And she will later express her "deep affection for those films which raised person-alities to almost a super-natural stature and created, briefly, a mythology of gods of the first magnitude whose mere presence lent to the most undistinguished events a divine grandeur and intensity—Theda Bara, Mary Pickford, Gish, Valentino, Fairbanks and the early Garbo, Dietrich, Harlow and Crawford."[17]

Deren's critique of the documentary film is, one notes, supple-mented by her strictures concerning the abstract film, which she sees not merely as derivative of painting, but for the most part, as animated paint-ing.[18] Arguing for the priority of the imagination, she clings, nonetheless, to a conception of cinema as defined by the indexical iconicity of what she terms "elements of reality." This principle is, in fact, fundamental to the aesthetic that she presents as an ontology; it is, one presumes, a cin-ema that would offer, as no other medium can, "real toads in imaginary gardens." It was, however, her closest and most seminal colleague, Stan Brakhage, who would define entirely new dimensions of visual abstrac-tion in the service of a mythopoeic cinema.[19]

Filmic abstraction would require, as Deren has it, a temporal abstrac-tion or composition.[20] It is for this reason that she nominates Duchamp's single cinematic work as an interesting and exceptional venture, astutely exempting it from her critical judgment of both abstract and Surrealist-inspired film. For *Anemic Cinema* "occupies, like the rest of his work,

a unique position."[21] And her brief analysis of this work remained for another three decades the only serious attempt to account for what has long appeared an anomalous object, a wrench thrown into the works of film history:

> Although it uses geometric forms, it is not an abstract film, but perhaps the only "optical pun" in existence. The time which he causes one of his spirals to revolve in the screen effects an optical metamorphosis; the cone appears first concave, then convex, and in the more complicated spirals, both concave and convex and then inverted. It is time, therefore, which creates these optical puns which are the visual equivalents, in *Anemic Cinema* for instance, of the inserted phrases which also revolve and, in doing so, disclose the verbal "sense."[22]

Deren's analysis of the dissociation of sensibility, its consequences, and the burden now placed upon the artist has led her to a critique of the aesthetic and ethos of art as expression: the manner in which the artist now often tends, as she puts it, to work out of "compulsions of individual distress." This critique no doubt informs her sympathy for Duchamp's enterprise as a whole. She goes on to propose other possible modes and functions of artistic production. Having rejected the role of unconscious processes in artistic production, she now displaces it, situating it on the level of the larger, general social formation: "Art must at least comprehend the large facts of the total culture and, at best, extend them imaginatively."[23] And she now invokes the role of a collective unconscious within "the deep recesses of our cultural memory, the release of a procession of indistinct figures wearing the masks of Africa, or the Orient, the hoods of the chorus or the innocence of the child-virgin … the faces always concealed, or veiled by stylization—moving in formal patterns of ritual and destiny."[24]

It is the importance of ritual (invoked against both the "confessional" quality of Surrealism and the "compulsive" narcissism of Expressionism) for a contemporary art that she ingeniously argues. It is thus not the expression of individual subjectivity, but rather "the application of … individual talent to the moral problems which have been the concern of man's relationship with deity, and the evidence of that privileged communication."[25] Interestingly enough, however, neither ritual nor those states of possession with which she is concerned are invoked as revelatory of a transcendental signifier. For she remarks that man cannot presume to have knowledge of divine omniscience and power. Her view of individual subjectivity and its aesthetic expression is, in fact, consonant with that offered by Eliot's "Tradition and the Individual Talent," a text which had, by the time of Deren's writing, achieved canonical status within Anglo-American debates on criticism and aesthetics.[26] Arguing for the crucial role of tradition as a sense of the past in truly dialectical relation to the present, Eliot had launched his attack on the valuation of "personality":

> The point of view which I am struggling to attack is perhaps related to the metaphysical theory of the substantial unity of the soul; for my meaning is, that the poet has, not a "personality" to express, but a particular medium, in which impression and experience combine in peculiar and unexpected ways. … One error, in fact, of eccentricity in poetry is to seek for new human emotions to express; and in this search for novelty in the wrong place it discovers the perverse. … Poetry is not a turning loose of emotion, but an escape from emotion; it is not the expression of personality, but an escape from personality.[27]

Armed with the support of a Symbolist-derived aesthetic which had been the object of her academic studies, Deren then develops the manner in which ritual treats the human subject not as the generator of

dramatic action, but as a somewhat depersonalized element in a dramatic whole. The subject is thus *enlarged* beyond the personal dimension and freed from the limits and narrow constraints of personality. She goes on to argue that she becomes "part of a dynamic whole which, like all such creative relationships, in turn, endows its parts with a measure of its larger meaning."[28]

We may then claim that ritual here performs for Deren the role that the epic form did for Eisenstein. And we may further and profitably compare this statement with Eisenstein's realization from his contact with oriental theater that

> when a common cultural heritage and conducting agent exist, it is perfectly possible to communicate by means of those general, emotionally charged complex units, lacking the sharp individualization of a precise, private, conceptual order. And this may, furthermore, act to enlarge the sphere of communication. It is interesting to note that this method has the advantage of a generalized evidence conferred by the symbol; it may sacrifice a certain intellectual sharpness and precision, but it became, for that very reason, the means of communication between untold numbers of people in the East.[29]

For Deren, ritual will provide the model for creation of form and effect through "conscious manipulation," through elimination of what she terms "spontaneous compulsions of expression" and "realistic representation." And it is this that brings ritualistic form into a relation to "modern science"—a relation far closer than that of the naturalism which has claimed science as its ground.[30]

Eisenstein, in the course of his own sustained investigation of the links between artistic practice and scientific research, had remarked on the way in which the scientific systems of the Chinese seem based on principles of sensual thinking, rather than on those of abstract thought.

Maya Deren, stills from *Ritual in Transfigured Time*, 1946.

Or in other terms, that Chinese science is constructed not on the model of scientific systems but in the image of the work of art.

III

> Life depends, above all, on the path which leads from the Dionysian forest to the ruins of the classical theater. This must not be merely stated, but repeated with the obstinacy of faith. It is insofar as existence avoids the presence of the tragic that it becomes trivial and ludicrous. And it is insofar as it participates in a sacred terror that it is human. It may be that this paradox is too extreme and difficult to sustain; it is, nonetheless, as essential to life as blood.

—*Georges Bataille*

Three great ruins mark the landscape of film history—documentary projects all, incomplete, fragmentary, undertaken by major figures at variance with the systems of industrial film production and dominant practice. Eisenstein, Deren, and Welles each essayed a turn from those systems to ethnographic projects and to alternative modes of production (involving, for Eisenstein and Deren, private patronage) to provide the condition for the working confrontation with foreign cultures. And this confrontation would confirm the problematic nature of their relations both to their own cultures and to those of their alternate arenas of enterprise. Like Eisenstein, who had turned to Mexico from his disastrous experience as the visiting artist-revolutionary summoned and dismissed by the American film industry, Deren approached her work in Haiti with the euphoric eagerness of discovery.[31] And like Eisenstein, she knew that she must "permit the culture and the myth to emerge gradually in its own terms and its own form." And she was later to speak of the felt necessity, upon her encounter with the seductions of Haitian culture, for a "discretion,"

balanced by "a sense of human bond which I did not fully understand until my first return to the United States." She then continues, in a passage that reads like a blow-by-blow description of Eisenstein's progress through America in 1930:

> At that moment I became freshly aware of a situation to which I had grown inured and oblivious: that in a modern industrial culture the artists constitute, in fact, an "ethnic group," subject to the full "native" treatment. We, too, are exhibited as touristic curiosities on Monday, extolled as culture on Tuesday, denounced as immoral and unsanitary on Wednesday, reinstated for scientific study Thursday, feasted for some obscurely stylish reason Friday, forgotten Saturday, revisited as picturesque Sunday. We too are misrepresented by professional appreciators and subjected to spiritual imperialism. My own ordeal as an "artist-native" in an industrial culture made it impossible for me to be guilty of similar effronteries toward the Haitian peasants.[32]

From their ethnographically inspired projects, both filmmakers gained access to a dimension of experience which was undoubtedly decisive in their later undertakings: a glimpse, widely sought but denied to many of their generation, of the meaning of community in its most absorbing and fulfilling instance, of collective enterprise grounded in the mythic. One may, in fact, see both as fellows in a program defined by the group of intellectuals gathered in the 1930s around Bataille, who defined their aims as follows:

> The precise object of the projected activity may be termed a sacred sociology insofar as it implies the study of social existence in all its manifestations in which the active presence of the sacred appears. It thus proposes to establish points of

convergence between the basic and driving impulses of in-
dividual psychology and the directional structures that com-
mand social organization and direct its revolutions.[33]

Deren had come to the theory and practice of film with prepara-
tion of a sort unique in her American lineage: that of her Marxist studies
and involvement in the Trotskyist youth movement.[34] These experiences
had undoubtedly stimulated a sense of community, and predisposed her
to shared goals and collective experience. They also provided a context
and stimulus for the rejection of Hollywood's native pragmatism and her
claim that industrial production's lack of creativity derived from its lack
of a theoretical dimension, and for the theorization of her own practice.

From the beginning, Deren had envisaged a cinema recharged,
as it were, with the energy of dance. Speaking of *Ritual in Transfigured
Time* (1946), a silent film whose opening sequence offers an exercise in
variational form distilled from the kinetics of the social convention of
the cocktail party, she accurately describes it as a dance film, but more
particularly as one whose continuity is established and sustained not by
the performer, but by the emotional integrity of the movement itself,
independent of its performer, by continuity of movement between dis-
parate individuals, in which the cinematic unity is a statement of com-
mon motivation shared by the individual elements.[35]

Studying in 1947 the footage of a performance shot in Bali by
Gregory Bateson and Margaret Mead, Deren sees with a sense of mount-
ing excitement the sacred rites therein performed as totalizing in their
design, their integrity supported by the compelling necessity of every
detail; they offer the aesthetic distillation of obsession.[36] She seizes on the
relation of accident to design, the attitude toward costume and disrobing,
the distancing of theatrical effects, the elimination of transitions within
Balinese performance structure. She establishes, in fact, an inventory of
what was later to become the idiom of Modernist performance. Read-
ing Balinese performance as a social text, she discovers another instance

of the complex integrity of form that she has already observed locally, in children's games as played on the streets of New York. Considering both such games and that of chess as secularized forms of ritual, she observes in configurations such as that of hopscotch an element of the "inviolable." She insists, moreover, on the centrality of that inviolability to the issue of formal autonomy. Its prestige, she says, is contingent on satisfaction of the form itself as authority, and that form may still be completely independent of our fundamental relation to actuality.

One recalls the reaction, a decade and a half earlier, of Antonin Artaud to the appearance of Balinese performers at the Colonial Exposition of 1931.[37] (A detailed comparative study of their respective analyses would doubtless yield interesting results.) In the two texts that set forth the deeply revelatory nature of this event, Artaud sees Balinese performance as exemplary. This experience will work to shape his call for a radical recasting of Western performance as the condition of possibility for a "metaphysical" theater. He declares that among principal sources of pleasure offered by the Balinese theater are the seamlessness of the whole, the actors' supremely skilled and spiritually informed articulation of an established system of gestures and movements, and the sense that these powerful signs were the fruit of a deep and subtle study such that they had lost none of their power over the passing centuries.

Deren's analysis of the Balinese material is propaedeutic to the development of a specific project of her own, to be composed of three ritual forms: children's games, Balinese performance, and Haitian Voudoun. "I wish to build the film, using the variations between them to contrapuntally create the harmony, the basic equivalence of the idea of form common to them all."

And Eisenstein's project? The interweaving of historical periods of Mexican history and culture into a unity, threads to be laid side by side in the *montagiste* tradition. Or, in his words,

So striped and violently contrasting are the cultures in Mexico running next to each other and at the same time being centuries away. ... No plot, no whole story would run through this *serape* without being false or artificial. And we took the contrasting independence of its violent colors as the motif for construction of our film, six episodes following each other— different in character, different in people, different in animals, trees and flowers. And still held together by the unity of the weave—a rhythmic and musical construction and an unrolling of the Mexican spirit and character.[38]

<div align="center">IV</div>

Every possession has a theatrical aspect.

—*Alfred Métraux*

Deren had not come unprepared to the study of specifically Haitian ritual, for she had produced, in 1942, well before her first journey to Haiti, "Religious Possession in Dancing," published as the first installment of an article with special reference to Haitian ritual.[39] In this conscientiously researched paper, Deren boldly set forth a number of the issues that are to dominate later debates in ethnographic theory, including the relation of possession to the nosology of hysteria. Concerned with establishing the distinction between the two, Deren does so in terms which are characteristically shy of psychoanalytic theory and its terminology. Like Alfred Métraux who, in his study of Haitian Voudoun, was to devote a section to the theatrical aspect of possession, she gives no consideration to Freud's illuminating rapprochement of the hysteric and the actor.[40]

Métraux does, however, consider that

> possession being closely linked with dancing, it is also thought of in terms of a spirit "dancing in the head of his horse." It is also an invasion of the body. ... The symptoms of the opening phase of trance are clearly psychopathological. They conform, exactly, in their main features to the stock clinical conception of hysteria. ... The preliminary phase can soon end. Every possession has a theatrical aspect. This is at once apparent in the general concern for disguise. ... Unlike a hysteric who shows his own misery and desires by means of a symptom—which is an entirely personal form of expression—the man who is ritually possessed must correspond to the traditional conception of some mythical personage. The hysterics of long ago who thought themselves the victims of devils, also certainly drew the devilish part of their personality from the folklore in which they lived, but they were subject to influences not entirely comparable to those felt by the possessed in Haiti.[41]

The dividing line is that which marks off the individual from the communal, the pathological from the social. Thus, having stated that, "Psychologists invariably characterize hysteria by an emancipation of a system of ideas as the result of the retraction of cerebral consciousness," Deren, in similar fashion, stresses the role of the hysterical subject's personal conflict: "In a possessed Haitian, the process is parallel, but remains distinct from hysteria by virtue of the social frame of reference. For although drum rhythms emancipate a system of ideas, that system is not the product of individual development; it is a culturally formalized system, so deeply rooted in the subconscious by long tradition that although it requires emotional emancipation from the inhibitions of the cortex, it manifests itself in socially prescribed terms."[42]

———

Despite one's impression of the parallels and similarities between the approaches of Deren and Eisenstein to the ethnographic, one is bound to recognize that they differ in an important respect. Deren's, elaborated in postwar America, is one from which historicity has been excised. Having set forth her *Anagram* in full consciousness of the critical historical context of her project, she appears to have become convinced, nonetheless, that "the ritualistic form reflects ... the conviction that such ideas are best advanced when they are abstracted from the immediate conditions of reality and incorporated into a contrived, created whole, stylized in terms of the utmost effectiveness." And it is with special interest that we realize that it is precisely with the attempt to bring history within the compass of her project that her enterprise begins to founder. Scrupulous observer that she is, she begins, as she penetrates Haitian culture, to realize that she is dealing with a form that defies the boundaries of her onto-aesthetic. It is with the realization that Haitian dance was not, in itself, a dance form, but part of something larger, a "mythological ritual," that she begins to perceive the "total integrity of cultural form" and its distinctive elements "which eventually led me to look for the possible interpolation of another culture, to investigate the history of the Spanish and Indian period of the islands, and finally, the determination of the Indian influences."[43]

This would lead, as one might have expected, to an assessment of the complex dialectic of power relations among white men, Indians, and blacks that subtends the rituals of Voudoun. And it was the full recognition and acknowledgment of the culture's integrity and of the complex historical processes inscribed within it that seem to have precipitated her acknowledgment of defeat and the eventual abandonment of the project. The humility and poignancy of this acknowledgment offer testimony to her rapture of discovery and intensity of involvement in the experience of community in ritual and myth. We can, in fact, conclude that by this point of her trajectory, the linguistic model operative in her theorization begins to replace that of ritual. It is recast as a central architectonic

element of a Modernism that advocates the concreteness and autonomy of the work of art, extending to that of the autotelic sign. In Section 3 of *Anagram*, she had ventured a theorization of the filmic signifier in the following terms:

> I do not intend to exclude the process of generalization; these are ripples spreading from images that can encompass the richness of many moments. But to generalize from a specific image is not the same as to understand it as a symbol for that general concept. When an image induces a generalization and gives rise to a notion or idea, it bears towards that emotion or idea the same relationship which an exemplary demonstration bears to some chemical principle; and that is entirely different from the relationship between that principle and the written chemical formula by which it is symbolized. *In the first case the principle functions actively; in the second case its action is symbolically described in lieu of the action itself.* An understanding of this distinction seems to me to be of primary importance.[44]

Artistic practice must be grounded in this realization, and it "must at least comprehend the large acts of an industrial culture and extend them imaginatively. ... The history of art is the history of man and of his universe and of the moral relationship between them. Whatever the instrument, the artist sought to re-create the abstract, invisible forces and relationships of the cosmos."[45]

It is this large project, informed by a consciousness of the history of science and technology and of their pervasive roles, that haunts her work as a tireless animator of the Independent film movement. Her predecessor in this vision was, of course, Jean Epstein, whose *L'Intelligence d'une machine* she notes as recently received, and although not as yet wholly

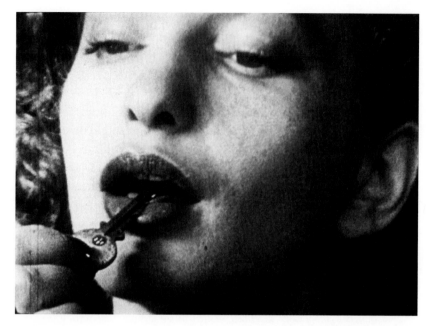

Maya Deren, *Meshes of the Afternoon*, 1943. Courtesy Anthology Film Archives.

read, distinctively interesting as a theoretical enterprise, free from the banalities of film history.[46]

And it is the scope and import of this large project that distinguishes her work from that of her contemporaries and successors—with one notable exception. For there is, in fact, a sense in which when reflecting on the four decades of American Independent Cinema as a *movement*, one may see it as bounded by the work of its founder, Maya Deren, and that of the late Hollis Frampton. It was Frampton—poet, filmmaker, and theoretician—who would assume and expand the strenuous and seminal role marked out by Deren, that of mediator in the difficult and delicate negotiation of the marriage of poiesis and mathesis, a union as scandalous and difficult in our culture as that sanctified by William Blake between heaven and hell.

NOTES

First published in *Maya Deren and the American Avant-garde*, ed. Bill Nichols (Berkeley: University of California Press, 2001). Minor corrections have been made for consistency.

1. See VéVé A. Clark, Millicent Hodson, and Catrina Neiman, *The Legend of Maya Deren: A Documentary Biography and Collected Works*, vol. 1, part 1, *Signatures* (New York: Anthology Film Archives/Film Culture, 1984), and part 2, *Chambers* (New York: Anthology Film Archives/Film Culture, 1988).

2. See "Poetry and the Film: A Symposium with Maya Deren, Arthur Miller, Dylan Thomas, Parker Tyler, Chairman, Willard Maas. Organized by Amos Vogel" (October 28, 1953), in *The Film Culture Reader*, ed. P. Adams Sitney (New York: Praeger, 1970), pp. 171–186.

3. Ibid., p. 177.

4. Maya Deren, *An Anagram of Ideas on Art, Form and Film* (Yonkers, NY: Alicat Book Shop Press, 1946); reprinted in Clark, Hodson, and Neiman, *Legend of Maya Deren*, vol. 1, part 2, pp. 560–603; and in *Maya Deren and the American Avant-Garde*, ed. Bill Nichols (Berkeley: University of California Press, 2001. Subsequent references are to the 1946 book.

5. "Poetry and the Film," p. 174.

6. Ibid.

7. See Roman Jakobson, "Two Aspects of Language and Two Types of Aphasic Distur-
bance," in *Language in Literature* (Cambridge, Mass.: Belknap, 1987), pp. 98–113.

8. Deren, in considering the lineage of cinema's innovators, takes care to credit her
compatriots. "Above all it must never be forgotten that film owes at least as much to D.
W. Griffith and Mack Sennett as to Murnau and Pabst of Germany, Méliès and Delluc
of France, Stiller of Sweden and Eisenstein of Russia." She adds, on the basis of what
appears to be a limited knowledge of Eisenstein's oeuvre: "At the risk of sounding
heretical, I feel that although *Potemkin* has sequences that are extremely impressive
(Eisenstein is nothing if not impressive, ponderously so), for sheer profundity of impact
and for an intensely poetic concept of film, I find nothing there to equal various
sequences in the much less publicized works of Dovzhenko, such as *Frontier* or *Ivan*."
See Deren, *Anagram*, pp. 44–45.

9. Ibid., p. 5.

10. See Deren's historical account of this issue in section IA of *Anagram*, pp. 7–10.

11. Ibid., p. 8.

12. Ibid., p. 37. Deren's acute and extensive diagnosis of the political and moral dilem-
mas confronting the scientific and artistic communities of the postwar period is informed
with the knowledge gained during her period as a student activist within the Trotskyist
segment of the American Left known as the Young People's Socialist League. This
activity, researched with the assistance of Hal Draper, a comrade of that time, is abun-
dantly documented in Clark, Hodson, and Neiman, *Legend of Maya Deren*, vol. 1, part
1, pp. 243–287.

13. Deren, *Anagram*, p. 23.

14. Ibid., p. 44.

15. See Delmore Schwartz, *In Dreams Begin Responsibilities and Other Stories*, ed. James
Atlas (New York: New Directions, 1978). Schwartz's title is in turn a quotation of the
saying cited by Yeats as derived from "an old play" and offered as epigraph to his
volume of poems called *Responsibilities*, of 1914.

16. Deren, *Anagram*, pp. 44–45.

17. Ibid., p. 50.

18. Ibid., p. 45.

19. The canonical account of this development is to be found in P. Adams Sitney,
Visionary Film: The American Avant-Garde, 1943–1978 (New York: Oxford University
Press, 1979), pp. 211–265. See also Stan Brakhage, *Metaphors on Vision* (New York:
Film Culture, 1963).

20. "To abstract in film terms would require an abstraction in time as well as in space; but in abstract films time is not itself manipulated. ... For an action to take place in time is not at all the same as for an action to be created by the exercise of time." Deren, *Anagram*, p. 45.

21. Ibid.

22. Ibid., pp. 47–48.

23. Ibid., p. 16.

24. Ibid., p. 18.

25. Ibid., p. 20.

26. Thus Eliot: "Tradition ... involves, in the first place, the historical sense ... and the historical sense involves a perception not only of the pastness of the past, but of its presence. ... This historical sense, which is a sense of the timeless as well as of the temporal and of the timeless and the temporal together, is what makes a writer traditional. And it is at the same time what makes a writer most acutely conscious of his place in time, of his contemporaneity." See T. S. Eliot, *The Sacred Wood* (London: Methuen, 1920), p. 49.

27. Ibid., pp. 56, 57–58.

28. These considerations, developed throughout *Anagram*, are laid out in Deren's "Outline Guide" and "Program Notes" prepared by her "for the use of those who introduce the films and who may lead the discussion following them." Reprinted in Clark, Hodson, and Neiman, *Legend of Maya Deren*, vol. 1, part 2, pp. 626–629.

29. Sergei M. Eisenstein, *Towards a Theory of Montage, Selected Works*, vol. 2, ed. Michael Glenny and Richard Taylor (London: BFI, 1991), p. 456.

30. Deren, *Anagram*, p. 20.

31. Eisenstein's experience within the American film industry is chronicled in Ivor Montagu, *With Eisenstein in Hollywood* (New York: International Publishers, 1967). The Mexican project is amply documented in Sergei Eisenstein and Upton Sinclair, *The Making and Unmaking of "Que Viva Mexico!,"* ed. Harry M. Geduld and Ronald Gottesman (Bloomington: Indiana University Press, 1970). See also Sergei Eisenstein, "Letters from Mexico," *October* 14 (Fall 1980): 55–64.

32. Maya Deren, *Divine Horsemen: The Living Gods of Haiti* (New York: McPherson, 1970), pp. 7–8.

33. Georges Bataille, "Sacred Sociology and the Relationship between 'Society,' 'Organism,' and 'Being,'" in *The College of Sociology, 1937–39*, ed. Denis Hollier, trans. Betsy Wing (Minneapolis: University of Minnesota Press, 1985), p. 74.

34. For detailed consideration of this aspect of Deren's activity and its intensification during her student days at the University of Syracuse, see Clark, Hodson, and Neiman, *Legend of Maya Deren*, vol. 1, part 1, pp. xx–xxii, 186–345.

35. See Deren's notes for the opening sequence in Clark, Hodson, and Neiman, *Legend of Maya Deren*, vol. 1, part 2, 452–453.

36. The journal in which she recorded her analysis of this footage is reproduced *in extenso* in *October* 14 (Fall 1980): 21–46.

37. In Antonin Artaud, *The Theater and Its Double* (London: Calder and Boyars, 1958); see "On the Balinese Theatre," pp. 53–67, and "Oriental and Occidental Theatre," pp. 68–74.

38. This description of Eisenstein's Mexican project, extracted from correspondence with Upton Sinclair, is included in S. M. Eisenstein, *Que Viva Mexico* (London: Vision, 1952), p. 10. For the fullest account of this entire episode, see Eisenstein and Sinclair, *The Making and Unmaking of "Que Viva Mexico!"*

39. This text is reproduced in Clark, Hodson, and Neiman, *Legend of Maya Deren*, vol. 1, part 2, pp. 480–497.

40. This relation is elaborated on in "Psychoanalysis and Religious Origins," a text of 1919 in which Freud postulated that if psychoanalysis "has hit upon a truth it must apply equally to normal human events and even the highest achievements of the human spirit must bear a demonstrable relation to the factors found in pathology … it was evident that the forms assumed by the different neuroses echoed the highest achievements of the human spirit."

41. See Alfred Métraux, *Voodoo in Haiti*, trans. Hugo Charteris, introduction by Sidney W. Mintz (New York: Schocken, 1972), pp. 120–121.

42. Deren, "Religious Possession in Dancing," in Clark, Hodson, and Neiman, *Legend of Maya Deren*, vol. 1, part 1, p. 592.

43. Deren, *Divine Horsemen*, pp. 10–11.

44. Ibid., p. 27 (Deren's emphasis).

45. Ibid.

46. Ibid., p. 47.

——

Anemic Cinema: Reflections on an Emblematic Work

*This study was originally prepared for an international conference on Duchamp's
work, organized by Barbara Rose and Moira Roth and held in 1971 at the Uni-
versity of California, Irvine. It was subsequently published in* Artforum *(October
1973). I had already learned, to my surprise, that despite the current renewal of
interest in Duchamp's work, there existed no study of his film* Anemic Cinema
*(1926). Inquiring of the distinguished group of Duchamp scholars how that had
come about, I was told that the discs (available as objects) that had composed the
film were of a certain interest, and had therefore been admitted to the Duchamp
canon, as against the film, which was of no interest to the community—by now
(and belatedly) quite large and active—of Duchamp experts. The film, when pre-
sented at an annual meeting of the Society of Cinema Scholars, had already elicited
the response that this work was not a film at all. I have consequently been pleased
to observe a growth of interest in and of literature on this work.*

*I had long been particularly interested in Freud's account of the structural
relations to be observed between neuroses or psychoses and the systems of phi-
losophy. Bettelheim's account of a child's case history struck me as possibly strong
and recent enough to be of interest to contemporary readers of* Artforum. *Their
reception of this text was warm indeed—particularly that of artists, as I observed
at the time. Given the intense and general condemnation of Bettelheim since his*

death, I must state that I never came retroactively to approve or condemn his career; I am inadequately familiar with it. Reading his account of "Joey's" case does not change my view of it with respect to my reading of the film.

I must, however, emphasize the importance of Freud's text for my account of Duchamp's work. This is a text that I had read and reread several times. I saw this account of a particular patient's syndrome as an occasion to explore somewhat the sources and dynamics of an oeuvre and career that seemed still to project the somewhat tantalizing character of his person.

A little reflection was bound to show that it would be impossible to restrict to the provinces of dreams and nervous disorders a view such as this of the life of the human mind. If that view has hit upon a truth, it must apply equally to normal mental events, and even the highest achievements of the human spirit must bear a demonstrable relation to the factors found in pathology—to repression, to the efforts at mastering the unconscious, and to the possibilities of satisfying the primitive instincts. There was thus an irresistible temptation, and, indeed, a scientific duty, to apply the research methods of psychoanalysis, in regions far remote from its native soil, to the various mental sciences. And indeed psychoanalytic work upon patients pointed persistently in the direction of this new task, for it was obvious that the forms assumed by the different neuroses echoed the most highly admired productions of our culture. Thus hysterics are undoubtedly imaginative artists, even if they express their phantasies mimetically in the main and without considering their intelligibility to other people; the ceremonials and prohibitions of obsessional neurotics drive us to suppose that they have created a private religion of their own, and the delusions of paranoiacs have an unpalatable external similarity and internal kinship to the systems of our philosophers. It is impossible

to escape the conclusion that these patients are, in an asocial fashion, making the very attempts at solving their conflicts and appeasing their pressing needs which, when they are carried out in a fashion that has binding force for the majority, go by the names of poetry, religion, and philosophy.

—*Sigmund Freud, "Psychoanalysis and Religious Origins," 1919*

Anemic Cinema (*Anémic cinéma*), that most singular of filmic objects, is, though made in 1926, a somewhat terminal work, the last of Marcel Duchamp's efforts to point in a significantly new direction. It has elicited surprisingly little comment from the official chroniclers, historians, and exegetes, and Duchamp himself spoke little of it, though he talked more of the circumstances of its making, the series of optical studies which surrounded it. I want to propose it as much more than singular, as illuminating, as emblematic of the entire range of painting, sculpture, objects, and games, and of speculative and poetic ventures which compose that elaborate system we know as Duchamp's lifework.

Duchamp spoke rarely of film in general, suggesting in that familiar, consistently deprecating manner of his, that movies would either be "amusing" or not be. In this he is, of course, unlike André Breton, Francis Picabia, and their crowd, who haunted the popular neighborhood movie houses of Paris and New York, passing in a trance of enthusiasm from one serial installment to another, from Louis Feuillade to Pearl White, from *Nosferatu* to *Potemkin*. For Breton, as for Louis Aragon, Robert Desnos, Tristan Tzara, and Philippe Soupault, the film had been, in fact, a privileged medium eliciting from them, as indeed from the leaders of almost every major aesthetic movement of the century, gestures of delighted appropriation.

In the early decades of the twentieth century, each fresh revision of aesthetic and social values reached out to claim film for its own, claiming, as it did so, an ontology of film inscribed within its aspirations, realized in its strategies. The radical innovations of Soviet montage in its heroic

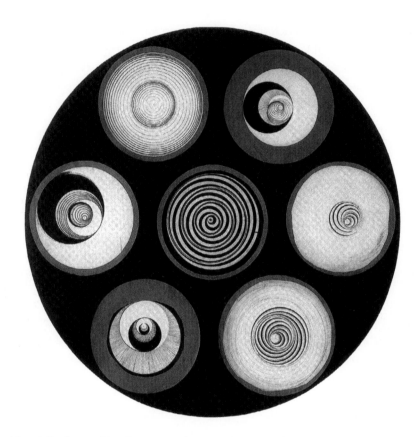

Marcel Duchamp, *Discs Bearing Spirals*, 1923. © Estate of Marcel Duchamp / Artists
Rights Society (ARS), New York.

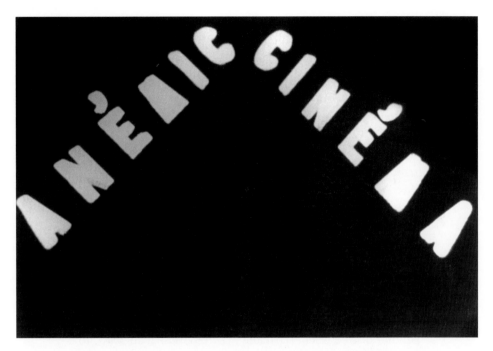

Marcel Duchamp, *Anemic Cinema*, 1926. © Estate of Marcel Duchamp / Artists Rights Society (ARS), New York.

period of 1924 to 1930, developing in the wake of Constructivism, were thus immediately and naturally acclaimed by the Surrealists. *Potemkin*, upon its release in Paris, was greeted as the first truly Surrealist film. The dialectical synthesis, embodied for Eisenstein in the hyperbolic montage of *Battleship Potemkin* (1925) and *October* (1928), spoke to the Surrealists as a conjoining of disparate objects in the conception of a new reality. Montage was indeed a "copulative" process, as Eisenstein somewhat playfully remarks in his essay "The Cinematographic Principle and the Ideogram." He said:

> [T]he principle of montage can be identified as the basic element of Japanese representational culture. ... The real interest begins with the second category of hieroglyphs, the *huei-i*—i.e., "copulative." The point is that the copulation (perhaps we had better say, the combination) of two hieroglyphs of the simplest series is to be regarded not as their sum, but as their product, i.e., as a value of another dimension, another degree; each, separately, corresponds to an *object*, to a fact, and their combination corresponds to a *concept*. From separate hieroglyphs has been fused—the ideogram. By the combination of two "depictables" is achieved the representation of something that is graphically undepictable.[1]

In this text, Eisenstein, extending his notion of montage as embodying the dialectic, attempting to support it through transcultural linguistic models, rediscovers, with a start of almost prudish surprise, the metaphor basic to Surrealist aesthetics: that of artistic production as a mode of erotic encounter. If, for Eisenstein, "montage thinking is inseparable from thinking as a whole," for the Surrealists, montage rendered the Encounter as the primary process of consciousness. Hegel and Lautréamont, then, presided in holy alliance over the generative process of creative editing.

To all of this Duchamp remained, as indeed one might expect, indifferent. The inventor of the great Agricultural Machine of *The Large Glass* was, in turning to film, concerned to fashion an entity embodying in as direct, powerful, and compressed a manner as possible those qualities of movement and ambiguity explored and deployed in his painting and objects. That Machine describes in its oscillating movement between upper and lower panes, between *MARiée* and *CÉLibataires,* an inner fissure of the Self; from it proceeds the iconography of ambiguity that utterly pervades Duchamp's work and thought. Cinema was to epitomize, in its illusionist power, this oscillating movement in deep and purely retinal space.

Duchamp had been consistently careful to dissociate his interest in movement from that of the Futurists, claiming with a particularly sharp and lonely insight that they were primarily "Impressionists of the City," only marginally engaged in the task of reconciling movement and stasis. He had, in addition, in his very brief remarks on film said, "I don't believe in cinema as a means of expression. It could be one—later, perhaps. But like photography, it doesn't go much further than a mechanical way of making something. It can't compete with art. If art continues to exist." And speaking of *Anemic Cinema,* he says, "The movies amused me because of their optical side. Instead of making a machine which would turn, as I had done in New York, I said to myself, 'Why not turn the film?'"[2] He then goes on to speak of the actual turning or cranking process of the camera (the undoubted origin of the French phrase for "shooting a film": *tourner un film*), stressing a return to the use of the hand as if interested in the subversion of the instrument's mechanical aspect. Certainly, when one begins to look at *Anemic Cinema,* one sees inscribed in it Duchamp's disregard for many of the medium's wide range of possibilities.

This seven-minute film consists of an anagrammatic title, followed by ten variant images of rotating spirals, intercut with inscriptions. The spirals derive their forms from the vocabulary generated by the *Rotary Demisphere (Precision Optics)* (1925) and its preparatory studies. The ten

images, rotating about a central axis, present, in their optical impulsion toward and away from the spectator, that shuttling, oscillating movement which animates Duchamp's work, literally, visually, conceptually, in all its major instances. Alternating with the spirals is a series of texts, alliterative and pun-filled, appearing as the suggestion of intertitles in this silent film. These are white relief inscriptions, pasted on black cardboard disks and, like the images, organized in circular form on a surface which rotates in turn, so that one must strain a bit to read them as they proceed in a clockwise motion whose staccato quality contrasts with the serene undulation of the drawn spirals. One's deciphering effort is compounded by one's impulse to commence the reading at a spot not quite coincident with the first word of each phrase, as it is placed in superb disregard of generalized typographical conventions. Keeping pace with the disk's circular motion then forces one, at almost every printed interval, to slightly adjust one's reflex to these strenuous conditions of legibility. And the aggressively sexual intimation of thrust and recession generated by the images is confirmed by the obscene humor and partial obscurity of these punning intertitles, a succession of phrases both loaded and cryptic, models of *double entendre*. The film's constant and multiple oscillation and rotation, between image and texts, black and white, flatness and relief, movement and stasis, thrust and recession, between the poles of sexuality is, moreover, subtended by the general compositional strategy which solicits alternately a reading and a viewing, a seeing *in* or *through* illusionist depth and an apprehending *on* a plane surface—which is, of course, itself a projected illusion of surface. *Anemic Cinema* is, finally, signed by Rrose Sélavy and stamped with her Master's fingerprints.

The film is pervaded, structured by, an ambiguity which is total—spatial and visual, verbal and conceptual. Its place in the catalogue raisonné immediately precedes that of *11, rue Larrey* (1927), that construction which refutes the dictum that a door must be either open or closed. And both works are followed by long silence, broken only in 1932 by the composition, together with Vitaly Halberstadt, of the treatise on

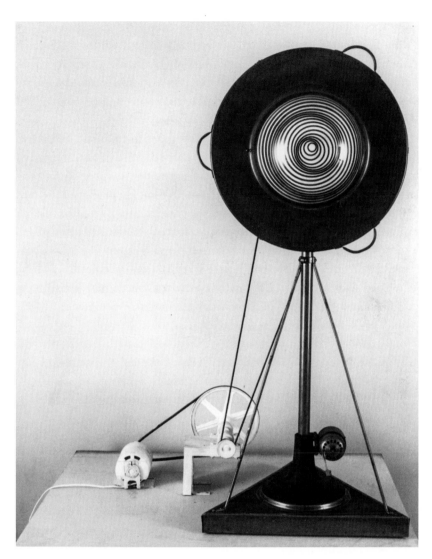

Marcel Duchamp, *Rotary Demisphere (Precision Optics)*, 1925. © Estate of Marcel Duchamp / Artists Rights Society (ARS), New York.

chess *L'Opposition et les cases conjuguées sont reconciliées (Opposition and Sister Squares Are Reconciled)*, which initiates that second half of Duchamp's career in which speculation, games, and the recasting of earlier work occupy the center of the stage, while the preparation of *Étant donnés*, the synthetic, illusionist reification of earlier work, proceeds in the wings. But we are getting a bit ahead in our story.

Duchamp's preoccupation with movement in time had, of course, brought him to maturity in the great canvases of 1912. It also supported his celebrated impatience with easel painting, and it was as a logical consequence of that impatience that he came to film. He produced in 1918 two works that mark the definitive break with painting. The first, his last canvas, *Tu m'*, is of special interest for students of cinema, and it is a painting explicitly discursive in nature, synthesizing Duchamp's reflections on a medium he is about to abandon. It is, in fact, his valedictory address. *The Green Box* contains a preparatory note for this canvas (it had been commissioned for Katharine Dreier's library), which specifies

> Shadows cast by ready-mades. Shadow[s] cast by 2, 3, 4, ready-mades *brought* together. Perhaps use an enlargement of that so as to derive from it a figure formed by an equal (length) (for example) taken in each ready-made and becoming by the projection a part of the cast shadow. ... Take these "becomings" and from them make a tracing without naturally changing their position in relation to each other in the original projection.[3]

And Robert Lebel, in discussing this work, remarks that

> Several photographs taken in the studio at 33 West 67th Street in 1917 testify to Duchamp's interest in the shadows of his ready-mades silhouetted on the wall. He rubbed the full sized cast shadow of a bicycle wheel on *Tu m'* in lead pencil,

118

Marcel Duchamp, *Tu m'*, 1918. © Estate of Marcel Duchamp / Artists Rights Society (ARS), New York.

as well as those of a corkscrew and a hat-rack enlarged by a magic lantern. The three shadows, as if superimposed, dominate the light background of this canvas which is one of the most colorful Duchamp ever painted.[4]

This last canvas, then, joins painterly representation of objects with pictorial representation of shadows in projection upon a surface rent by a painted tear and closed by real safety pins. The picture plane is derogated even as it is affirmed, destroyed in representation, redefined by painted shadows as a surface for projection.

In *To Be Looked at (from the Other Side of the Glass) with One Eye, Close To, for Almost an Hour*, also from 1918, the picture plane is, so to speak, suspended. In this work, which so directly prepares us for *The Large Glass*, we look both at and through the surface, into the space beyond, perceiving in a sort of visual warp, through the magnifying glass attached to the surface, the space beyond it. In these gestures of adieu, Duchamp critically explores the notion of surface, naming conditions for the subversion of painterly illusionism as he passes to the incorporation of the space beyond *The Large Glass*, its animation framed by it as by a lens.

———

Marcel Duchamp, *To Be Looked at (from the Other Side of the Glass) with One Eye, Close To, for Almost an Hour*, 1918. © Estate of Marcel Duchamp / Artists Rights Society (ARS), New York.

Duchamp is now free to extend and redefine the modalities and limits of illusionism through an intensification of optical concerns. For this task he will adopt another surface—the screen; another medium—light; another perceptual and compositional mode—temporality. He has been, in fact, engaged in an extraordinarily rapid and subtle recapitulation of three decades of history. By the time of cinema's birth in 1895, the steady contraction of deep pictorial space had modified the claims of painterly illusionism. It was the retrieval of deep space and of the "object" inhabiting it by the new temporal art that spoke so urgently to Duchamp's Surrealist friends and colleagues, though not, of course, to them alone. Duchamp, defining the terms of illusionism in the complex paradoxes of his last two painted works had thereby exhausted them, and for him, as for everyone else, film promised to assume the burden of illusionism which, as a dissident from Surrealist orthodoxy, he no longer wished to impose upon painting. Working, unlike Buñuel or Dalí, in the spirit of the "reconciliation of opposites," he maintains that characteristic refusal of "either/or" situations which was, of course, to endear him to a generation of American artists maturing in the 1960s in reaction against the ethos of choice and risk enshrined in the sensibility of existentially inflected Abstract Expressionism. He chose to make his statement on the nature of cinematic illusionism in complete independence of the representational codes preserved in Surrealist film and painting. The purity and the power of that statement, of *Anemic Cinema*, are contingent upon the rigorous dialectic of seeing and reading proposed by optical abstraction and print in movement.

The *Bride*'s great field of glass, incorporating painting, fabrication, projection, extended the spectator's depth of field as its iconic complexity accommodated the movement of its surrounding space. For the inventor of the great Agricultural Machine, cinema became, in three years' time, the new illusionist instrument, the plow that definitively broke the picture plane.

It is precisely as one becomes aware of this juncture that a space opens up elsewhere, everywhere in Duchamp's work, disclosing the field of the oscillating moment of meaning or intention that begins to intensify and accelerate in the work. *11, rue Larrey* (1927), the door simultaneously open and closed, renders that space, that oscillation most literally and most perfectly. They are, however, evident in the wordplay and, by the early 1920s, in a play with sexual identity, in Man Ray's photographs of Duchamp in drag, used in the fabrication of the work known as *Belle Haleine, eau de violette* (1921), the encased bottle of perfume bearing his new pseudonym in signature, Rrose Sélavy.

The Green Box acquaints us with the extent of Duchamp's efforts at systematic subversion of language. The "spoonerisms" published by Rrose Sélavy in 1939 are added to the alternate grammars, alphabets, systems of perspective, of classification: schemes for the confounding of categories of recognition are proposed, and the last utopian notation is the proposal for a society "in which the individual has to pay for the air he breathes (air meters; imprisonment and rarefied air) in case of non-payment simple asphyxiation if necessary (cut off the air)."[5] These games, schemes, projects involving subversion of language and logical categories betray the deep and seminal influence of Raymond Roussel, whose methods of work, epitomized in *Locus Solus* (1914), are described in *How I Wrote Certain of My Books* (1935). Choosing a phrase of potential ambiguity, he would initiate his novel with its first meaning, using the second as the final sentence. The space that opened between the two senses of the given phrase was the scene of the narrative. Into the vacuum created by a verbal tissue crowded the fantastic scenes and events, the exotic places, prisons, human machines, and mechanized beings of Roussel's iconography. That fissure forced open within image and work had mightily impressed Duchamp, who had adapted in "Lits et Ratures" (1922) the Rousselian idea of a grammatical rule in which "the verb agrees with the subject in consonance—as in *le nègre aigrit, les nègresses s'agrissent, on naigrissait*," etc. And we find the echoes of that strategy in the celebrated alliterative titles of *Anemic Cinema*.

122

II

Embarking, then, upon the description and account of a filmic object, one is rapidly led beyond the limits of description—beyond the limits of this very "retinal" film, to acknowledge that there is a sense in which Duchamp's final victory is to make exegetes and iconographers of all those who approach his work. To study this seven-minute film, neglected in the major accounts of art and film history, is to confront the quasi-totality of a lifework and the dialectic of its evolution. Returning, for a moment, to the object at hand, one finds again the overwhelming illusionist power of circulating movement within a deep space. *Anemic Cinema* is a sort of visual machine made by a man who proclaimed his desire to rid painting of its sensuality and personality. His efforts revolved for a decade about the construction of a complex aesthetic machine whose fissured panels, articulated through the complex representation of objects, and sub-machines designed for cyclical motion were (as in the case of the *Chocolate Grinder*'s round, revolving drumlike forms in all its successive versions) in turn variants of previous plans and designs. Turning to the texts offered in elucidation of that sustained and infinitely complex effort, one finds that they conceal almost as much as they reveal.

Seeking to understand this one small work, we must, respecting Duchamp's own expressed belief, realize that we are confronted with a lifework which constitutes, to a degree rare in any time, a total semiotic system. To enter upon an understanding of a part of that work, one must seek to apprehend the system of relationships which compose the whole. This undoubtedly is the source of the power and mystery which so stubbornly resist iconographic interpretation and the niceties of formal analysis. Their understanding requires the general structural grasp of the relations obtaining between parts, between language games and optical concerns, between verbal ambiguities and spatial strategies; modes and forms of play, construction, conceptualization, projection, role definition, innovations, and retrogressions must be grasped in structural

interrelationship. Looking for a model which may help us to grasp the nature of that structure, we find it, I believe, in the quite extraordinary lifework of an autistic child. That particular child's name was Joey and he lived for some years in the Orthogenic School of Chicago. His celebrated case history has been recounted by Bruno Bettelheim, and I shall, in what follows, draw heavily upon that account, published in *The Empty Fortress*.

Joey, we are told, at some time very early in his childhood, began to feel so threatened that he could no longer afford to live in the human community, and had transformed himself into a machine.

> He did not move arms or legs, but had extensors that were shifted by gears. ... [He] was a machine, the wheels busily cranking and turning, and as such held us rapt, whether we liked it or not. ... His was not a reduced human existence, nor an animal-like one. He was "real," all right, but his reality was that of machines.
>
> During Joey's first weeks with us, we watched absorbedly, for example, as he entered the dining room. Laying down an imaginary wire, he connected himself with his source of electrical energy. Then he strung the wire from an imaginary outlet to the dining room table to insulate himself, and then plugged himself in. These imaginary electrical connections he had to establish before he could eat, because only the current ran his ingestive apparatus. He performed the ritual with such skill that one had to look twice to be sure there was neither wire nor outlet nor plug. His pantomime was so skilled, and his concentration so contagious, that those who watched him seemed to suspend their own existence, and become the observers of another reality. ... [Everyone] took care not to step on Joey's imaginary wires, lest they interrupt the current and stop his being. ...

Occasionally some part of the complex apparatus fell down that Joey had fixed to his bed, making it a car-machine that would run him (or "live him") while he slept. This breathing machine he ingeniously created out of masking tape, cardboard pieces of wire, and other odds and ends. Usually our maids, as they clean, will pick up such things and put them on a table for the children to find. But to Joey's machine, they carefully restored parts that had fallen because "Joey had to have his carburetor to breathe." It was a car-machine that powered him, and a "carburetor" that enabled him to breathe. In the same way they would carefully preserve for him the exhaust pipes through which he exhaled, or the motors that ran his digestion. ... "Move over," [children] would say. "Can't you see you're pushing Joey's transistor?" And they made way for a transistor Joey had fashioned out of empty space.[6]

The first signs of autism were retrospectively to be seen in his extremely remote behavior, as a child of one and a half, and his absorption in machinery, most of all with an electric fan that his father gave him at age one. Bettelheim continues,

This [fan] he could take apart and put together again with surprising deftness. ... The bizarreness of the toy and of such a focus of interest failed to startle the parents for years to come, as did the more obvious danger sign that Joey's speech was directed only to himself. ... Joey's language became, step by step, abstract, depersonalized, detached. He lost the ability to use personal pronouns correctly and he tended to abstraction. While at first he named foods correctly, calling them "butter," "sugar," "water," and so forth, he later gave this up. Instead he subsumed particular foods into new groupings, but in doing so deprived them of their nutritive character.

125

He then called sugar "sand," butter "grease," water "liquid," and so on. ... Far from not knowing how to use language correctly, there is a spontaneous decision to create a language that will match how *he* experiences things—and things only, not people. ... While he never came out of his autism, he began after a while to use personal pronouns in reverse, as do most autistic children. He referred to himself as "you" and to the adult he was speaking to as "I." A year later he called his therapist by name, though still not addressing her as "you," but saying, "Want Miss M. to swing you."[7]

What was the nature of his obsession with rotating fans? He had made early visits to an airport with his father. As the psychologist notes,

A fan was something Joey could take apart. Circling objects are fascinating to most autistic children. They seem to be particularly suitable for expressing something that typifies the disturbance in general. I believe it to be that they circle around and around, never reaching a goal. Rather than speculate further I prefer to rely on Joey's comments to us on a visit some years after he left us. [The brilliant and moving account of the intensive course of therapy is concluded by the glimpse of a happy ending: Joey's case is both spectacular for the patient's energy and ingeniousness and that of his therapists.] At that time he told us what we had only guessed up to then, that for him, the very shape of those rotating objects suggested the circle he was helplessly caught in. They represented the vicious circle of longing and fear, of wanting so much from others and of being mortally afraid to let his longing be known, either to them or to himself.[8]

For Bettelheim,

[A]ll childhood psychoses, but particularly infantile autism, can be traced to the child's conviction that his life is in mortal danger. Short of this conviction one simply does not erect such wholly debilitating defenses. …

The child longs for mutuality. He wants to be a part of a circle consisting of him and his parents, preferably with him as the center around which their lives revolve. This the autistic child states in his back-and-forth rocking and his circling. … The back and forth twiddling of Marcia and the tearing round and round of Laurie represent the same desire for and fear of the breast; they are thus more primitive precursors of the rotation of objects.[9]

For Joey, electricity was light and warmth and power. It literally empowered him to live, when he plugged himself in. While working with Bettelheim, Joey developed to a point at which he could articulate this "pseudo-logic,"

as when he claimed that the wooden block had nerve impulses that caused its muscles to move. But for the most part he spoke so much in opposites, in private allusions, and with such erratic word order and usage that for a long time we could make little sense of what he said. Through talking in opposites, he asserted autonomy and was able to bind his anxiety about threatening things he felt he could not control.

The process used was to slowly, very slowly and with infinite precautions, restrict the use of his various apparatuses, replacing them with human connections. Dependent on tubes for connections, we told him, when we felt he had acquired some trust in our good intentions, that we would no longer

"Joey's car machine which powered him, including (at the foot of the bed) the carburetor that permitted him to breathe, and the motor that ran his body." From Bruno Bettelheim, *The Empty Fortress* (New York: Free Press, 1967), p. 237.

"The machine that ran Joey by remote control, showing (as marked by Joey) both the 'oil seal' that protected him somewhat from total disembowelment, and the 'Transmission of Blinderator' which makes blind (prevents seeing and understanding)." From Bruno Bettelheim, *The Empty Fortress* (New York: Free Press, 1967), p. 305.

replace broken tubes, and eventually, he began to run out of them since he would explode them in violent, self-destructive impulses. Joey did not, of course, abandon the use of tubes simply because we stopped buying them. He just fabricated them out of cellophane, cardboard, masking tape, and pieces of wire. But since he himself produced them, and knew exactly what they were, he controlled them in a way, instead of the other way around. This, we believe, was the most positive gain in our withholding of real equipment. It forced Joey to assert himself in more direct ways—at least to the degree of forging the tools he felt he needed for living. We had created a situation that made him indeed *homo faber*, man the tool maker. It started him on the long trek of transforming, first material things to fit them to the needs of his life, and later himself, too, so that he could not only have the things but also the life he wanted.

Like other autistic children, Joey tended less to hide his thoughts than to pose them in riddles to be solved, and in this way, he tested our desire to understand him, a desire that would also attest to our willingness that he should exist.[10]

Duchamp's lifework, then, when considered in its totality will suggest—on the grandest possible scale and in a fashion that has, in Freud's phrase, the "binding force" of "achievement"—the creative instantiation of the energies and strategies at work, the rigorous economy of a syndrome. The lifework has the expressive coherence of a syndrome considered as a language system. The *Large Glass* is its major expression and *Anemic Cinema* its most powerful and succinct *emblem*.

The study of Duchamp's general thematic concerns and formal strategies must, then, proceed somewhat on the order of an analytic study of a syndrome *as* a form of language. The long process of elaboration which produces the *Bride* is a bodying forth of a complex and fissured image

"Closeup of the headboard of Joey's bed showing the wheel (left), the battery (lower center) that powered the speaker (right), and other parts of the machinery that ran him during sleep. The 'speaker' not only enabled Joey to talk but also to hear." From Bruno Bettelheim, *The Empty Fortress* (New York: Free Press, 1967), p. 237.

of the self; its dynamics suggest the infinitely postponed healing of that fracture in a whole Marcel, as Joey's obsession with his mysterious "Connecticut Papoose" revealed itself as a fantasy of rebirth, turning upon the redirection ("Connect-I-Cut") of electrical energy. Duchamp's persistent interest in *Rotary Spheres*, in the forms of rotation and motion, the insistence upon the usefulness of objects (exemplified in his joy at the possibility of *Anemic Cinema* being considered as a therapeutic device to be used in the restoration of vision), the elaborate linguistic play, the recasting of natural laws into highly artificial and controlled codes, the subversion of

measure, the constant movement between alternatives which supported his *esprit de contradiction*, the disdain of community, the extreme interest in scientific discovery, the enchantment with the pseudo-science of pataphysics, represent only few strategies of the autistic economy so remarkably converted by him to the uses of art and speculative thought.

Basic to these is the fact that "solipsistic" subjects create a world not based on common experience. Only those experiences that one can objectify through the laws of mathematical logic, such as the principles of mathematics or the lawfulness of a number chain, need no confirmation by others. These logical mathematical constitutions carry their own objectification within one's self, and must be of enormous importance to the fundamental structures and function of thought in general and of child logic in particular.

To see the scope and quality of Duchamp's achievement as a system whose complexity, integrity, and force is analogous to that of a pathological economy is to confront concretely, and in the liveliest and most extensive detail, Freud's recognition that the "forms assumed by the different neuroses ... have an unpalatable external similarity and kinship to the systems of our philosophers" and artists. Our present recognition that the psychoanalysts have assumed a large share of the tasks defined by Plutarch or Vasari rests on the more essential recognition that the lowliest of schizophrenics is involved in an enterprise of heroic scale. The economy of autism will impel patients like Joey to a synthetic construction of a language system in which word, gesture, and movement are organized with a quality of grandeur.

It was in Duchamp's own youth that the Surrealists proclaimed their celebration of the discovery of conversion hysteria as a major spiritual and aesthetic innovation. Taking Freud at his word, they believed, indeed, that "A little reflection was bound to show that it would be impossible to restrict to the provinces of dreams and nervous disorders a view such as [psychoanalysis provided] of the human mind." Aware of the manner in which neurotics and psychotics became "imaginative artists," they then

132

Marcel Duchamp, *Anemic Cinema*, 1926. © Estate of Marcel Duchamp / Artists Rights Society (ARS), New York.

proceed, in an inversion commanded by their role as artists, to explore the possibilities of the neurotic syndrome as formal model for aesthetic innovation. Significant and probing analyses of that inversion and its consequences had yet to be undertaken. Breton and Eluard's adoption of the language and rhetoric of schizophrenia and Dalí's appropriation of the strategies of paranoia (developed through his reading of Lacan's early theoretical work) represent the two most immediately accessible instances of that inversion.

Marcel Duchamp, *Anemic Cinema*, 1926. © Estate of Marcel Duchamp / Artists Rights Society (ARS), New York.

Like the celebration of the discovery of conversion hysteria, these were, however, mere episodes in the evolution of style and rhetoric. In Duchamp's case, the variety, the power, and the sustained mystery of his work suggest something quite apart, an impulse so basic and compelling that it transcends the separate decisions and choices which articulate it. What was, in fact, the source of the lifelong sympathy and admiration which Breton gave to him as to no other man? The sense of rigor grounded in compulsion, of that detached and playful intellect as a passion, of a beauty that was, indeed, "convulsive"?

NOTES

First published in *Artforum* 12, no. 2 (October 1973): 64–69. Minor corrections have been made for consistency.

1. Sergei Eisenstein, "The Cinematographic Principle and the Ideogram," in *Film Form: Essays in Film Theory*, ed. and trans. Jay Leyda (New York: Harcourt, 1949), pp. 28–29.

2. Pierre Cabanne, *Dialogues with Marcel Duchamp* (London: Thames and Hudson, 1971), p. 68.

3. Marcel Duchamp, *The Bride Stripped Bare by Her Bachelors, Even*, trans. George Heard Hamilton (New York: George Wittenborn, 1960), n.p.

4. Robert Lebel, *Marcel Duchamp*, trans. George Heard Hamilton (London: Trianon Press, 1959), p. 42.

5. Michel Sanouillet and Elmer Peterson, *Salt Seller: The Writings of Marcel Duchamp* (New York: Oxford University Press, 1973), p. 31.

6. Bruno Bettelheim, *The Empty Fortress: Infantile Autism and the Birth of Self* (New York: Free Press, 1967), pp. 234–236.

7. Ibid., pp. 240–243.

8. Ibid., p. 248.

9. Ibid., p. 249.

10. Ibid., pp. 248–249.

Joseph Cornell, *Rose Hobart*, 1936. Courtesy the Museum of Modern Art, New York.

Rose Hobart and *Monsieur Phot*: Early Films
from Utopia Parkway

for Jonas Mekas

One Christmas day I answered my ringing telephone and received the most generous of season's greetings from a stranger. "My name is Joseph Cornell, and although we have never met, I believe we know of each other," he said with an exact and deeply flattering tact. "I also know something of your interest in the films of Louis Feuillade, and I should like to offer you a Christmas gift—I have placed a short film of his on deposit in the Anthology Film Archives. It is yours to see and to do with as you please. It is called *When Autumn Leaves Fall*. I am not sure it is complete, but I do think it may possibly interest you."

When I had said something of my astonishment and delight, we began a long conversation, I mostly listening as Cornell talked of early films he had seen in nickelodeons, theaters, and provincial carnivals. I then told him that I had been seeing and thinking about his own films, only recently collected and now regularly screened in the Anthology Film Archives' cycles, that I had wished and hesitated to write, putting to him some questions that had occurred to me. He protested—gently, of course—against the reputation for seclusion which informed that hesitation, and we agreed to see one another and talk eventually, when I had looked at the Feuillade.

The film required cleaning and slight restoration and time passed, as Cornell wished to receive me in fine, warm weather, when his small garden and its quince tree would bloom. This meeting and a number of long conversations were to tell me little about his films, though we talked of other and all sorts of things—of Debussy, the few surviving friends I'd met in the Paris of the '50s, of Déodat de Séverac, whose biography I found upon his desk—but never of the circumstances or consequences of his filmmaking. Two memories precious to him were the yellow covers of an early film magazine sold in a shop kept by a friend of his father's and the "enchanting" (it was his word, to which we shall return) stroll in Central Park about the set of *Portrait of Jennie*. That would have been in 1945. "It was after hours, and Jennifer Jones was not there, but the set, the atmosphere of things was so wonderful." Another vivid recollection was Dalí's nakedly expressed jealousy upon the screening of Cornell's first film, *Rose Hobart*, in the Julien Levy Gallery.

Of the circumstances surrounding Cornell's cinematic work, we know, for a start, that his was a life almost exactly coextensive with that of film. Cornell, born in 1903, witnessing every significant development of the medium, had a particularly rich experience of its genesis and youth—a youth which was his own. He had known its ties to the theater, to magic and prestidigitation, its severance, its evolution from still photography. This was a child who saw his first films in peepshows, had peered through the framed apertures of stereopticons, and experienced the miraculous apparition, recalled sixty years later, of the star of an early film—Francis X. Bushman, for example—in that other space of the "personal appearance" at a suburban movie theater. Witnessing, then, the transition between photography and film, Cornell saw, as well, the appearance of color, the transition from black-and-white to hand-tinted print to Technicolor, and the sudden eruption into sound. These transitions would be recapitulated in his own films, endowed, moreover, with that particular immediacy of effect which suggests a dialectic of trauma and fascination.

Cornell collected films. The group of one hundred or so donated in 1971 to the Anthology Film Archives includes a great deal of early films, many anonymous, some by Méliès, Bitzer, Griffith, documentary and educational footage, "features" of the 1920s, 1930s, and later. Some are fragments. A great many derive from that remote period called "primitive," but the collection does include sound films. Cornell, moreover, organized public screenings of his collection on occasion at the Julien Levy Gallery in the 1940s. The program from a 1963 session, organized at 9 Great Jones Street in New York, reads as follows:

FILMS FROM THE UNIQUE COLLECTION OF JOSEPH CORNELL
MAGIC—VARIETIES—FANTASY

INCLUDING

3 Melies Magic Shorts
Zecca—A Detective's Tour of the World
The Wonderful Beehive
Hanky Panky Cards
Six Deinef Sisters
Metamorphosis
A Cabman's Delusion
Automatic Moving Co.

Cornell, then, was part of that very special and obscure network of collectors, acquiring films through correspondence and auction, buying and exchanging. Films and fragments of films carry occasional comments: "Wonderful shots of birds" and such. The Archives' (rather thin and fragmentary) file on Cornell contains as its most spectacular and tantalizing item a postcard addressed to Cornell from Billy Bitzer, Griffith's celebrated cameraman, responding to a request for an appointment and suggesting a meeting on a day when he proposed to be in New York for the fitting of a new hearing device.

Cornell collected film stills and production shots as well. About 15,000 of these were, I had been told, housed in two or more places in Manhattan and Brooklyn. He spoke occasionally of wishing to find a "sanctuary" for them. And he was, as one could sense in conversation, still going to movies at the end of his life. Asking me whether I had seen *Is There Sex after Death?* (1971), he then said, in a wistful tone, that he had found it "disappointing."

Lastly, Cornell wrote occasionally on film, and "'Enchanted Wanderer': Excerpt from a Journey Album for Hedy Lamarr," published in *View* magazine, is a text that solicits our particular attention. It is a literary variant of the portrait, a privileged genre in Cornell's work. It takes its place with his subtle and allusive evocations of dancers and actresses— Marie Taglioni and Lauren Bacall, among them—and it begins with an invocation of those presences, those specific performances, which animate Cornell's historical consciousness of the medium: Renée Jeanne Falconetti in *Joan of Arc*, Lillian Gish in *Broken Blossoms*, Nadia Sibirskaya in *Ménilmontant*, Carola Neher in *Die Dreigroschenoper*, whose magical apparitions are enshrined in the silence of early film, and now joined by Lamarr.

> Among the barren wastes of the talking films there occasionally occur passages to remind one again of the profound and suggestive power of the silent film to evoke an ideal world of beauty. ... And so we are grateful to Hedy Lamarr, the enchanted wanderer, who again speaks the poetic and evocative language of the silent film, if only in whispers at times, beside the empty roar of the sound track. ... [A]mongst screwball comedy and the most superficial brand of claptrap drama she yet manages to retain a depth and dignity that enables her to enter this world of expressive silence.[1]

Film was, for Cornell, silent par excellence. He was twenty-six when sound came, with a long, intensive experience of the silent era. Of the films by Cornell remaining to us, almost all are silent. In *Rose Hobart*, the silence is imposed upon a sound film, from whose footage the soundtrack is eliminated: that silence is then reinforced, enveloped in another way by the substitution of an assertively rhythmical musical accompaniment. His preference for silence involved a complex and interesting formal choice, originating no doubt in the nostalgic attachment to the youth which he had shared with cinema, but sustained by the development of an innovative filmic imagination. To think about that imagination is to think about Cornell's relation to Surrealism and Surrealism's involvement with film.

There is a special sense in which almost all the major authentic movements and styles of this century—Futurism, Dadaism, Constructivism, Surrealism—reacted to the growth of cinema. Each fresh revision of aesthetic and social values staked its claim upon film, claiming as well that its aspirations and energies subsumed and articulated a filmic ontology. The early developments of montage thus spoke to the Surrealists as the conjoining of disparate objects in the synthesis of Lautréamont's Encounter, rendering concrete and vivid that Encounter as the primary mode of consciousness. Cornell, involved since the early 1930s with the Surrealists through his association with the Julien Levy Gallery, shared with them that enchantment with the generative power of montage. His own sense of the richness contained in popular culture paralleled their feeling for it, and his haunting of the silent movie theaters and his walks through New York extended the tradition of the Surrealist promenade through the urban landscape. He was, like Aragon, Breton, Éluard, a tireless peripatetic, and like them, he haunted the neighborhood film theaters, absorbing with particular delight Keystone comedies, Mack Sennett farces, the early serials, Pearl White and Feuillade, Max Linder's films, those of Chaplin, and, of course, those of German Expressionism.

———

Breton had isolated, in *Nosferatu*, that intertitle which read, "And when he had crossed the bridge, the shadows came to greet him," proclaiming it to be one of the most powerful of contemporary poetic texts. Surrealism's claim to film was grounded in the manner, obscurely sensed, of the way in which its formal strategies seemed to facilitate a mimesis of the dynamics of the unconscious in its dream-work, the way in which the processes of displacement and condensation, the conditions of representability in dream as Freud had specified them, were rendered in the qualities of movement, editing, superimposition, the lability, the synthetic temporality of the filmic image. Film had, however, begun with that primary retrieval, through temporality, of the deep recessive space of painting called into question by painting since Impressionism. The Surrealist animus against Cubism, against Cézanne, had been an outcry of loss, of deprivation, a protest, as it were, against the shrinkage of that deep pictorial space which could alone contain the theater of Lautréamont's Encounter. That dissection table which is its ground must be seen as a stage, inscribed with the orthogonals of Renaissance perspective.

And early film, as in the work of Méliès and of Feuillade, not only retrieves this depth, but extends the convention of pictorial composition elaborated in the Renaissance. Thus, the diagonals of the *Train Entering the Station at La Ciotat*, of Méliès's studio set, return to that convention, to the exact moment of its ultimate, its consummate development, in the animated space of that master of the pictorial freeze-frame, Tintoretto. Surrealism's sense of exhilaration at the discovery of film is, then, a sense of triumphal restitution, celebrating the extension of lost dominion.

Breton had anticipated in 1928 the cleavage between those artists who were to exploit the techniques of automatic creation in the interests of structural and rhythmic coherence, and those who were to produce an art of oneiric representation, contrasting automatism of gesture in the Masons of that period with the imagery of Max Ernst, whose canvases and collages of the 1920s and '30s compose a monumental celebration of the Encounter. It is Ernst whom we must regard as a major, seminal

figure in our view of Cornell's own development, most importantly through the collage novels which begin with *La Femme 100 têtes*. Their narrative, a series of péripéties, unfolds in a constant play upon scale whose ground or condition is that set of conventions of pictorial perspective reclaimed by Surrealism. Ernst's influence on Cornell was to be immediate and pervasive.

Cornell moves from the collage *Schooner* (1931), in which he conjoins disparate objects and plays with scale, to the construction of an object which unites a mannequin's hand and a bunch of roses within that glass bell that appears so often as a standard framing strategy of Surrealist art. (He will use it shortly again, in his film scenario, as Jean Vigo had done in *Zéro de conduite*, a film which stands as the subtlest cinematic distillation of Surrealist sensibility.) Creating shadow boxes, Cornell will work exclusively with found objects. He will increasingly use those which can move—thimbles rotating on needles and balls suspended on string—and introduce the suggestion, as in the later boxes, of suspended or arrested movement. Above all, he has intuited the Surrealist space of the Encounter as that of a theater and literalized it, creating the box form, with its frame as proscenium arch. One no longer looks at the object; one looks past the arch into the space of this theater, confirming the typical Surrealist mode of vision as one of seeing through and past.

It is in the early 1930s that Cornell begins the tripartite film *Cotillion / The Children's Party / The Midnight Party*. *Rose Hobart* will be the first major film to be finished (1936).

The impulse behind Cornell's movement toward film is, however, directly, if retroactively, revealed in his own commentary upon his *Penny Arcade Portrait of Lauren Bacall*, in the exhibition announcement for the Hugo Gallery in 1946:

> ... impressions intriguingly diverse ... that, in order to hold
> fast, one might assemble, assort and arrange into a cabinet ...
> the contraption ... worked by coin and plunger, or brightly

Joseph Cornell, *Sand Fountain; for Paul Valéry*, 1968. © The Joseph and Robert Cornell Memorial Foundation / VAGA, New York.

colored pin-balls ... traveling inclined runways ... starting in motion compartment after compartment with a symphony of mechanical magic of sight and sound ... into childhood ... into fantasy ... through the streets of New York ... through tropical skies ... etc. ... into the receiving trays the balls come to rest releasing prizes.

Cornell is constructing the notion of a Surrealist object as a temporal construction. In matters of film he speaks like a Surrealist, as an editor (the dots following each phrase act as cuts, setting off and conjoining disparate objects and places). The entire contraption is set into movement, followed, as by the camera, which can indeed trace the pinballs traveling the runways, into fantasy, through the streets of the city, tropical skies, childhood, through the space of document and subjectivity, and back into the receiving trays, in that "symphony of mechanical magic of sight and sound" that is a film. It is as though for Cornell the penny arcade, like the stereopticon and the wax museum, the nineteenth century's proliferating forms of popular distraction, offers an intimation of the cinema—and these forms were, of course, together with so many other forms of narrative, subsumed in film. Cinema could begin to satisfy Cornell's desire for movement in his work. It could facilitate and enormously extend the play upon scale; it could, in its recording process, imprison the past, evoke absence, and it could satisfy the basic, primary impulse to see into a deep recessive space as into that past. It could join objects, spaces, scales, and modes of vision through montage. It used the modes and processes of boxes and collages, extended the framing, through editing, of found materials, of footage commissioned from other filmmakers—among them Stan Brakhage; it could integrate the editing of other men—among them Larry Jordan.

Cornell's first completed cinematic work of any sort—and it is a major work—is his scenario *Monsieur Phot*, written in 1933 and included in Julien Levy's anthology *Surrealism*, published by the Black Sun Press in

145

1936. Presenting it as the project for a "stereoscopic" film, Cornell stresses his feeling for the nineteenth century's interest in the heightened illusion of photographic depth. The script presents a unique fusion of silence and sound: "The voices will be silent and the rest of the picture will be in sound." The film is a rare fusion of black-and-white and of color, bursting from time to time into color and subsiding into black-and-white.

It is a fascinating text, turning upon the seamless continuity created through assertive editing, between photographic and cinematic image, between the space of document and of subjectivity, between filmmaker as spectator and spectator as actor. It presents, in its successive variational manipulations of primary material, a strategy basic to Cornell's work, distributed through series of boxes; its recombining of images, characters, and objects (urchins, pigeons, harp, birds, a horse car, among others)—its conjunction of objects first seen separately—projects an implicit, completed narrative action.

The radical editing process is mediated by the figure of the Photographer, first seen "at almost close-up distance" on the left side of the field of vision, photographing a row of nine street urchins. The film's movement is, with a single exception, movement within the frame, and the Photographer with "his manner … of excessive politeness" is seen in close-up. "Then back to the original scene." This is one of Cornell's ways of indicating a cut; he will not use technical terms but narrate them. Then "At this point" (another cut), we are "permitted" to view the scene through the lens of the polite Photographer's black box. Five or six movements of birds (they become a major theme in Cornell's later work of the 1940s and '50s) precede the intrusion of a brilliantly colored pheasant; that is, its appearance precipitates the film into color (before the Photographer has time to press the bulb). It is the pheasant's exclusion—by the Photographer—which sends the film back into black-and-white, still viewed through his camera. The presence of music associated with birds (the lone urchin's rendering of Reynaldo Hahn's "Si mes vers avaient des ailes!") effects a kind of conversion of the Photographer,

146

emerging, deeply moved, in an attitude of gentle ecstasy from the black sheet covering him, and we have a fadeout into the original, a view seen directly now, and not through the Photographer's camera.

We are subsequently presented with the same sequence, though seen in close-up, in a photograph we are "permitted" to view. The succession of still photographs culminates in the colored photograph of the pheasant seen over the Photographer's shoulder as he stands now in the huge parlor of a Victorian hotel. The room is complete with mirrors and chandeliers, a piano, a maid in starched uniform carrying a duster whose feathers are identical to those of the pheasant. The Photographer is disturbed by this metamorphosis, as by that of piano music into the sound of the chandeliers, and his viewing (in close-up) of the chandeliers reflected into the mirror in black-and-white is transformed by a dissolve into the chandeliers inside "a large, sumptuous glass and china establishment seen through plate glass windows." Cornell follows this indication with the statement, parenthetically added: "This episode opens with color." The dissolve is also a bleed into color. And the ensuing sequence brings us the central, revelatory passage describing the close-up of a blown glass fountain whose music evokes that of Debussy. Cornell now tells us, "The close-up has permitted us to realize better the fairylike and supernatural atmosphere of the glass store. In this miraculous setting we feel that anything might happen. We are so enchanted that two or three minutes of the close-up, just as it is, do not seem too long."

The introduction of that first-person plural inserts itself, as it were, into the primary fictive, descriptive space of the scenario, confounding spectator, reader, writer, and Monsieur Phot in one as the multiple witness, the faceted consciousness of the filmic project. These pronouns—"we," "us"—postulate a dissolve, in which the space of reader, viewer, actor have fused, permitting "us" that enchantment which reorders the temporal experience of the close-up: "It does not seem," to that triple consciousness of that close-up's fascinated gaze, "too long." We have been confronted, through the sudden apparition of that multiple consciousness,

147

with another space and another time, with a dimension of ambiguity which subtends the creation of a new, autonomous genre: the narrated film. Its nearest precedent is, I think, the work of Raymond Roussel and most particularly, his long narrative poem, *La Vue* (much later to serve as a source for Alain Robbe-Grillet). *La Vue* is, very simply, the description of a tiny photograph inserted within a magnifying lens which in turn is inserted into a penholder. That description is articulated in all the ambiguity of the present tense (the scene is a beach; a man stands/is standing; he looks/is looking). And it is as if the space contained within that articulation opens to admit the thin edge of a temporal wedge:

A woman sits
is sitting … arms extended, and tense
and even a bit careless, twisted,
For she is not at all amused and
finding not a single curious word to say
on a subject that does not interest her;
She lets her mind wander, preferring
not to offer her opinion and limiting herself to the role
of listener, accepting in advance with no control the bad or
 good told her.[2]

It is as if Roussel has insidiously set a tiny wheel whirring within the static scene described. With that motion, posture and gesture externally described become, indeed, "attitudes" subjectively projected. This static scene is described in the ninth line of *La Vue* as a very fine photograph, presumably black-and-white, placed in a glass ball, tiny, and yet visible when the eye approaches so close as to risk catching an occasional eyelash on it: "I peer with one eye (the other eye is closed to ambient distractions) and as my gaze penetrates into the glass ball, my hand, shaking the penholder containing all this, tends involuntarily to render the image fleeting and 'unstable,' but as my gaze penetrates the glass lens, everything

swells up." The photograph, the View, is now seen to represent a space of *action*. It is within the distended space of this zoom or close-up that the temporal wedge is inserted, and the photograph will, while remaining a photograph (the man on the beach is old, he has bushy eyebrows, he's a sailor who will live to be a hundred and more …), become a motion picture, narrating, as it does so, the advent of cinema.

As I've said, Cornell narrates as an editor; movement is within the frame. He unites the disparate spaces and fiction of the film by way of cuts, fades, color bleeding, and some fairly long dissolves. There is, however, one interesting instance of a camera movement in the text; it occurs in the dissolve from the glass shop into the hotel parlor's mirror. At this point, "the camera pulls back enough to take in the doorway." We now discover the cause of a preceding disturbance: "The pianist stands in the doorway surveying the debris of the glass from all the chandeliers which is scattered on the carpet." The camera movement intervenes to reveal the cause of the shattering of that ecstasy of the triple consciousness. It is "we" who now discover it, but in the following paragraph, Cornell has the Photographer walk "through the doorway, turning, to the left, oblivious of the pianist," the agent of that shattering. The triple consciousness has then presumably shrunk—"we" are now ourselves alone with the narrator. "We" have taken our places outside the fictive space, as reader; we see what the Photographer does not see, and the next shot is "original view, long shot from the other end of the hall."

The epilogue, entirely in color, its action "carried out as in a ballet," has as its scene an old-fashioned stage setting seen through a portal. There is an aisle through the center, flanked by a row of decorative lamp posts behind which is dense foliage reaching to the ceiling. Its space is that of a theatrical spectacle—seen through a portal (it is not specified as the proscenium arch, but presumably serves that function). The photographer emerges from the background toward the footlights, then exits. We see him at a reverse angle in relation to the first sequence, in which we had observed the scene over his shoulder. After some mishaps, he exits to the

149

left, reappearing to free the bird imprisoned in a glass bell standing upon the piano which has materialized during a change of lights. Another dimming of the lights, and in complete silence, illuminated only by the streetlamps, the snow falls upon baskets of laundry scattered in "the aisle which stretches into the distance," into the recessive space of cinematic illusion.

Cornell will now turn to the making of *Rose Hobart*. Completed in 1936, it antedates the trilogy *Cotillion / The Children's Party / The Midnight Party*, begun in the 1930s but completed according to his instructions by Larry Jordan in 1969. These two works I take to be the core of Cornell's filmic enterprise. They reveal most distinctly the manner in which the maker of the collages and boxes conceived film, or rather, the reasons why, the manner in which, the imagination at work in the objects more generally known to us was touched by the possibilities of cinematic form. (Cornell was later to use cameramen, and both *Gnir Rednow*, shot by Brakhage [it figures in Brakhage's filmography as *Wonder Ring*] and *What Mozart Saw on Mulberry Street*, filmed by Rudi Burckhardt, provide clear and subtle demonstration of Cornell's sensibility as powerfully active through the intercession of other artists.) I shall, then, be concerned to indicate the ways in which *Rose Hobart* extends the sovereignty of Cornell's enterprise in a manner congruent with the concerns and strategies of his boxes and collages. A preliminary listing of those ways should be of some immediate practical help:

1. The affirmative use of the frame
2. The use of found materials
3. Their assemblage or montage as the organizing principle
4. The play with, variation on, scale
5. The implication of temporal flow and its arrest
6. Narrative tension
7. Rhythmic use of compositional elements

8. Repetition and variation
9. The use of color, and of blue in particular, to make an ambience of space
10. The use of other artworks as material
11. The interest in reverse sides and angles
12. The female portrait as a privileged genre

Rose Hobart's running time is twenty-four minutes, and it is blue. It has been made by reediting and tinting a found object. That object was a 16 mm print of a film entitled *East of Borneo*, made in 1931 by a relatively obscure Hollywood director, George Melford, working with an excellent cameraman, George Robinson, and using, it would seem, some stock footage—shots of volcanoes and of thrashing, gnashing alligators. Melford's romance seems to be an early, indeed a somewhat premature, variant on the *Green Goddess*, a Warner Brothers sound film released in 1930, directed by Alfred E. Green, and starring George Arliss as the Eastern potentate who, while holding a group of British prisoners, is captured by the virtue and charm of the young heroine, who is, in turn, torn between fidelity to her fiancé, a doctor, and the possibility of freedom for them all. In Melford's version, the lovers are Charles Bickford and the young Rose Hobart. It is her cool, frank beauty and quiet chic which are celebrated in Cornell's film.

Rose Hobart is, to my knowledge, the first of the compilation films to be synthesized from fictional footage. As a fictional film originally incorporating documentary footage, then recomposed with possible additional, extraneous shots, it initiates with striking complexity a genre which will flower only in the late 1960s. Its ultimate descendant will be, of course, Ken Jacobs's masterwork *Tom, Tom, the Piper's Son* (1969), discussed in some detail by Lois Mendelson and William Simon in *Artforum*, September 1971. Jacobs had worked for a time at a variety of small tasks for Cornell, and had been able to show *Rose Hobart* to his friend Jack Smith; the consequences were particularly important for

151

the development of the taste, sensibility, and styles of both men, as for independent filmmaking as a whole. The particular critical and reflexive qualities of Jacobs's work were, however, elicited by Jacobs's recent experience as a teacher of film. *Tom, Tom*'s thrust is intensively epistemological; *Rose Hobart* is a more compact, but dazzling exercise in the techniques of assertive editing, and in its "copulative" propensity, to which Eisenstein had somewhat blushingly referred in *Film Form*; as such, it might very well have excited the envy of Dalí. Demonstrating the generative uses of junction and disjunction, Cornell will use the cut, the cut on gesture, and the jump-cut with a kind of insolent ease.

We see first of all a crowd assembled on a bare field—perhaps an airstrip—looking toward the upper right-hand corner of the screen, as if watching the sky and, after the first cut, a cabin perched high in a jungle tree. Cornell has begun his film with a mismatch which posits a spatial and temporal continuity in tension with a distinct geographical disjunction. We draw closer, through a remarkably sinuous crane shot, past the veil of mosquito netting that shades the cabin. A dissolve gives us Rose Hobart; she lies sleeping, dressed in riding clothes, upon a cot. She stirs, turns leftward. A cut then gives us a close-up of a burning candlewick. Rose, in the next shot, rises and, as the camera glides rightward and down, she passes or is passed out of the frame, and the empty screen is filled, after another cut by a very quick shot, in close-up once again of the sun. Another brief shot of Rose and the Sultan, seen together for the first time, then Rose, alone; Rose once again, looking down. The following shot gives us the focus of her glance: a splash, huge, in close-up and slow motion, preceded by the suggestion of a reflecting object whose downward fall we retroactively take as the cause of that splash.

All of this has taken no time at all—thirty seconds or less—but there are already many things to notice. That initial mismatch is succeeded by others: the framing of Rose's first appearance between the close-ups of candle flame and burning sun; the cutaway which establishes the slow-motion splash as the locus of Rose's glance. These are perfectly synthetic,

Joseph Cornell, *Rose Hobart*, 1936. Courtesy the Museum of Modern Art, New York.

conjunctive in their effect—except that one suspects the three close-ups and that of the slow-motion splash in particular have been inserted from other footage. It is, of course, the sort of image which held a fascination for filmmakers of the period. Jean Epstein is the prime example, and his subtle and innovative use of that technique in *The Fall of the House of Usher*, cited approvingly by Eisenstein, had been completed only three years earlier; its consequences, in the work of Buñuel, his assistant on that film, and elsewhere were to be considerable. In general, however, the interest in slow motion was strongest in the European avant-garde and among those documentary and educational filmmakers who shared the sense of excitement and power elicited by the unique fusion of plasticity and analytic clarity it provided. That elation felt by Epstein, René Clair, and Dziga Vertov was not, on the whole, common in America. This shot of the splash—and it will be repeated in the transformation of a solar eclipse into a splash, repeated still again as a jewel, cast by the Sultan into a cup, will produce the ever-widening circles in slow motion—is, one suspects, introduced by Cornell from other, found footage. (Close inspection of his personal collection of films might reveal or point to its source.) In *Rose Hobart*, then, we have a complex object. Cornell has introduced footage into a context already containing the stock footage of jungle creatures and tropical nature. A kind of generational montage is at work.

Rose has been seen in several changes of dress, and we shall see them reappear, just as the shots of the candle and the splash will reappear. Cornell has selected, is setting up a repertory of shots which will be repeated in variations made possible by the changing context of the narrative—for there is the sense of a narrative, its linearity continually interrupted, turned back upon itself. The drawing of a curtain, amplified in the Sultan's grand gesture, unveiling, as it were, his own private volcano, glimpsed in the lush distances of his domain, will be followed by the second repetition of an opening door seen earlier. Or Rose will be seen and seen again, in a reverse angle immediately following her appearance in a medium shot advancing toward him. The rhythmic repetitions

Joseph Cornell, *Rose Hobart*, 1936. Courtesy the Museum of Modern Art, New York.

function formally, producing intimations of flashbacks and echoes of actions rehearsed earlier. Rose's air is one of constant apprehension, sustained but never focused, visually linked to nothing specific, so that it too supplies a curious narrative tension. We expect to discover its source, or to see it resolved. The sequence in which she dresses for dinner, moves from her dressing table to extract in a slow gesture the small revolver she then places in her small purse, is a standard moment of the genre, abstracted by Cornell from its context.

We are constantly offered a set of actions or signs without referents, and the expectation of the referents provides a tension, a special sort of suspense—that of the expectation of intelligibility. Rose moves through palace and jungle and cabin and terrace, from bedroom to salon, to terrace to salon, to salon, to salon, in jodhpurs and in polo coat, in "afternoon" and "evening" dress. Her apprehension, evidenced in the glance directed always somewhere inaccessible to us, focuses upon something we have not seen, do not see. And as we see her, seated at dinner glancing uneasily slightly past us before the film's final shot fades into a blue field, we know that we will not see, that the expectation of intelligibility will remain unfulfilled. What remains is the pleasure taken in the rhythm and movement of shots, the healthy, aristocratic grace of Rose Hobart, the synthetic liaisons and disjunction which animated them and evoked that expectation.

Rose Hobart frames a found object, and that object is (as in much of Cornell's work) a work of art (it may elsewhere be a photograph of a Gainsborough or Velázquez portrait). Cornell has reinforced his sense of the frame as proscenium arch, turning from the theatrical mode of the box to that of film, and to precisely that mode of filming which corresponds to the sensibility and skills of an assembler and collagist. Decomposing and recomposing in his elaborate cutting and splicing, he reinvents and elaborates upon the basic synthetic innovations of Lev Kuleshov, revived by Alain Resnais and Robbe-Grillet in the supremely exacerbated montage of *Last Year at Marienbad* (1961), whose conjunction of assertive editing with the long and sinuous tracking shot pivoted upon

Joseph Cornell, *Rose Hobart*, 1936. Courtesy the Museum of Modern Art, New York

Joseph Cornell, *Rose Hobart*, 1936. Courtesy the Museum of Modern Art, New York.

the disjunctive match in a paradoxical articulation of a seamless continuity of subjectivity and the world. *Marienbad* is a veritable textbook of editing conventions proposed through counterexamples.

Resnais and Robbe-Grillet compound the confusion by extending the principle of the mismatch to sound, substituting one voice for another, or organ music for the sound that should be issuing from stringed instruments. Resnais and Robbe-Grillet had intended to dedicate their film to Breton, whose *Nadja* (1928) suggests itself as the source of a great many of the thematic and formal components of the script. Breton's outrage, expressed at a screening, forestalled this. Trying to account for that fury of rejection, one has the sense that *Marienbad* is, like *Rose Hobart*, in Breton's phrase, "une forêt d'indices," a forest of signs, of signs without the referents which Surrealism postulates behind the phenomenal world, at the heart of its "mystery." Rose Hobart, the daughter of *La Femme 100 têtes*, prefigures Delphine Seyrig's A in *Marienbad*, as Cornell anticipates Resnais in the generation of the jump-cut, the mismatch, the staggered, the repeated shot, the contradictory tangles of sight lines.

The montage principle quite generally provides the filmic equivalent of Cornell's most basic technique of assemblage, but the play with scale, dominant in the boxes, is extended in cinema. The *Solar System Box* (c. 1960) is one fine example of scale manipulation, combining pictures of the sun, of planetary phenomenon with scaled diagrams of them, juxtaposing a sun with colored glass balls, contained, like suns, in wine-glasses, endowing the small rings that hang from a rod with a largeness of scale that cannot be dispelled.

Of the play with scale in boxes such as the *Medici Slot Machine* (1943) and *Medici Princess* (1948), I want to say less; their directly cinematic morphology, their alteration of medium shots and close-ups are well known. It is rather the more general and subtle impulses—spatial, rhythmic, and thematic—which issue in films and boxes and collages that more urgently solicit attention. It is that cut from a medium shot of a human figure to the enormous burning candlewick that speaks to us in a way consistent with

the scalar manipulation of *Solar System Box*. The concern with temporal flow and its arrest shown in the interruptive cuts of *Rose Hobart* and in the later use of freeze-frame in *Children's Party* has its multiple origins and/or parallels in a work such as *Sand Fountain; for Paul Valéry*, in which one has the evidence, as it were, of the arrest of the flowing sand by the broken edge of glass, the suggestion of time's measurement disrupted. In *Ostend Hotel*, among other boxes, the ball or globe is poised, seems stopped in its onward course, rather than simply, stably there. In a late collage, the juxtaposition of a Gainsborough portrait with a picture of the Grand Canyon will unite, within a single frame, the human figure and the landscape in the striking and improbable synthesis we have seen in film.

Cornell's abiding concern with the reverse and under sides of things will find another mode of articulation in film. *The Nearest Star* bears, on its reverse side, its title, elegantly printed, Cornell's signature in reverse, and a Dutch stamp, whose image is a child's portrait; these are placed, stained, and colored with great care. And Cornell was often, as we know, to offer us double-faced collages. Most curious and perhaps most directly significant for us is a series of three untitled collages; the first presents a Rococo statue of a young woman, gracefully poised toward the left side of the surface, facing us against a dark blue sky brightened by the Big Dipper; in a second panel the figure stands at the right-hand edge of the frame and is seen from the back, as in a reverse-angle shot, bending away from us, looking to the left, silhouetted against a bird-thronged sunset; in the third, she faces us once more against a background of sleet. It is that multiple view, those reversals of position, those changes of landscape which Cornell will continually generate as he sends Rose Hobart from jungle to palace, to garden, to cabin, to terrace, from opening door to opening door, from the position of speaker to that of interlocutor.

Cornell's interest in spatial plasticity and the multiple point of view will also produce the use of mirrors in the box known as *Bird and Bell*; objects placed in the central theatrical space of the box are reflected in and from that off-stage or wing space in a way that becomes difficult to

plot. He uses in this single structure the cinema multiplicity of viewpoint to achieve, through reflection, the effect of variation already familiar to us. That process of variation and repetition had been, of course, introduced in the script for *Monsieur Phot* when Cornell recomposes, in the second sequence, the elements of his first: children, pigeons, the horse car are reassembled, and new spatial relationships are established between the elements selected for us at the film's beginning.

Rose Hobart is blue, like the muslin curtains in the porch windows of Utopia Parkway. Its tint relocates it in an ambience we know well from so many other works, that of the hotel windows which look out upon galactic skies, that of the *Sand Fountain*. It is the blue of *Jackie Lane*, the half-nude adolescent performer of a collage, who stands beside a glass jar containing a tiny Infanta and a bird. All three are seen under dark blue glass, and the collage reversed yields Cornell's signature, a Hungarian stamp, an ancient Spanish text, a cherub, and the following fragment of printed information: "Jackie Lane, 18 (with Big Ben, above and at home, right) has already appeared in several movies, including *The Gamma People*, in which she is converted into"—but those last six words have been crossed out. Cornell has here condensed a number of the formal components of his films: the juxtaposition of disparate objects, the idealization of a female performer, the use of found materials and of aestheticized ones, the multiple point of view (evoked verbally), and a spatial displacement into an aerial medium. That pervasive tint, moreover, acquires, in *Rose Hobart*, another, parallel mode; it is the musical score, a medley of Latin American dance tunes orchestrated into an Overture entitled *Cordoba* which fill the theater. Cornell's written instructions direct the distributor to darken the hall and play the record through before beginning to alternate Band Four of Side One and Band One of Side Two for the remainder of the film. He specifies that the original music for this film had been "'Rhumba Rhapsody' by Caney, played by him (instrumental only) ad infinitum," and that "my own preference is for the lyrical stringed sections of above—as model if students want to use alternate

Joseph Cornell, *Soap Bubble Set (Ostend Hotel)*, c. 1958. © The Joseph and Robert Cornell Memorial Foundation / VAGA, New York.

Joseph Cornell, *Rose Hobart*, 1936. Courtesy the Museum of Modern Art, New York.

Joseph Cornell, *Rose Hobart*, 1936. Courtesy the Museum of Modern Art, New York.

choices—nostalgic and poignant overtone to match the mood of film. ... Tone down strident passages of music used in main body of film."

The film begins, then, with music, not with titles. (Cornell will in fact generally not use them, though he will, in *Cotillion*, make a brilliant use of titles reading backward inserted into the body of the film.) The effect of this very dominant, highly rhythmic score, generally played with a volume in excess of Cornell's stated intentions, is, curiously, an intensification of the film's silence. It is as if the rhythm, pitch, and intensity dispel the subliminally sensed voice issuing from Rose Hobart's moving lips. We cannot hear the words we speak for her. Rose Hobart moves with the splendor of Gradiva, enveloped in a silence intensified by music, through a landscape decomposed, a space distilled, into a blue inane.

To James Wood of the Albright-Knox Gallery in Buffalo, I owe the instructive pleasure of handling and examining the images and boxes assembled for the gallery's exhibition in the spring of 1972, and later installed with a simplicity and elegance unequalled, I believe, on any other such occasion.

I take this opportunity to indicate as well my special regard for Thomas Fitzharris's thoughtful study of Cornell's films undertaken during the graduate seminar on New American Cinema held at the Archives for New York University in the fall of 1971. The stimulation and confirmation of my developing concern offered by Mr. Fitzharris, through his more general and extensive view of the later films in particular, dictate an acknowledgment intended to transcend that of the footnote.

Notes

First published in *Artforum* 11, no. 10 (June 1973): 4–57. Minor corrections have been made for consistency.

1. Joseph Cornell, "'Enchanted Wanderer': Excerpt from a Journey Album for Hedy Lamarr," *View*, series 1, no. 9–10 (December 1941–January 1942): 3.

2. Raymond Roussel, *La Vue* (Paris: Alphonse Lemerre, 1904), pp. 10–11.

TOWARD SNOW

The working of his thought is thus concerned with that slow transformation of the notion of space which, beginning as a vacuum chamber, as an isotopic volume, gradually became a system inseparable from the matter it contains and from time.

—*Paul Valéry,* Introduction to the Method of Leonardo da Vinci

My eye, turning toward the imaginary, will go to any wavelengths for its sights.

—*Stan Brakhage,* Metaphors on Vision

There is a metaphor recurrent in discourse on the nature of consciousness as cinema. And there are cinematic works that present themselves as analogs of consciousness, finding in cinema a striking, and uniquely direct, presentational mode of the nature and processes of experience. The illusionism of the moving image reflects, and occasions reflection upon, the conditions of knowledge; it facilitates a critical focus upon the immediacy of experience in the flow of time. Thus Aron Gurwitsch,

on the origins of this inquiry: "Hume expressly likens consciousness to a theater, but it is, so to speak, a theater without a stage. In modern terminology one could compare consciousness with a perpetual succession of cinematographic pictures ... a unidimensional sphere of being, whose fundamental structure consists only and exclusively in temporality."[1] And Gérard Granel, discussing its modern developments: "Phenomenology is an attempt to film, in slow motion, that which has been, owing to the manner in which it is seen in natural speed, not absolutely unseen, but missed, subject to oversight. It attempts, slowly and calmly, to draw closer to that original intensity which is not given in appearance, but from which things and processes do, nevertheless, in turn proceed."[2] Epistemological inquiry and cinematic experience converge, as it were, in reciprocal mimesis.

There are, in the history of film, very few artists whose work, in its radical purity and incisiveness, strikes one as paradigmatic in this respect. Among them is Michael Snow, whose *Wavelength* (1967) is now a celebrated film, a turning point for many in the history of the medium as well as in the maker's own development. It was once described by Manny Farber, distinguished for the accuracy of his insights, the vigor of his style, and the firmness of his allegiance to the tradition of American action film, as "a pure, tough forty-five minutes that may become the *Birth of a Nation* in Underground films ... a straightforward document of a room in which a dozen businesses have lived and gone bankrupt."[3] And indeed, the film does seem to be, among other things, just that—which is to say "that" observation strikes one as "just" and accurate—conveying, however, an insight which, in sixteen successive viewings and considerable reflection on the film, had never at any time occurred to me. I will wish to examine briefly and to account for both the accuracy and the surprise of that remark. But here, to begin with, is Snow's description of his film, prepared for the 1967 International Experimental Film Festival of Knokke-le-Zoute, at which it took first prize:

Wavelength was shot in one week [in] Dec. '66 preceded by a year of notes, thots [sic], mutterings. It was edited and first print seen in May '67. I wanted to make a summation of my nervous system, religious inklings, and aesthetic ideas. I was thinking of, planning for, a time monument in which the beauty and sadness of equivalence would be celebrated, thinking of trying to make a definitive statement of pure Film [sic] space and time, a balancing of "illusion" and "fact," all about seeing. The space starts at the camera's (spectator's) eye, is in the air, then is on the screen, then is within the screen (the mind).

The film is a continuous zoom which takes 45 minutes to go from its widest field to its smallest and final field. It was shot with a fixed camera from one end of an 80-foot loft, shooting the other end, a row of windows, and the street. This, the setting, and the action which takes place there are cosmically equivalent. The room (and the zoom) is interrupted by 4 human events including a death. The sound on these occasions is sync sound, music and speech, occurring simultaneously with an electronic sound, a sine wave, which goes from its lowest (50 cycles per second) note to its highest (12000 c.p.s.) in 40 minutes. It is a total glissando while the film is a crescendo and a dispersed spectrum which attempts to utilize the gifts of both prophecy and memory which only film and music have to offer.[4]

Among details one would want to add to that description would be the quality of the "human events," their somewhat scattered, random aspect. They take place abruptly, are discrete from one another, and are played in a range which runs from the strongly distanced and flat to the conventionally mimetic, linked in some suggestion of causality by only a few lines of dialogue. Secondly, there is the occurrence, throughout

Michael Snow, *Wavelength*, 1967. Courtesy Michael Snow.

Michael Snow, production still from the making of *Wavelength*, 1967. Courtesy Michael Snow.

the film, of color flashes in a range of extraordinary intensity, of sudden changes of the field from positive to negative, of superimposition of fixed images over the progressive zoom, itself by no means absolutely steady, but proceeding with a slight, optical stammer. The superimpositions and stammer function as a sort of visual obbligato, as does the evidence of splice marks, the use of varying film stocks, creating within the movement forward a succession of fixed or still moments. Then there is the precise nature of the visual field in focus: it is, as we have said, the far end of a loft, opening through windows onto a street whose signs, sounds, traffic, and traffic lights are perceptible to us beyond the tall rectangular windows which are each in turn composed of eight small rectangular panes. The juxtaposition of wall, of window, of street will be modified in clarity by color, by superimposition, as the crescendo of the sine wave will modify our perception of the sound within and beyond the loft. The camera's movement is, of course, beginning to slowly reduce and redefine the visual field, and as we ever so slowly move closer to the wall, we begin to perceive—or rather to sense—two things: first, the presence of some other, rectangular objects on the central panel of the wall (they are as yet only perceptible as small rectangular surfaces) and then, as well (though the temporal threshold of this perception will vary with the viewer), the destination of the camera. Or rather, we sense the fact that it *has* a destination, that its movement will terminate inexorably in a focusing upon a particular area not yet known to us. The camera lens, in the movement of its zoom, installs within the viewer a threshold of tension, of expectation; within one the feeling forms that this area will be coincident with a given section of the wall, with a pane of the window, or perhaps—in fact, most probably—with one of the rectangular surfaces punctuating the wall's central panel and which seems at this distance to bear images, as yet undecipherable.

The effect of these perceptions is to present the movement forward as a flow, which bears in its wake discrete events: their discreteness articulates an allusion to the separate frames out of which persistence of vision

organizes cinematic illusion. Above all, however, they create, through the slow, relentless focusing and directionality, that regard for the future which forms a horizon of expectation. We are proceeding from uncertainty to certainty, as our camera narrows its field, arousing and then resolving our tension of puzzlement as to its ultimate destination, describing, in the splendid purity of its one slow movement, the notion of the "horizon" characteristic of subjective process and fundamental as a trait of intentionality. That steady movement forward, with its superimposition, its events passing into the field from behind the camera and back again beyond it, figures the view that "to every perception there always belongs a horizon of the past, as a potentiality of recollections that can be awakened; and to every recollection there belongs as an horizon, the continuous intervening intentionality or possible recollections (to be actualized on my initiative, actively), up to the actual Now of perception."[5] And as the camera continues to move steadily forward, building a tension that grows in direct ratio to the reduction of the field, we recognize, with some surprise, those horizons as defining the contours of narrative, of that narrative form animated by distended temporality, turning upon cognition, toward revelation. Waiting for an issue, we are "suspended" toward resolution. And it is as if by emptying the space of his film (dramatically, through extreme distancing; visually, by presenting it as mere volume, the "scene" of pure movement in time), Snow has redefined filmic space as that of action. As the eye investigates the length of the loft, moves toward that conclusion which is a fixed point, in its movement toward that point, alternative conclusions and false "clues" are bypassed, as street signs and certain objects pass from view. The camera reaches the object of its trajectory. That object is indeed another surface, a photograph of the sea. The view is held, as the sound mounts to its highest intensity, splitting off from itself, doubling, sliding up and down the range of cycles as the photograph is reprojected in superimposition upon itself. Vision is projected forward through a photograph out beyond the wall and screen into a limitless space. The film is the projection of a grand reduction; its "plot" is the

Michael Snow, *Wavelength*, 1967. Courtesy Michael Snow.

Michael Snow, *Wavelength*, 1967. Courtesy Michael Snow.

tracing of spatiotemporal *données*; its "action" the movement of the camera as a movement of awareness developing slowly.

The film is a masterwork, a claim hardly to be seriously contested at this point in film history, and though we have strayed some distance from Farber's observations, we are now in a position to consider them more clearly and to see their very real interest. Indeed, for someone so deeply and exclusively committed to the film of tight narrative structure, *Wavelength* could, above all other films from the American avant-garde, present something welcome, both new and familiar. For the continuity of the zoom action stands as a quintessential instance of the spatiotemporal continuity subtending the narrative integrity of those comedies, westerns, gangster films which formed the substance of the Hollywood tradition, and the object of Farber's delight and lifelong critical attention. Or to put it another way: Snow's work came at a time in the history of the American avant-garde when the assertive editing, superimposition, the insistence on the presence of the filmmaker behind the moving, hand-held instrument, and its resulting disjunctive, gestural *facture* had conduced to destroy that spatiotemporal continuity which had sustained narrative convention.

A tradition of the independently made film, from Maya Deren and Kenneth Anger through Stan Brakhage, had been developed as an extension, in American terms, of an avant-gardist position of the 1920s in Europe, violating the continuity and negating the tension of narrative. Grounded in the experience of Surrealism and of Expressionism, its will to destroy narrative was an attempt to situate film in a kind of perpetual Present, one image or sequence succeeding another in rapid disjunction, tending ultimately, in the furious pace of single-frame construction, to devour or eliminate expectation as a dimension of cinematic experience. The disjunctiveness of that perpetual Now can be seen, at its most intense, in both the work and the theoretical writings of Stan Brakhage. As filmmaker and theoretician, Brakhage is concerned with the primacy of a quintessential vision, innocent, uncorrupted by the conventions of

a pictorial perspective inherited from the art of the sixteenth century and built into the very lens of the camera. With that Platonic inflection of a terminology characteristic of the Expressionist sensibility, this vision is described in the writings as truer, finer, higher, in that it is the direct visible projection of inner or "inward sight"; it is, in fact, presented by Brakhage as a "closed eye" vision, the inner vision projected through the eye. Reading Brakhage, and especially when watching the films, one recognizes the images in question as tending toward both the intimacy and elusiveness of those we know as "hypnagogic," those experienced in the half-waking state. Like the hypnagogic image, the Brakhage image, "truer than nature," does seem situated inside the eye. It aspires to present itself perceptually, all at once, to resist observation and cognition.

Sartre, in *L'Imaginaire*, defies anyone experiencing a hypnagogic image of the Pantheon to count the number of columns of the facade in the image. For the hypnagogic is immediate, appears and disappears all at once, does not fade out of view; it is not subject to the laws of perception—to those of perspective, for instance. It has the property of exciting attention and perception. "I see something but what I see *is* nothing."[6]

Such indeed is the state toward which the style, the rhythm, the cutting and lighting of Brakhage's films tended. In the great works of his maturity (between 1958 and 1969), in *The Songs, The Art of Vision, Anticipation of the Night, Fire of Waters,* there is no time, no room, as it were, for expectation; the spatial *données* are obscured or fractured by spasmodic movement, by painting upon film, by speed; continuity is rhythmic, postulated on the metaphoric syntheses elicited in the viewer by cutting from one image to the next. *Wavelength*, then, in a very special sense was an "eye-opener," as distinguished from both the hypnagogic vision of Brakhage and the steady stare of Warhol. Snow, in reintroducing expectation as the core of film form, redefines space as being what Klee, in fact, had claimed it was: essentially "a temporal notion." *Voiding the film of the metaphoric proclivity of montage, Snow created a grand metaphor for narrative form.* The consequences are still incalculable; Snow's example and

influence, intensified through subsequent work, in film as in other media, acknowledged and unacknowledged, are among the strongest factors in a current situation of the most extraordinary interest. Together with the films of Hollis Frampton, Ken Jacobs, Ernie Gehr, Joyce Wieland, and George Landow, Snow's work defined a new level of cinematic endeavor, opened a new era in the evolution of cinematic style. This, I believe, explains the manner in which it could unite, in attention and fascination, critical opinion of a great many normally divergent kinds. Snow, in restoring the space of "action" through a sustained form and relentless investigation of the modes of filmic presentation, created a paradigm, transcended the a priori distinctions between the "linear" and the "vertical," the "prose" and "poetic" forms, the "realist" and "mythopoeic," the "vertical" and "horizontal," the styles of continuity and of montage which had long animated film theory and polemics.

The paradox which turns upon the creation of a grand metaphor from the elimination of the metaphorical function of montage is by no means unique in Snow's work. One might say that all of the films of Snow's mature period are animated by a central visual or perceptual paradox. *One Second in Montreal* (1969) is a cinematic construction which plays upon the seriality of still images. A succession of still photographs, representing park sites for a projected monument in the city of Montreal under winter snow, forms the film. Each unit is held progressively longer as we approach the work's midpoint, and the pace speeds up again as the film comes to an end, forcing upon the spectator the consciousness of time as duration—precise but immeasurable, expanding and contracting in the act of attention to detail, the acceleration producing a curious effect of structural contraction. But the central paradox involves the presentation of still photographs as a film and the still more curious impression that, despite the fixity and discreteness of each image, we are involved in a filmic experience, rather than a slide projection. Classical experiments in cinematic perception do instruct us that the projection of a photograph of a place or object and that of the place or object as

Michael Snow, *One Second in Montreal*, 1969. Courtesy Anthology Film Archives.

filmed do not produce the same visual effect. The flow of time is some-how inscribed in the filmic image, immediately given, perceptible in our experience of it. That inscription remained to be articulated. Snow seizes upon it, projecting the photographic still cinematically, so that the flow of time is superimposed, inscribed upon the projection of the photograph's fixity—as the discrete images of the loft had been superimposed upon its traversal by the zoom.

In ⟷ (1969), he isolates the panning movement of the camera and in acceleration of that movement back and forth carves out a kind of sculptural segment of its projected space (that of a classroom, as against a loft), producing the impression of a flatness and pure directionality which negate its visual depth and incident. Proceeding, as in *Wavelength* and *One Second in Montreal*, through temporal acceleration, the film, as it speeds up, converts a haptically defined space into an optical one, returning, in a ritardando, from the projection of a space flattened by that speed into a plane parallel to the screen's surface back to the projection of room space. The film holds in balance those two degrees of visual illusion. As in *Wavelength*, the "human events" (a class in session, a man sweeping, a cop peering through a window, men sparring with one another) are, so to speak, contained as discrete units within the rhythmic structure of the film, at variance with it, and though these events (the passing of a ball back and forth, the sweeping, etc., the appearance of the title signs upon the blackboard) echo the panning movement of the camera, they punc-tuate rather than structure the action of the film. In general, the effect is one of succumbing to the grip of the moment; compelled to follow it, we are unable to focus, to settle upon a given object or point within the field. The effect, then, is of rhythmic compulsion and relaxation. The notion of limitation is transposed from the gradual reduction of the size of the field to the gradual imposition of insistent directionality, intensi-fied by the metronomic click, which seems sometimes to lead, sometimes to accompany, the action.

Michael Snow, *One Second in Montreal*, 1969. Courtesy Anthology Film Archives.

In each of these three filmic works, the artist has seized upon a strategy proper to the medium and carried it to ultimate consequences, exploring its resonances, reenforcing it with parallel strategies, insisting on the isomorphism of part and whole. These strategies and the persistence of a certain speculative quality in Snow's art, a preoccupation with the manner in which a statement generates counterstatement, variation, and extension, can be seen as constant in his evolution as filmmaker and as painter and sculptor.

The catalog of a 1970 exhibition at the Art Gallery of Ontario testifies to the manner in which Snow's range of preoccupations is pressed into service—or admitted to testify—in the presentation of present explorations. The family and childhood mythology, as documented and ordered into *A Survey,* finds its ultimate and playful pendant in the photographic restatement of the "framing" process in the images of the tray of ice cubes or the Canadian landscape seen through windshield and rearview mirror. Two less playful, less casual instances of that coercive theme are the *Portrait* of 1967 (literally a frame visibly assembled from aluminum elements held by clamps) and, most interestingly, *Sight* (1967), a remarkable two-sided panel of aluminum and engraved plastic, measuring fifty-six by forty-two inches. Free standing, it contains one narrow aperture. One side is incised with squares, some of these divided by parallel lines; the slanted aperture traverses the space between upper right-hand to lower left-hand corner of the square located next to the last at the right-hand edge of the larger square and one-third from the top. The aperture totally absorbs the tiny fraction of extraneous visual material through it; it is all somehow drawn into the total composition of the surface, absorbed into its linear pattern, its accident and irregularity tamed, as it were, to the uses of geometry. Turning around to the other side of the surface, peering through the slot which breaks its even, unarticulated, glistening aluminum surface, punctuated only by occasional bolts, we perceive the total unassimilability of the scene beyond it.

Snow's early work is that of an extremely talented young painter passing quickly from the rhythmic articulation of the figure to very sophisticated strategies of abstraction articulated in a somewhat geometric mode. *Lac Clair* and *The Drumbook*, both of 1960, explore the modalities of a figure-ground relationship. In *Lac Clair* (oil on paper on canvas), the central area is a kind of *bleu canard*, painted in free, light strokes, intercepted at each corner by a strip of paper superimposed on the canvas side. It is an altogether simple and elegant work, very much involved with a kind of single image later to become popular in New York in the '60s. *The Drumbook* is a series of rectangles, dark blue upon yellow ground, of slightly varying sizes, setting up discrete and contiguous framing areas which seem, nevertheless, to form a continuous ground. *White Trash* (1960) is a collage of "soiled and folded paper," managing in its pleated elegance to convert its soiled aspect into subtle color, like that of a worn tennis shoe. There are a number of works in folded paper, penciled and "expanded" or expansible, which in their modesty, casualness, and subtle variety testify to a kind of constant playfulness, later to flower in the major series, implementing metaphors grown central to Snow's investigations. Concentrating on painting minimally articulated silhouettes and on filmmaking (Snow had begun in 1956 to work in film), he is obviously preoccupied with spatial variation. Objects such as *Shunt* (1959) and *Quits* (1959) explore sculptural form and seek new ways of support, leaning along the corner of wall and floor. *Quits* is rather like a collapsible and deformed ladder, wood painted black, and a trace of blue paint runs down the bottom side of the first four steps—and probably on the last, which stands directly on the floor. And when you approach it, you see green paint on the upper surface of the steps, and thereby deduce its reversibility.

Snow soon after turned his attention to the articulation which stimulated and emerged from his immersion in the processes of filming and recording, turning back, as well, from time to time, upon past work (as the past is visualized in the space and movement of *Wavelength*), upon its materials and processes. For Snow everything is usable, including old work.

Thus *Atlantic* (1967), a structure which holds thirty photographs of the sea, placed in deep metal frames. With sides projecting at a slight angle to the back surface covered by the photograph, the frames reproduce the conical visual field of film. These frames, moreover, reflect the image contained within them. One sees, then, a surface of water, continuous, contained within the larger frame of its reflection, a rendering of the penultimate superimpositions of *Wavelength*, with the images held flat as the zoom image within the depth of a conical field, described by that of the camera.

Snow's subsequent screenings have also given us *A Casing Shelved* (1970); it is, to begin with, a redefinition of the notion of film through sound. One colored slide shows us a series of shelves in the artist's studio; they bear a very disordered load of materials, objects, photographs, implements. The film then starts as the artist's voice, taped, begins cataloging the objects, bringing them into our view, directing the spectator's eye in a reading of the image, thereby making of that still image, a movie—and, once again, a narrative movie. For the contents of the shelves, framed by the twelve or so boxlike structures composing it, are mostly materials that have been used in the making of film or sculpture, and the describing, the telling of their origin and function, composes the narrative of the maker's past as he directs the viewer's eye.

If, for Snow, everything is usable, it is also reusable—at least once. Thus, *Untitled*, shown recently at the Bykert Gallery, is a sumptuous "slide show" which alludes largely to the making of *Wavelength*; using stills from the film, the filters and plastic colored sheets employed in its making, emphasizing in a very painterly manner the ambiguity of spatial relationships created by superimpositions, juxtapositions of filters, alterations of perspective and of angle of vision. Red and purple filters are seen over and against each other on white. A plastic sheet, seen in three-quarters view, is read alternately as flat or in perspective. Hands hold up and press down upon flat sheets of color, hold up a still from *Wavelength*, are seen under purple plastic, seen still closer through red. A still is seen again

Michael Snow, *Atlantic*, 1967. Courtesy the Art Gallery of Ontario. © Michael Snow.

at night. A strip of Kodak film, superimposed against the daytime blue beyond the loft window, creates a strangely elusive and purely optical distance between the blue of the windowpane and the blue to be seen through the clear interstices of the strip. In a characteristic gesture, the camera has apparently been trained back upon the projector itself, so that we see its lens through color. Or the window of the loft is seen against a flat white surface whose distance from the wall on which it is projected is, again, purely optical. Filters, used as windows, held over the windows of the loft, gorgeously stain the white radiance of daylight. Strenuous reading efforts induce ambivalence in the spectator: planar differences are cued by color values, but the cues can be misleading. A hand peeling red plastic from a white surface is succeeded by a field of pure color, an optical magenta, made probably of two superimposed filters, but we no longer can be sure. Within the succession of the slides are tiny recapitulations of fragments of the film. We see a hand holding a small photograph of *Wavelength*, all under plastic. We look out the window, we draw closer in another slide, still closer in another, and a sunny yellow patch appears in the lower left-hand corner. ... The succession of slides in the carousel composes these projections of filmmaking, slide making, projection into a loop of coloristic variations which stands somewhere between *Wavelength* and *One Second in Montreal.*

It is indeed that circularity one would want to stress as characterizing Snow's work. Operating on two levels, it involves, first, a movement of revolution about the formal object, the multiplicity of approaches through variety of materials, the freely variational form, the manner in which language itself is pressed into service—with playful and witty results that strain at the limits of meaning. The solution of sculptural or filmic or painterly problems is often returned to again, used as material, transposed into other contexts, or hypostasized from film into object or sculpture.[7] Secondly, there is the manner, shared with other artists, in which the individual work tends toward the circular structure, the tautological form, the perception of the work necessitating the recognition

or recapitulation of the process involved. Thus, to cite only recent examples: *Crouch, Leap, Land* (1970)—a series of three photographs taken of a woman in these actions and photographed, presumably through glass, from below—is suspended, face down from the ceiling, obliging the spectator, in bending, to peer up from a position approximating that of the photographer. Or *Tap* (1969), a complex work, a kind of "still sound movie" composed of black-and-white photographic prints, typewritten text, enclosed speaker, black wire, and tape recorder which, distributed over several rooms of the Art Gallery of Toronto, made for a work experienced in circuit, and whose circular structure was heightened by its own discursiveness (in the typewritten text) on the process of composition. *8 x 10* (1969), first shown in the Toronto retrospective and more recently in New York, presents eighty photographs of a rectangle, their dimensions a standard eight by ten inches, separated by intervals of identical dimensions, marked out, framed in tape. The variables within the photographs—distance, angle, and lighting—produce an immense range of spatial articulations, distending and contracting space in the circular play upon the notions of framing as photography and of photography as framing. And both *A Wooden Look* and *Of a Ladder* (both 1969) oblige one, in the perception of the curious optical bend produced by successive photographs of a single object, to resituate the object in the photographic field of vision, reconstruct the progressive process of its recording in relation to one's own perception of that record.

The charting, then, of Snow's course, produces a shifting constellation of epicyclic figures, whose complex and firm geometry is sustained by the breadth and probing consistency of an inquiry into the modes of seeing, recording, reflecting, composing, remembering, and projecting. Those shifting, interlocking cyclical movements might describe as well the architecture of the work just now in progress: "a film in which what the camera-eye did in space would be completely appropriate to what it saw, but at the same time equal to it. ... You see, the camera moves around an invisible center point completely in 360 degrees, not only horizontally,

but in every direction, and in every plane of a sphere. Not only does it move in predirected orbits but it itself also turns, rolls and spins. So that there are circles within circles and cycles within cycles. Eventually there's no gravity."[8] This work will be known as *La Région centrale*.

Notes

First published as "Toward Snow (Part 1)," *Artforum* 9, no. 10 (June 1971): 30–37. The text has been edited for publication in this volume.

1. Aron Gurwitsch, "On the Intentionality of Consciousness," in *Phenomenology: The Philosophy of Edmund Husserl and Its Interpretation*, ed. Joseph J. Kockelmans (Garden City, N.Y.: Doubleday, 1967), p. 125.

2. Gérard Granel, *Le Sens du temps et de la perception chez Husserl* (Paris: Gallimard, 1968), p. 108. The translation is my own. For other instances of this increasingly frequent metaphor, I refer the reader to pages xxi and xxii of Peter Koestenbaum's introductory essay in Edmund Husserl, *The Paris Lectures*, trans. Peter Koestenbaum (The Hague: Martinus Nijhoff, 1964). The view sustaining these observations is also adumbrated in an essay of my own, "Bodies in Space: Film as Carnal Knowledge" (*Artforum* 7, no. 6 [February 1969]), written, however, before the present essay had presented the occasion for this sort of anthologizing. The earliest text known to me, bearing upon these considerations is Hugo Münsterberg's *The Film: A Psychological Study*, originally published in 1916 and reissued in 1970 by Dover. It is an early and remarkable attempt at a phenomenological analysis of the cinematic experience.

3. Reprinted in *Negative Space: Manny Farber on the Movies* (New York: Praeger, 1971), p. 250.

4. Michael Snow, "A Statement on *Wavelength* for the Experimental Film Festival of Knokke-le-Zoute," *Film Culture* 46 (Autumn 1967): 1.

5. Edmund Husserl, *Cartesian Meditations* (The Hague: Martinus Nijhoff, 1960), p. 44.

6. For the discussion of the hypnagogic image, I have relied heavily on Jean-Paul Sartre's *L'Imaginaire* (Paris: Gallimard, 1948), pp. 58–76.

7. As Dennis Young has remarked in his introduction to *Michael Snow/A Survey*, published by the Art Gallery of Ontario, Toronto, in collaboration with the Isaacs Gallery on the occasion of the exhibition "Michael Snow/A Survey," February 14 to March 15, 1970. This volume contains as well P. Adams Sitney's discussion of Snow's cinema, by far the finest and the most comprehensive published to date.

8. "Converging on *La Région Centrale*: Michael Snow in Conversation with Charlotte Townsend," *artscanada* 28, no. 1 (February–March 1971): 47.

ABOUT SNOW

I

The entire conduct of our life depends upon our senses, of
which sight is the noblest and most universal, so that those
inventions which serve to increase its power are surely the
most useful possible.

—*Descartes,* First Discourse on Light, Dioptrics

Jules Olitski once wistfully revealed his desire to spray color upon the
vacant air, a fantasy anticipated and realized some seventy-five years
before in the projection of the first tinted film. The intensity of this illu-
sionist aspiration, apparently frustrated by the materiality of canvas and
stretcher, was to generate some of the most improbably and perversely
painterly sculptures of the 1960s. Frustration and perversity alike may,
as I have in another context suggested,[1] be read as elements of a more
general syndrome, that of a crisis of pictorial enterprise. It is as though
contemporary painting had acknowledged, through color field painting,
an impasse, hesitated upon the threshold of temporality before retreating,

capitulating to sculptural materiality. It is in this critical moment that the polyvalent venture of Michael Snow originates.

That Snow began as a painter, exhibiting in Canada and later in New York, is generally known. The climate in which he matured was that of the mid-1960s, when the interpenetration of painting, theater, and dance, the flowering of "Happenings" and "performance work" were intensive. The systematic exploration of interrelated modalities of sculpture and performance, as in the early work of Robert Morris and Yvonne Rainer; the modification of the space of gallery and museum; the prospecting of new arenas and theaters of operations: these shaped the expanding and somewhat eccentric areas of inquiry which Snow, together with figures such as Ken Jacobs, Richard Foreman, and Jack Smith, developed. The consequent displacements and redefinitions were not to be accommodated by the decorum of pictorial Modernism; these men drew upon the synthetic tradition of pictorial, sculptural, theatrical, and poetic enterprise—the cinema of the Bauhaus, the theater of Constructivism, the objects of Surrealism, the festivities of Dada, preserved, partially and precariously, through the emigration of European artists driven to this continent by fascism.

The great survivor of that older generation, the most sympathetic and seminal figure, was, of course, Duchamp; and it was his multiplicity of effort and confusion of genres, his own passage from painting to sculpture to cinema, his excursions into photography which were exemplary for some younger artists of this time. He was, in fact, a model of that polyvalence we shall see in Snow, who passes from painting to sculpture to film, and whose mature work circulates more freely and regularly between film and photography, music and video and environmental installation, in contestation of the purity, discreteness, and irreducibility of pictorial effort central to the theoretical and critical orthodoxy of that time. For it was not only the polyvalence of Duchamp that disturbed; the subtle and radical manner in which he had long since introduced temporality into painting was now sensed as a threat to the integrity

of pictorial space. The optical drawings made to turn and be filmed in *tournage*, and the work *To Be Looked at (from the Other Side of the Glass) with One Eye, Close To, for Almost an Hour* (1918), can now be seen in their fully subversive functions—like the concept of "the delay in glass," with its ambiguous resonance of the time limit inscribed within the material as well as *delayer* for the stirring, turning, revolving figure, so constant in Duchamp's work.[2]

Above all, however, it was the idea of framing as the quintessential compositional strategy that challenged, in a characteristically paradoxical way, the value of pictorial purity. The frame, empty and infinitely mobile, directed literally and metaphorically toward the world itself, proved an implacable generator of forms. Against the irreducible purity of the image-free, color field painting in its frame, Duchamp proposed *The Large Glass*, that painted window whose frame constantly renewed, in interstitial space, the composition of the visible world beyond it.[3]

To a young painter such as Snow, working in a Canadian animation studio, impressed by the implications of Duchamp's framing gesture, the motion picture camera quite naturally presented itself as the most powerful instrument devised for the further implementation and articulation of that gesture's implications. *Wavelength* (1967), the first wholly achieved articulation of that intimation, takes as its central statement the framing process itself, organized as an extended spatiotemporal strategy of complex resonance. Creating a radically new conception of filmic action as being literally the camera's use and exhaustion of a given space, punctuated by changes of stock, filters, light flares, superimpositions, alternations of positive and negative images, Snow made of the slow and steady optical tracking shot or zoom the axis of a displacement whose perceptual solicitations and formal resonance are those of narrative action.[4] The film, presented at Knokke-le-Zoute in 1966, broke upon the world with the force and power of conviction which define a new level of enterprise, a threshold in the evolution of a medium. Upon this threshold, differences of sensibility and of theoretical commitment were reconciled, conflicts of

dominant and marginal efforts were transcended. This work came as if in ironic response to Stan Brakhage's characteristically categorical declaration: "My eye, tuning towards the imaginary, will go to any wavelengths for its sights."[5] This film quickly won an adherence which has surpassed any other of its period. But *Wavelength*, in its traversal of a space in depth, restoring the depth of narrative space, comes to rest on the framed flatness of the still photograph; this "monument to time," as Snow himself termed it, ends with an *instantané* (snapshot). And Snow will now move with increasing freedom between still and moving pictures.

Atlantic (1967) is a culminating work of that period. Still and cinematic image are comprehended within and mediated by a sculptural structure which confirms the specific properties of each. Thus, thirty images of the waters upon which *Wavelength* concludes its trajectory are disposed in thin, deeply recessed frames of tin, the whole forming a grid measuring seventy by ninety-six by twelve inches. Each photographic image is reflected on the polished surfaces of the grid, so that the structure is perceived as both an ordered series of discrete units and as a whole. Continuity is virtual, the effect of those reflections which subsume the frame which is their surface, in a general aspect that recalls *Wavelength*'s penultimate visual cadenza of superimpositions. As was immediately remarked upon its completion, *Atlantic* is the work of a particular moment in sculptural development; its idiom is that of Minimalist sculpture of the mid-1960s, the most seminal working period of Morris and Judd, of LeWitt and Smithson. In it the elements which will now come to dominate Snow's work are focused and fused: the framing strategy, the adoption of the strong gestalt and of the systematically permutational form. And in the play between real and virtual image, the dominant axis of Snow's work now emerges in its obsessional force, replacing the incessant variational experimentation of the earlier *Walking Woman* series. It is the dynamics of the perceptual process, of sight, reflected in the titles of the works to come—*Blind, Sight, A Wooden Look, Scope, Glares*, among others—that henceforth occupies the center of Snow's thematic and formal preoccupations.

Michael Snow, *Atlantic* (detail), 1967. Courtesy the Art Gallery of Ontario. © Michael Snow.

The period of Minimalist art, whose full consequences have yet to be appraised, is that of a systematic exploration of the modalities of perception, epitomized not only in the sculpture and painting of its artists, but in a particularly rich theoretical production as well. The period of 1964 to 1971 is that of Robert Morris's "Notes on Sculpture," Smithson's textual variations on the theme of entropy, Judd's "Specific Objects." To these we must add the writings of Frampton, Sharits, and the printed statements of Breer and Landow, all following upon the preceding, pioneering work of Brakhage. If one were to characterize this period in terms derived from older art historical tradition, one might say that it brought about the recapitulation, in the idiom of abstraction, of the passage from the theory and practice of Expressionism to that of a New Objectivity.

This transition, developing within a North American context—that is to say, within a relatively thin theoretical tradition—relied upon conceptual substructures largely imported from abroad. These artists proceeded to replace the ideological postulates which had served the preceding generation of Abstract Expressionists (a somewhat Jungian psychoanalysis and the immediately postwar continental Existentialism) with perceptual theory, grounded in phenomenology and the more specifically Anglo-American tradition of analytic philosophy. In this context Peirce and Wittgenstein had privileged status.

It was the peculiar strength of these artists—and of their predecessors—to have assumed and, as it were, exploited the contradictions of a syncretic positivism. Shaped by an empirical tradition, artists on this continent have refrained from giving to their successive sets of postulates, axioms, and methodological options the status of orthodoxy; these have functioned instead as working hypotheses, generative, productive, or, when not, easily disposable. The intense concentration on phenomenologically grounded perceptual theory as implemented by the art of Judd and Morris, among others, was, moreover, supported by a critical tradition which extended from the writings of Roger Fry to the younger

critics, many of them grouped around *Artforum*. Analytic and descriptive functions now succeeded the expressive imperatives of the 1950s.

The situation of filmmaking presented one very different aspect: a kind of continuity through change. Two related factors assured a continuity between the theory and practice of these two successive periods, between, let us say, the work of Stan Brakhage and that of Michael Snow: an insistence on the primacy of vision and a correlative emphasis on the primacy of light. Further study should reveal the seminal strength of what we might call the scopophilic and fetishistic characters of this American avant-garde in its perpetuation of the idealist primacy of vision.

Independent film between 1950 and 1965, as exemplified by the work of Brakhage, had adopted an artisanal mode of production, in 16 millimeter. The problematic sound technology of that format was joined with the primacy conferred by a romantic poetics on the sense of sight to produce an oeuvre that is, with very few exceptions, silent, predicated upon the optical spatiality and the gestural dynamics of Abstract Expressionist painting. It went so far, in fact, as to incorporate a gestural painting on the surface of the film. And Brakhage's theoretical production, comparable in both its scope and its contradictions with that of Kandinsky, rehearses in its central text, *Metaphors on Vision*, the notion of film as the luminous inscription of the Imagination, deployed in a pristine purity of vision. This is a vision supposedly uncorrupted by that Fall we know as the Renaissance, perpetuated by the codes of representation and ground into the very lenses of the camera. We recognize in this seminal text of 1963 Brakhage's anticipation of the major theoretical and critical themes to emerge in the French literature following upon the crisis of 1968.[6] The cinema of Brakhage, however, aims at pure presence, in which the limits separating perception and eidetic imagery are annulled in the light of Vision as Revelation.

Snow, speaking on *Standard Time* at a screening in August 1967, said: "I'm interested in a kind of balance that has some similarity to the way Cézanne equalized the physical facts and the presented illusions in

painting. On film the transformation is into light and time and the balance is between the illusions (spatial and otherwise) and the facts-of-light on a surface."

It had been the singular achievement of Brakhage, as a typically New World artist, to have fashioned from the contradictions between his Modernist strategies (drawn from Pound, Stein, Cage, Olson) and his idealist presuppositions the working hypotheses which could generate the constantly renewed filmic enterprise of two decades. This interesting and, as I have suggested, generally characteristic contradiction is further articulated in a prime filmic text of 1970, Hollis Frampton's *Zorns Lemma*, a tripartite structure in which the central section, whose form is derived from set theory, is preceded by the presentation of that set, which is the English-language alphabet in the seventeenth-century version of the *Bay State Primer*, the first textbook published in New England. This section is then followed by a twelve-minute sequence whose soundtrack is composed of a metrical reading from the cosmogony of Robert Grosseteste, bishop of Lincoln (1168–1253), celebrating light as the shaping agent of form. "Light, the first bodily form which drew out matter along with itself into a mass as great as the fabric of the world," is celebrated in a metaphysics that stands beside Grosseteste's contribution to scientific method and the theory of knowledge. Frampton, in a characteristically lucid and allusive manner, translated the contradictions between lyric and analytic modes, between idealist and Modernist tendencies at work in the theory and practice of his predecessors and contemporaries.

Asserting "difference," film as proposed by *Metaphors on Vision* solicited, nonetheless, a hallucinated gaze. Not narrative form, but the *space in which it takes place*, was the object of radical assault. For the gaze of fascination, the filmmakers of the late 1960s were to begin substituting analytic inspection. Jacobs's *Tom, Tom, the Piper's Son* (1969), which subjects a ten-minute early film to an hour-long review on an analytic projector, is the key work in this vein.

Adopting and expanding the repertory of filmic "anomalies," as Vertov had termed them, the Independents made use of superimposition, slowed and accelerated action, freeze frames, alternations of color with black and white, conspicuous change of focal length, and the aforementioned empty frame, among other devices. (The elimination of gestural camera movement and of sexual thematics, following upon Warhol's *Chelsea Girls* [1966], makes for a de-eroticization of the Independent film of that period.) It was, however, insofar as these "anomalies" were enlisted in the subversion of the perspective constructions which served as models for the construction of cinematic space and its narrative forms that filmmakers implicitly claimed the sovereignty of the spectator. The hallucinated viewer was, so to speak, replaced by the cognitive viewer, but common to them both was the status of *transcendental subject*.

It is within this broader context that Snow's particular contribution may now be viewed, and for elucidation of its crucial quality, I turn to a celebrated text of Jean-Louis Baudry.

Situating the ideological role and function of the cinematic machine within Western ideology, Baudry, in a text which acquires a very precise resonance for viewers of the Independent cinema, traces the origins of that ideology in the rationalization of perspective performed by the artists and theoreticians of the Renaissance:

> Fabricated on the model of the *camera obscura*, it permits the construction of an image analogous to the perspective projections developed during the Italian Renaissance. Of course the use of lenses of different focal lengths can alter the perspective of an image. But this much, at least, is clear in the history of cinema: it is the perspective construction of the Renaissance which originally served as model. The use of different lenses ... does not destroy [traditional] perspective but rather makes it play a normative role. Departure from the norm, by means of a wide-angle or telephoto lens, is clearly marked in com-

parison with so-called "normal" perspective. We will see in
any case that the resulting ideological effect is still defined in
relation to the ideology inherent in perspective. The dimen-
sions of the image itself, the ratio between height and width,
seem clearly taken from an average drawn from Western easel
painting. ... [T]he painting of the Renaissance will elabo-
rate a centered space. ("Painting is nothing but the intersec-
tion of the visual pyramid following a given distance, a fixed
center and a certain lighting."—Alberti.) The center of this
space coincides with the eye which Jean Pellerin Viator will
so justly call the "subject." ... Monocular vision which, as
Pleynet points out, is what the camera has, calls forth a sort of
play of "reflection." Based on the principle of a fixed point
by reference to which the visualized objects are organized, it
specifies in return the position of the "subject," the very spot
it must necessarily occupy.

 In focusing it, the optical construct appears to be truly the
projection-reflection of a "virtual image" whose hallucinatory
reality it creates. It lays out the space of an ideal vision and in
this way assures the necessity of a transcendence—metaphori-
cally (by the unknown to which it appeals—here we must re-
call the structural place occupied by the vanishing point) and
metonymically (by the displacement it seems to carry out: a
subject is both "in place of" and "a part for the whole").[7]

To this powerful exercise in the archaeology of the cinema, we may
add Snow's own description of "trying to make a definitive statement
of pure Film space and time, a balancing of 'illusion' and 'fact,' all about
seeing. The space starts at the camera's (spectator's) eye, is in the air, then
is on the screen, then is within the screen (the mind)."[8]
 We are now, I believe, in a position to more fully understand the
particular impact of Snow's filmic work from 1967 on, to discern the

reasons for the large consensus given to the work honored at Knokke-le-Zoute, and to answer questions of the following sort: How did Snow's film differ from other recent uses of the long take? Why was it that differences of taste and of theoretical orientation were so promptly reconciled on the appearance of this work? Why was it that viewers and critics, hitherto resistant to the innovations of Independent filmmaking, found themselves engaged by this particular new work? Why, in fact, did it seem to constitute, even at that time, a threshold in the development of the medium so that a critic known for his allegiance to dominant narrative cinema could speak of it as a kind of *Birth of a Nation* of the avant-garde?

Snow invented, in the camera's trajectory through empty space *toward* the gradually focused object on the farthest wall, a reduction which, operating as the generator of the spatiotemporality of narrative, produces the formal correlative of the suspense film. Baudry's text, however, gives us another grasp upon the reasons for the impact of this work and of others that were to follow. For Snow had, in that reductive strategy, *hypostatized* the perspective construction within the space of cinematic representation, and in so doing he had laid bare the manner in which cinema proceeds from the conventions of painting. He had made visible the way in which, as Alberti defined it, "painting is nothing other than the intersection of the visible pyramid according to a given distance, a fixed center and a specific light." He had, in fact, by restoring and remapping the space of perspective construction, reestablished its center, that place which is the space of the transcendental subject.

Wavelength, then, appeared as a celebration of the "apparatus" and *a confirmation of the status of the subject*, and it is in those terms that we may begin to comprehend the profound effect it had upon the broadest spectrum of viewers—especially upon those for whom previous assaults on the spatiotemporality of dominant cinema had obscured that subject's role and place. The spectator for whom that place was obscured—and threatened—by the spatial disorientations of, say, *Dog Star Man* (a space purely optical and a temporality of the perpetual present) could

respond, as if in gratitude, to Snow's apparently gratifying confirmation of a threatened sovereignty.

But Snow was not content to reestablish "the referential norm"; he subjected it—and in this he is, indeed, the follower of Cézanne he claims to be—to constant analytic transformation. Thus the slight, constant movement of the camera within its sustained propulsion forward, the light flares and filters which punctuate that movement, the changes of stock and the final shot which intensifies, in superimposition, the flatness of the photograph on which the camera comes to rest. The depth and integrity of the perspective construction is at every point subjected to the questioning and qualification imposed by the deployment of anomalies as differences within the spatiotemporal continuum.

II

Even our judgments about the cosmic regions are subordinated to the concept we have of regions in general, insofar as they are determined in relation to the sides of the body.

—*Kant,* On the First Ground of the Distinction of Regions in Space

Snow now proceeded to embark upon a series of films which systematically explore the modalities of camera movement; they culminate in *La Région centrale* (1970). This film marked, to begin with, a significant break with the technology and production system with which filmmakers such as Snow had been involved. It was made possible by substantial grants from the Canada Film Development Corporation and Famous Players. State patronage and the film industry joined in financing this venture, for which a special machine was designed to control a maximally mobile camera. There is at roughly this point, among filmmakers as a whole, a developing interest in an expanded technology (use of video, computers,

sound synthesizers), and it will be largely the role of universities to provide these in exchange for teaching duties. The situation develops somewhat on the order of musical composition in the United States during the 1960s, and its consequences, insofar as one can at all foresee them, raise a number of questions. Having returned to Canada from some years of work and residence in New York, Snow found himself free of the particular academic constraints which characterize the American filmmaker's situation, and *La Région centrale* is one among a number of major enterprises benefiting from government patronage.

The camera of *La Région centrale*, instructed and controlled by the machine, turns in a wild and isolated Canadian landscape in a series of circular variations whose multiplicity—of speed, direction, focus—is the function of a "liberated" eye. As Snow himself has said, "I wanted the spectator to be the lone center of all these circles. It had to be a place where you can see a long way and you can't see anything man-made. That has something to do with a certain kind of singleness or remoteness that each spectator can have by seeing the film." And, "just think of that … that there is nobody there."[9]

Returning now to Baudry's text, we pursue the investigation of the role of camera movement within the cinematic apparatus:

> To seize movement is to become movement, to follow a trajectory is to become trajectory, to choose a direction is to have the possibility of choosing one, to determine a meaning is to give oneself a meaning. In this way the eye-subject, the invisible base of artificial perspective (which in fact only represents a larger effort to produce an ordering, regulated transcendence) becomes absorbed in, "elevated" to a vaster function, proportional to the movement which it can perform.
>
> And if the eye which moves is no longer fettered by a body, by the laws of matter and time, if there are no more assignable limits to its displacement—conditions fulfilled by

Michael Snow beside the machine used to shoot *La Région centrale*, 1970.

the possibilities of shooting and of film—the world will not
only be constituted by this eye but for it. The mobility of the
camera seems to fulfill the most favorable conditions for the
manifestation of the "transcendental subject."[10]

It is, of course, this disembodied mobility of the eye-subject which is
hyperbolized in *La Région centrale*, and it is again the spectator as "lone
center" and as "transcendental subject" who is personified in the cam-
era, whose extended mobility rivals that of dominant cinema—that of
Ophüls, Welles, or Kubrick.

 La Région centrale was conceived and shot during the two years which
followed the most intensive period of America's space program, culminat-
ing in the fulfillment of the Apollo Mission, itself the most extensively
filmed and televised event in history. Snow's film conveys most powerfully
the euphoria of the weightless state; but in a sense that is more intimate and
powerful still, it extends and intensifies the traditional concept of vision
as the sense through which we know and master the universe. This film,
in its circling, spiraling, rising, sweeping movements, crossing the distances
between peaks, creating, in imperceptible loops through empty skies,
reversals of direction which disorient the riveted spectator, seems to ques-
tion, through kinetic counterexample and disorientation, the "ground" of
the Kantian "view" which founds the modern sense of "place":

> Since through the senses we know what is outside us only
> insofar as it stands in relation to our selves, it is not surprising
> that we find in the relation of these intersecting planes to our
> body the first ground from which to derive the concept of
> regions in space. ... Even our judgments about the cosmic
> regions are subordinated to the concept we have of regions
> in general, insofar as they are determined in relation to the
> sides of the body.[11]

Michael Snow, stills from *La Région centrale*, 1970.

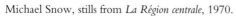
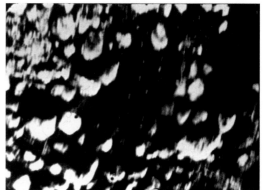

Michael Snow, stills from *La Région centrale*, 1970.

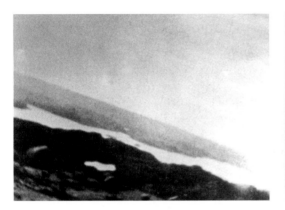 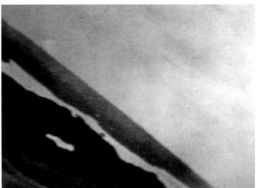

Man in space. Courtesy NASA.

For Snow, in jettisoning all anecdotes, in enforcing the collapse of camera or filmic agent into "character," has deprived the spectator of all other possible source or medium of corporeal grounding and identification. He remarks that "It's not handmade but rather as if the film were made by the machine. The film seems to come from the machine towards the spectator. The reconstitution is more mental than physical. For some films, you think of the cameraman when you see camera movement. He sees for you. Here, it is as if you were the cameraman."[12] This ultimate identification of spectator with the camera completes and intensifies, as well, what Christian Metz has described as the primary cinematic voyeurism, unauthorized, and reenacted, through framing, as a direct recapitulation of the child's vision of the primal scene. Snow's infinitely mobile framing, his mimesis of and gloss upon spatial exploration offer, most importantly, a fusion of primary scopophilic and epistemophilic impulses in the cinematic rendering of the grand metaphor of the transcendental subject. *La Région centrale* gives new meaning to the notion of science fiction.

<div align="center">III</div>

Cinema is a Greek word that means "movie." The illusion of movement is certainly an accustomed adjunct of the film image, but that illusion rests upon the assumption that the rate of change between successive frames may vary only within rather narrow limits. There is nothing in the structural logic of the filmstrip that can justify such an assumption. Therefore we reject it. From now on we will call our art simply: film.

—*Hollis Frampton, "For a Metahistory of Film"*

A thing is what it is and not another thing.

—*G. E. Moore*

Let us suppose we must compile a set of instructions for the use and understanding of Snow's work. One might begin by listing the basic formal and discursive strategies which animate films, photographic work, projections, sculpture, and painting. To hypostatization and hyperbolization one would add such pairs of terms as identity and contradiction, reduction and extension, punning and disjunction.

I have chosen to consider Snow's film work—and it is extended in the vast and systematic exploration of image-sound relation of *Rameau's Nephew* (1974). Consideration of the above paired terms and the manner in which they function throughout the range of work leads one, however, to locate axes and continuums which join seemingly disparate efforts. Or rather, let us say that Snow's obsessively systematic investigations exclude the notion of disparity.

Consider, for example, *One Second in Montreal* (1969), a work which he has described as an attempt to construct a purely temporal structure. It is one of his less frequently screened and appreciated works and one of his finest and most arresting. It offers a filmic projection of a serially composed succession of still photographs of squares and parks in Montreal (possible sites for a monument), seen "under snow"—the sort of small, assertive pun in which this artist delights. The images succeed one another in series of expanding and contracting length. The main compositional parameter is that of duration, and the work offers, consequently, with unadorned intensity, the tension inherent between still photograph and filmic image. Or rather, it forces the question: Why present still photographs in filmed succession rather than through slide projection? Reply: the temporality which circulates through the optical flicker of projected film joins to the rhythm of images in static succession the pulse of an ostinato. This is, then—not unexpectedly—the most musical of a musician's visual constructions. And if one reflects upon the nature and condition of the continuity-in-stasis given each still image projected at twenty-four frames per second, one sees, as well, that they compose, in a sense that is both strictly and paradoxically Framptonian, that cinematic entity, a "movie."

Machine used for shooting *La Région centrale*.

Snow then continues to pursue, with an obstinate sort of wit, the exploration of the modalities of photographic imagery. Thus, *A Casing Shelved* (1970) has two components: a colored slide in projection and a taped recording of the filmmaker's voice. Before one, on the screen, is the single still image of a bookcase (most likely the one installed near the beginning of *Wavelength*). Its bisected shelves, structurally recalling *Atlantic*, contain (frame) the contents which Snow begins to enumerate and describe in a narrative that evokes the years of work and residence memorialized in the accumulation of objects and documents. The disjunction of the narrative is generated by the random order of objects and intensified by the manner in which Snow directs our attention to events separated in time through the scanning of objects scattered in space. And we, instructed by the author's verbal scanning of this "landscape," find ourselves performing those eye movements over the surface of the projected still image which composes the repertory of the camera: the pan, the tilt, the crane shot. The reduction performed in the passage from film to filmed photograph to projected slide has generated a continuum structured by the formal strategies of identity and contradiction.

When is a film not a film? And when is a film a movie? And, as they say, "What is cinema?" Well, let us make a movie (we will call it *Wavelength*) and show that it is a film. Then, let us take the still photograph and show it as a movie. And if we instruct the camera-subject to scan the surface of the still image as though it were a landscape, what must we expect—a film or a movie?

NOTES

First published in *October* 8 (Spring 1979): 111–125. Minor corrections have been made for consistency.

1. See Annette Michelson, "Paul Sharits and the Critique of Illusionism: An Introduction," in *Projected Images* (Minneapolis: Walker Art Center, 1974), pp. 20–25.

2. For a detailed consideration of these particular temporal aspects of Duchamp's work, see Annette Michelson, "*Anemic Cinema:* Reflections on an Emblematic Work," *Artforum* 12, no. 2 (October 1973): 64–69; reprinted in this volume.

3. Christian Metz has noted the affinities between framing and camera movements in cinema, on the one hand, and the mechanisms of censorship and desire, on the other. Further study of Duchamp's radicalization of the framing gesture and of Snow's multiple adaptation of it might well profit from consideration within this context. Metz, *Le Signifiant imaginaire* (Paris: Union Générale d'Éditions, 1977), pp. 104–106.

4. See Annette Michelson, "Toward Snow (Part I)," *Artforum* 6, no. 10 (Summer 1968): 67–71; reprinted in this volume as "Toward Snow."

5. Stan Brakhage, *Metaphors on Vision* (New York: Film Culture, 1963), n.p.

6. This anticipation is discussed in Annette Michelson, "Reading Eisenstein Reading *Capital* (Part 2)," *October* 3 (Spring 1977): 77–78.

7. Jean-Louis Baudry, "Effets idéologiques de l'appareil cinématographique de base," *Cinéthique* 7–8 (1970): 1–8; this translation by Alan Williams appeared in *Film Quarterly* 28, no. 2 (Winter 1974–1975): 39–47. The reader is advised to consult the original text for a sense of the specific historical context provided by the journal *Cinéthique*.

8. Michael Snow, "A Statement on *Wavelength* for the Experimental Film Festival of Knokke-le-Zoute," *Film Culture* 46 (Autumn 1967): 1.

9. Michael Snow, in Jonas Mekas, "Interview with Michael Snow on *The Central Region*," recorded January 2, 1972; tape deposited at Anthology Film Archives, New York.

10. Baudry, "Ideological Effects," p. 43.

11. Immanuel Kant, "On the First Ground of the Distinction of Regions in Space," in *The Changeless Order: The Physics of Space, Time, and Motion*, ed. Arnold Koslow (New York: Braziller, 1967), p. 129.

12. Michael Snow, "Entretien avec Michael Snow," in *Michael Snow: Retrospective* (Quebec: Cinémathèque Québécoise/Musée du Cinéma, 1975), p. 19.

Carlos Argentino Daneri, poet, inveterate developer of pictures, and the
true hero of Jorge Luis Borges's "The Aleph," condemns "our modern
mania for having books prefaced, 'a practice already held up to scorn
by the Prince of Wits in his own graceful preface to the *Quixote*.'"[1]
He does, however, acknowledge the foreword's use as "accolade," and
proposes that "'Borges' act as 'spokesperson for two of (his) book's unde-
niable virtues—formal precision and scientific rigor—inasmuch as this
wide garden of metaphors, of figures of speech, of elegances, is inhos-
pitable to the least detail not strictly upholding of truth.'" Borges, he
whose name stands free of inverted commas, nowhere to my knowledge
provides—not even in the *Essay on Ancient Germanic Literature*—sanction
for the delicacy of Dasent, translator of the *Prose* or *Minor Edda*, who felt
"no hesitation in placing the foreword to the ... *Edda* at the end of the
volume." So be it.

The coordinates and contours of Frampton's plot have been traced
against the exfoliating chaos of the decade's discourse on film and pho-
tography. Like printers in the darkroom, we have been watching the
development, in sharpened and proliferative detail, of a structured field

in depth: Photography. To pursue this obvious simile one turn further, we are surprised by that now coming into view. We had thought Time captured, arrested, but it is History, encoded within the developing economy of production, that emerges as the shaping, compositional object of that presumed arrest. We ought, by now, to have anticipated this, and yet there is, in all the current literature, the sense of an epiphany, delayed and redoubled in its power. Now, we are told, is Photography truly located, and now it is that we must set to work, establishing an archaeology, uncovering a "tradition," in the euphoric constitution of an aesthetic, reclaiming an indeterminate corpus, through scholarship and speculation, from the limbo to which it has been consigned.

It was in 1848 that Alphonse de Lamartine declared, "It is photography's servility which accounts for my deep contempt for that chance invention which can never be an art, merely an optical plagiarism of Nature. Is the reflection of glass on paper art? No, it is a sun stroke caught through a maneuver. But wherein lies its human conception? In the crystal, perhaps. Surely not in Man. … The photographer will never replace a painter; one is a Man, the other a Machine. The comparison ends there." The refrain is by now familiar. But it is also Lamartine who, in the "twilight" of his life, brazenly proclaims that, "Photography is more than an art; it is a solar phenomenon in which the artist collaborates with the sun." Romanticism's hubris had found, and has retained, its true Accessory; it is only in the brief Futurist moment propaedeutic to revolution that Romanticism will call, one half-century later, for the reconciliation and realignment of Man and Machine in a common *Victory over the Sun*.

The breach within the reversal was one of twenty years of development of the techniques of mechanical reproduction. Lamartine's revision of judgment ratifies the already suspected implications—scientific, industrial, aesthetic—of that acceleration; it does not, however, project the epistemological malaise generated from the first by the technique as such.

If we may claim a position of privilege, it is insofar as we are witness to "the return of the repressed." The structure of a market in formation,

the nature of its exchange mechanisms, the manner in which standards are defined and imposed, the transmutation of an ontologically inscribed plenitude into artificial scarcity are now plain to see, though still largely unarticulated in the contemporary discourse of photography; scholarship and commerce are implicated in this setting into place. Thus, issues of provenance and value, of perceptual and semiotic analysis, a rhetoric of textual criticism are now formulated with reference to photographic process. They derive, most evidently and in the main, from the older traditions of art historical and art-critical scholarship, as the commerce of photographs is derived from the practices and institutions governing the exhibition and diffusion of prints and sculptural casts. Theory and history of photography strain, however, to ignore this complicity, much as art historical connoisseurship feigns the disdain of the commerce it sustains. The notions of value, of aura or authenticity currently revived and adapted for photography are, as we know, the guarantors of such commerce/discourse.

We need, we urgently need, a radical sociology of photography to force upon us, to disclose the view, the inescapably ideological and historical nature and implications of our present photographic revisionism. Bernard Edelman, in the only rigorous study of this sort known to me, began to trace the process whereby the photograph begins to acquire value as originating in the sudden appearance of those techniques of reproduction that provoked a disequilibrium in stable categories of description.

The history of this process can be divided into two parts. In the first, the reproductive capacity is defined as imputable to the machine itself. This is the artisanal period of the mid-nineteenth century, when the photographer is very much the worker; he is then both in the service of the machine and at one with his tools: the proletarian of "creativity." Photography is, at this point in history, variously described as a curiosity, as a toy, as useful. It has not yet been subjectivized.

The inscription of subjectivity will involve a reversal of relation between means and end. The work of the machine becomes the work of the subject, and this work is a means of "creation." Photographic reproduction then received the mark of the subjective or intellectual act of "creativity," and it is then, precisely, that it begins to be the object of legislative protection. The photographer moves from the level and role of artisan to that of proletarian, and in time, to that of the artist. For it is in the interest of industry and of the market to guarantee, first of all, the status of the photograph as commodity, and subsequent to this, that of the photographer as artist. These will in turn generate the re-creation of scarcity which reenforces the value of the print, revived from the pre-industrial era. Above all, it engages the discourse of photography in the constitution of an ontology whose center is the founding presence of the artist, author, and authorizing figure, reinstating precisely at that moment when the discourse of historiography is under fire and revision, its most suspect set of presuppositions.

Thus, in an interesting discussion organized in 1973, as if in immediate response to the crisis inaugurated by this revision, dealers debate with a historian and a photographer the modalities and mechanisms of photography's emergence into the fine art market.[2] This exchange of views turns, between euphoria and anxiety, upon one question: value as a function of scarcity. What can the artist and his dealer expect to gain or lose from the recognition that this is a medium of industrial multiplication? How, without absurdity, can it be restored to the privilege of a preindustrial form? And the difficulties and contradictions in the problem are rehearsed in the obsessive insistence upon the privileged status of the darkroom as the locus, within the productive chain, of "the creative process," as the ultimate origin of subjectivity and value within photographic production. Until the moment of high comedy in which the Photographer (Aaron Siskind) acknowledges his inability to distinguish the print made from his negatives by another from those of his own developing. In that moment, the artist/producer is seemingly disposed,

evicted from his lair, his last refuge, as guarantor of craft, authenticity, autonomy, and value.

The claims, then, of pioneers of the modern era such as Strand and Weston, assessed by Frampton, are informed with the cathectic exorbitance involved in sustaining, containing the contradiction between "the primacy of photographic illusion and ... the autonomy of the photographic artifact," and Frampton's diagnostic reading of their implication within this crisis supplies, for the first time and with a salutary impiety, another set of terms for their understanding.[3] Weston, alternately protective and aggressive in his magisterial appropriation or mapping of the world, is understood as the Forebear against whose erotic imperium, against whose apodictic terms, against whose voice—laconic and stentorian—over and against whose Name, one must locate one's own pretexts and construct one's practice.

It is then, within the extended moment of crisis articulated in those claims, that Frampton intervenes, relocating, displacing the terrain and terms of argument, elaborating over twenty years of artistic practice, a meditation upon Film and Photography. In image, text, film-text, textual film, the body of the world is explored, known in its temporality. The metaphors and elegances of these developing gardens reinscribe the paths traced by those obsessive aporias instituted by the discourse of the Stoics and the paradoxes of Zeno, which have, time and again, provoked dissent, refutation, revision in the West's discourse upon Time and the formation of its Analytics. Alone then, among filmmakers, Frampton can see "persistence of vision" as more than the perceptual construction of continuity between discrete frames, and rather as a hypostatization of the argument against "the flow of Time" as such. Consider, for example, Fox Talbot's "incisions" in history. They are first made, we are told, in 1832, the *annus mirabilis* which produces Galois's founding of set theory, Büchner's *Woyzeck*, and the first photographic images of Niépce, as well. There is, however, a contextual term missing, for the immediately preceding

215

year is that of the birth of Dedekind, to whose axiomatic intervention the image of the "incisions" specifically refers.

It has been pointed out that Dedekind's axiom constitutes a particularly adroit presentation of our representation of Time: "If all points of a straight line fall into two classes, such that every point of the first class lies to the left of any point of the second class, then there exists one and only one point which produces this division of all points into two classes, this severing of the straight line into two portions." So it is that we intuitively establish, within Time, a past and a future which are mutually exclusive. Together they compose Time stretching into eternity. Within this representation, "now" constitutes the division which separates past and future; any instant of the past was once "now," and any instant of the future will be "now." Therefore, any instant may constitute this division. Although we know and retain discrete instants, we nevertheless complete them, establishing that continuum in which Time, for us, flows.

Dedekind argues that the discontinuousness of space, were it to be established, would not prevent us from filling in its gaps in thought, thus making it continuous. And this claim finds its response in the observation that such, indeed, is already the case, that gaps in Space are inexistent for us in so far as we cannot think the gap in Time.

Now, Frampton: "Talbot believed he was somehow augmenting history, by implanting, into brief incisions, new values as stable, as endlessly recurrent and irrational, as the decimal *pi*."[4] The discovery of which, one might add, the Greeks are said to have celebrated by the hecatomb, that slaughter of 100 oxen which represented their most resplendent order of tribute, and for which the extravagance of late Georgian England seems to have devised no reasonable facsimile. Frampton's absorption in set theory (it has helped to shape the formal structure of his practice) works, as it were, *to contain a photogenic epistemological malaise within the terms of logic.* And yet, and yet …

There exist several texts, absent from *Circles of Confusion*, which point elsewhere, further, to an obstinately persistent, darker, more

216

disquieting sense of things, one more difficult to contain within that conjunction of poetry and science of which Frampton is the lonely, per- cipient negotiator. I turn now to two of these, offering first some par- ticulars of description.

Text I, entitled *Poetic Justice*, is presented in two forms: as film (black and white, silent, 16 mm, running time: 30 minutes) and as book, pub- lished in 1972 by the Press of the Visual Studies Workshop. Description is contained in the particular that this work *is* one of description, that is, it answers to the description of film script, complete with shot sizes: a film-text in the most complete and condensed sense of the phrase. Pro- jected through the written summary of each shot/page is the narrative of a triangle, its three points/agents designated by pronominal shifters, and consequently empty of identity and gender. "I," "You," "Your Lover," then, move in an invariant present (that of the speech act transcribed by the film-text-script) through a series of postures, gestures, attitudes, described in relation to a limited number of objects within a space (exte- rior/interior), whose integrity the reader/spectator will never apprehend or reconstruct. Central within that constellation of objects are a camera, still photographs (of protagonists), and central to the dynamics of this work is the passage from shots of cinematic action to those of still pho- tography, effected within the grammar of a narrative, with the protago- nists sometimes viewed as photographers and/or cinematographers.

It is at the center of this narrative, at what we might term its cli- max, beginning at shot number 122, that "in the Bedroom; You and Your Lover embrace, naked on the bed. Outside the window are spruces and junipers under snow." And from numbers 132 through 180, "outside the window," as "You and Your Lover" continue to "embrace, naked upon the bed," there transpires a catalog of the world's infinity in fifty-seven varieties of its events: outside that window "are," for example, and in the following order:

peacocks strutting on a turf green
hyenas disputing a carcass

217

strands and bladders of kelp
wrestler in a tag match
an automatic turret lathe in operation
a calm inland sea
a squadron of pipers
rings of Saturn, looming
little girls skipping rope
tumbled stacks of cordwood
a display of ophthalmoscopes
a party of mountaineers
a park of bay trees
a sky full of wheeling pigeons
truck wheels splashing in muddy water
three red-haired women rolling dice …

Any interruption of such a catalog is necessarily arbitrary, but the limits of this fragment do, however, point to an interesting (and significant) semantic distinction, within this text, of nominal and adjectival functions. "Green" and "red" have, in this text, quite different functions; "turf green" denotes a place or site, conceivably (like "village green"), within the space of this representation in black and white. The color "red" is, however, here inextricable from "hair." This film-text has bled into color, and the cascade of images contains a subtle cue which impels the fascinated spectator/"I" to register that passage in bleed, as if in positive reply to the anxious, mocking query of Carlos Argentino Daneri, "Did you see everything—really clear, in colors?" "Oh yes, yes," shuddering, like "Borges" seeing/reading through the Aleph/frame, the intimation of endless replication inscribed with "The Last Machine." What is it that, finally, blocks the chain of the visible? It is the appearance of the "filled" shifter, the "I" aiming his camera in countershot of the naked couple. Reflexivity reified staunches the hemorrhage of Imagination.

Hollis Frampton, *Poetic Justice*, 1972. Courtesy Anthology Film Archives.

Hollis Frampton, *Nostalgia*, 1971. Courtesy Anthology Film Archives.

Text II. *Nostalgia*, 1971. Film, 16 mm, black and white, sound, running time: 36 minutes. One dozen photographs, exposed, then burnt on screen, their subjects and circumstances of making narrated in the first person by the maker/author, this *bildungsroman* spoken by a second voice; each image out of synch with its account, so that text and image in superimposition produce a temporal torsion. Reminiscence, narrative, iconographic *exercises de style* succeed each other, ending with the account of a photograph in which "*Something invisible to me*," reflected in a window and reflected once again in a rearview mirror attached to a vehicle, the smallest of details, subsequently enlarged, "yet hopelessly ambiguous in which hides a dread, a loathing such that I think I shall never dare to make another photograph again." And we are given to see on the blank, black screen, the faceless, nameless image for which each spectator has a face or Name.

It has long seemed that photography and then cinematography, with their promise of imminent revelation, would provide access to the nature of the recesses of the phenomenal world, as if the revisions of perception and judgment impelled by that access would act as corrective to empirical fictions. Jean Epstein remarked a half-century ago that "little or no attention has been paid until now to the many unique qualities film can give to the representation of things. Hardly anyone has realized that the cinematic image carries a warning of something monstrous, that it bears a subtle venom which could corrupt the entire rational order so painstakingly imagined in the destiny of the universe."[5] Frampton, revivifying for us the Stoic discourse, has restored to the theory of mechanical reproduction its alethiological function. It is the venom's antidote.

Notes

First published as the foreword to Hollis Frampton, *Circles of Confusion* (Rochester: Visual Studies Workshop, 1983), pp. 13–21. Minor corrections have been made for consistency.

1. This and subsequent quotations are from Jorge Luis Borges, "The Aleph," in *The Aleph and Other Stories*, trans. Norman Thomas di Giovanni (New York: Dutton, 1978).

2. "Photographs and Professionals: A Discussion by Peter Bunnell, Ronald Feldman, Lucien Goldschmidt, Harold Jones, Lee Witkin and Aaron Siskind," *Print Collectors' Newsletter* 4 (July 1973): 54–60.

3. Hollis Frampton, "Meditations around Paul Strand," *Artforum* 10, no. 6 (February 1972); reprinted in *Circles of Confusion* (Rochester: Visual Studies Workshop, 1983), p. 130.

4. Hollis Frampton, "Incisions in History / Segments of Eternity," *Artforum* 13, no. 2 (October 1974); reprinted in *Circles of Confusion*, p. 94.

5. Jean Epstein, "The Universe Head over Heels," trans. Stuart Liebman, *October* 3 (Spring 1977): 20; original in *Écrits sur le cinéma* (Paris: Seghers, 1974), pp. 257–263.

Hulkes falleth of whan come is cleansed with a syfue or wyth a Ryddyll.

—*John de Bartholomeus de Trevisa,* De proprietatibus rerum

"Frampton," Stan Brakhage in conversation once declared, "strains cinema through language." How are we to construe this assertion, offered in slightly uneasy admiration by one whose filmic poiesis was grounded in silence? Perhaps by initially acknowledging, assisted by the O.E.D., possibly pertinent meanings and variants of *distrain* in its aphetic form? *Strain* will then signify the levying of a distress upon a thing. Or we may understand it as a stretching to an extreme degree of capacity, as tending to pull asunder, to render disjunct from proper use, as subjecting to pressure or exigency. Straining, one may embrace, clasping tightly in one's arms; one may thereby constrict, compress, contract, diminish. One may force beyond an object's legitimate extent or scope; to strain may then be to impair or to imperil the strength of a material thing by excessive tension. In later use and in a wider sense, strain will be force or pressure tending

to cause fracture, change of position, or alteration of shape. It is, as well, the condition of a body or a particle subjected to such force or pressure.

We speak, too, of diction or of thought, when labored or affected, as strained.

One may, however, strain by pressing through a filtering medium. We filter liquid through a porous or perforated medium which retains the denser portions in the solid matter, held in suspension; in so doing, we free solid matter from the contained or accompanying liquid. By filtration we purify or refine. The brewer would thus strain his juice through a coarse sieve, keeping back its grosser particles. We say that in so doing, he clarifies. Moreover, a variant of the sieve, the coarse-meshed form with circular rim, its base of strong wires crisscrossed at right angles, used for separating solids—sand from gravel, ashes from cinders, and chaff from corn—is known as a riddle. Might we not then describe a riddle of this sort as a system of geometric relations devised in the interests of clarification?

One further consideration thrusts itself upon us: the devising by the Greeks, in the third century B.C., of that system for the discernment of prime numbers to which they gave the name of Archimedes' colleague, the Librarian of Alexandria; it is known as the Sieve of Eratosthenes.

One begins, then, to discern in Brakhage's admiring, albeit somewhat apprehensive, characterization of Frampton's project the core of a sound and defining intuition. One now wants to say: Embracing cinema, Frampton was to bring to the practice of filmmaking, pursued independently of its industrial constraints, an implementation of language as one system which might extend, reshape, and clarify the limits and parameters of the medium.

The letters addressed to Reno Odlin give us Frampton's early view, in 1964, of Brakhage's enterprise: "Let me say that what of Brakhage's I've *seen*, I admire. It will be necessary to see more, and many times. I cannot pay any higher compliment to a work of art than that, at least without extreme familiarity." And then, "Brakhage may have exceeded

in intensity and by several orders of magnitude the ambient of historic cinema; if that is true, what he is doing is now the cinema, and the other stuff is predecessors an' also-rans." And later, still:

> Suppose I just propose a model that could *include both* of us, rather than one or the other of us, and suggest that Stan has been concentrating for a long time on a different segment of the seeing or perceiving process. ... There's no question at all in my mind about the debt that I personally owe to Brakhage's work. We all do, or at least many of us do. But I remember very, very clearly having in my still photographs felt that I was being forced into film. ... And one of the deciding things was a suspicion that there were, after all, some films that Stan Brakhage had not made. Obviously other people had made films, but no-one was important in my own understanding ... not what film had *done*, but what the ultimate dream of what film art might be, at least as to its magnitude, its pride, if you will, as Brakhage was.[1]

Determinant in Brakhage's project had been the excision—almost, though not quite, categorical—of sound and, consequently, of speech:[2] the decision to constrain film within the parameter of the image. The reason adduced—a concerted hypostatization of the romantically grounded metaphor of an Adamic vision, rehearsed in the extraordinary textual production of Brakhage himself, and in the ensuing critical literature—offers, beside its own historical interest, powerful instruction in the generation of both theory and practice by the material conditions of production. For the history of independently made film of the postwar period is that of a transvaluation of values through which an enforced reversion to an artisanal mode of production (that of the silent, 16 mm format) enables the conversion of necessity to virtue. It was a modesty of means and constriction of the arena of exhibition which impelled

the rethinking of the medium; the consequent inscription of a radical subjectivity within the filmic founds Brakhage's oeuvre as the central, seminal force within the movement. That strenuous inscription, involving the intransigent rejection of the full range of codes which order the dominants of cinematic representation, dictated the dissolution of the spatiotemporal coordinates of representation. The twin fortresses of that representation, defending it against radical assault, were seen to be those of narrative structure and of the perversion, constructed and maintained by corporate control, of a rationalized division of labor in industrial production. Film theory has explored the labyrinth of passageways connecting those two guard posts, even when it has been reluctant to recognize the manner in which Brakhage, succeeding Maya Deren, led the assault upon them. If, however, we wish to understand and to place Frampton within this movement, we must first retrace, if only briefly and allusively, the contours and direction of Brakhage's project, as epitomized in his major effort of the late 1960s. (It is, of course, the period of Frampton's first mature work in film.)

Scenes from under Childhood (1967–1970) is a large-scale work in four sections, and its footage, like that in so much of Brakhage's work, records his family's daily life. The characteristically abstractive use of superimposition; of extreme close-up in which the camera isolates, enlarges, and dissolves both detail and spatial definition; the effects of texture, color, rhythm, intensity of light and movement thus produced; the rapid editing pattern joined with the camera's insistent choreography—all these work to produce a seamless, mobile visual field. Add to this a rhythmic interception by "empty" frames, filled, nevertheless, with solid color—mostly black and red—and you have the pulsating flux of Brakhage's extenuation of reference which so confounded, and continues to confound, the expectations of large numbers of even those nominally committed to the rethinking of the cinematic.

Scenes from under Childhood was, as well, however, Brakhage's final attempt in the late 1960s to come to terms with the parameter of sound.

———

The track of Section One—ordinarily suppressed in projection upon instruction from the filmmaker—has nonetheless a particular interest for our purposes. It is a kind of concrete sound score; its sources, indeterminate, are described as evocative of the trumpeting of beasts, heavy breathing, rhythmical clicks, percussive sounds of unidentified objects or instruments. This track is actually composed of sounds recorded on tape during the birth of Brakhage's first child. The cries of the emerging baby and of her mother, together with the ambient sound, were slowed, subjected to acoustical variation within an echo chamber. This soundtrack is not continuous, but intermittent, frequently intercepted by silence for periods of varying length.

The fusion of the two parameters induces that rhythmic contraction and expansion of visual and acoustical space, that plasticity and "presence" of image and sound which reinforce the extenuation of reference already noted. *Scenes from under Childhood* marks the fullest limit (although by no means the terminal point) of an enterprise which we must now understand in terms somewhat larger and more radical than those of a lyrical cinema. It has been claimed that Brakhage does not, in his filmmaking practice, engage with the "symbolic." The truth, however, is other; it must be quite differently stated. Rather, he has sustained, within an abundant and varied production, a long and quite solitary adventure: the intensive evocation of that phase of the constitution of the human subject which precedes access to language. He has, himself, suggested by implication the Kleinian aspect of a scenario which, like *Scenes*, offers "a visualization of the inner world of … beginnings, the infant, the baby, the child—a shattering of the 'myths of childhood' through revelation of the extremes of violent terror and overwhelming joy of that world darkened to most adults by their sentimental remembering of it … a 'tone poem' for the eye."[3]

In her seminal work of the past decade Julia Kristeva has suggested the terms in which we may begin to think the expressive register anterior to the initiation of the thetic function. In terms which echo and

227

elaborate upon Brakhage's own, she warns of the extreme difficulty and delicacy of access to this moment, of the projection of the features of adult memory and adult discourse onto the space of childhood in a spurious myth of continuity in ontogeny:

> In like manner, the function of the familial context in the *precocious* formation of the child (before puberty, before Oedipus, but also before the "mirror stage") tends to be minimized. This is only too evident not only in ego-centered currents of child psychology, but also in that psychoanalytic practice which posits the subject as beginning with the "mirror stage." The most important debates and innovations in psychoanalysis are consequently and necessarily organized around this knot. The point is the heterogeneity between the signifying libidinal organization in infancy (the "semiotic"—*le semiotique*) and the "symbolic" functioning of the speaker following language acquisition and the consequent parental identifications. On the other hand, ... this precocious, presymbolic organization is grasped by adults only as regression—jouissance or schizophrenic psychosis. Thus, the difficulty, the impossibility of this attempt to gain access to childhood: *the real stakes of the discourse on childhood within Western thought involve a confrontation between thought and what it is not, a wandering at the limits of the thinkable.*[4]

I have described Brakhage's adventure as solitary, and in its assiduousness, its obstinate multiplicity of effort, it is indeed. It is, however, not entirely without poetic precedent.[5] Brakhage himself had entertained the possibility of a poetic homology of his cinematic project: "Non-representational language, enchanting non-sights into non-words ... writing only sound poems, ... communicating on an emotional level only distantly related to all the known word origins of any written sound ...

the embryonic form of a purely onomatopoetic art." He seems, however, to have been unaware of a full-scale exploration of the register of the "semiotic" already undertaken, that of Andrei Bely, who did produce, in his novel, *Kotik Letaev*, a textual chronicle of the formation of the subject. (Written in 1916, it is therefore entirely contemporaneous with the composition of *Portrait of the Artist as a Young Man*.) I excerpt from this volume of 215 pages, in awkward translation, two brief passages only, from its first section:

> The first "thou-art" grips me in imageless deliria;
> and—
> —as ancient kinds, familiar immemorially: inexpressibilities,
> nonhappenings of consciousness lying in the body,
> the mathematically exact sensation that you are
> both you and not you, but … a kind of swelling
> into nothing and nowhere, which all the same is not
> to be overcome, and—
>
> —"What is this?" …
> Thus would I condense in a word the inutterability
> of the advent of my infant life: —
>
> —the pain of residing
> in organs: …
> —there
> was no division into "I" and "not-I," there was
> no space, no time. …[6]

> The first conscious moment of mine is—a dot; it
> penetrates the meaninglessness; and—expanding,
> it becomes a sphere, but the sphere—disintegrates:
> meaninglessness, penetrating it, tears it apart …

———

Flocks of soapy spheres fly out of a light straw ... A
sphere—would fly out, quiver, lose brilliance; and—
burst; a tiny drop of viscous fluid, puffed up with
air, begins to play with the lights of the world. ...
Nothing, something, and again nothing; anew something;
all is in me, I am in all ... such are my first moments ...
then—

scarcely visible torches flashed; gloom (like snakeskin
from a snake) began to crawl from me; sensations
separated from skin: they went off under my skin:
out fell lands born of blackness—

 —the skin became
 for me like ... a vault: such is the way we perceive
 space. ...[7]

Now Brakhage, in *Metaphors on Vision*: "Forms merge, as the finger-
tips closing to touch, closely viewed, reach a blur of their color, changing
their contour, visually merging with each other before physical contact.
... Within this aura of nonshape, shapes reshape ... until one is involved
purely with the innards of what one once knew only as an outline."[8]

Most radically at issue throughout Brakhage's project is the explor-
atory reconstruction of a *topos*, that of the prethetic chora, "neither
model nor copy ... anterior and subjacent to figuration and thus to
specularization ... admitting no analogy except with vocal or kinetic
rhythm."[9] And the condition of access to this *topos* is the lucid, delicate,
scrupulously sustained acknowledgment of its heterogeneity with respect
to articulate representation. Such a cinema, straining, we might say, at the
limits of meaning, abjuring the discursive and didactic function assumed
by much recent work, thereby assumes the poetic function. It will there-
fore choose to dwell in the prethetic, in suspension at the threshold of
language.

———

T. W. Adorno, in a text whose title, "Transparencies on Film," reads rather like one by an American theorist of the contemporary avant-garde, voiced his aversion to the cinematic image, his sense of its radical insufficiency of abstractive power, its irremediable, analogical implication in established and repressive codes of representation:

> The photographic process of film, primarily representational, places a higher intrinsic significance on the object, as foreign to subjectivity, than aesthetically autonomous techniques; this is the retarding aspect of film in the historical process of art. Even where film dissolves and modifies its objects as much as it can, the disintegration is never complete. Consequently, it does not permit absolute construction: its elements, however abstract, always retain something representational; they are never purely aesthetic values.[10]

To this account, we might join Roland Barthes's confession of an aversion even stronger, a kind of nausea induced by both the wealth of information within the cinematic signifier and its continuity, its apparent resistance to fragmentation, the seemingly incessant, ineluctable chatter of the image track.[11] (Sound seems not to enter into these considerations.) It is, for Barthes, as though this temporal medium had inherited something of history's hysteria.

The enterprise of the American avant-garde is most clearly understood as directed toward the destruction of those presuppositions as canonically received and established. The production of the 1960s and '70s—epitomized, to be sure, in Brakhage's work but exemplified, as well, in that of Paul Sharits, Peter Kubelka, Michael Snow, George Landow, Ernie Gehr, and Ken Jacobs—contravenes those presuppositions in its foregrounding of filmic processes and properties (of grain, of light, emulsion, stock, of recording) and in its insistent interception and blocking of diegetic continuity; it advances an asseveration of film as a chain of

discrete images, producing, in its concern with the plasticity and para-
doxes of filmic temporality, a school of cinema that we may, in more than
one sense, term that of stoics.

Working on the threshold of signification, Brakhage was to pro-
duce in the early 1970s two films which, by virtue of their very titles, are,
one might say, "literally" intriguing. *The Riddle of Lumen* (1972) may be
read as an answer to Frampton's resounding intervention of the previ-
ous year, *Zorns Lemma*. *Riddle* was followed in 1974 by the work known
as *Text of Light*. Both establish as protagonist light itself in its endless
play of reflection and refraction through a filtering ambience. Light is
this *Riddle*'s answer;[12] light is this text's substance. The dissolution of the
object is now entire, and both films participate in a movement of evacu-
ation which frees the screen of image in the period under discussion, and
which I have elsewhere considered in some detail.[13] White or black or
color-filled, subliminal or assertive, weak or saturated, grainy or dense,
the screen is image-free rather than empty; it signals most immediately
acknowledgment of shape and surface, of the boundaries and lumines-
cence of the screen itself, the impossibility of emptiness. This acknowl-
edgment traverses the development of advanced filmmaking of this time,
as though some accelerated implosion had condensed the succession of
images generated by the hyperbolic montage of avant-garde practice into
the integral, even radiance of a flickering rectangle.

Frampton, embracing film in the late 1960s, did so as a member of
a generation with an intense interest in the systemic, a fresh confidence
in the uses of generative mechanisms and decisions for artistic practice.
(Among the companions of his youth were, as the correspondence with
Reno Odlin informs us, Frank Stella and Carl Andre.) A precedent most
commonly invoked for this generation is that of Duchamp. In Frampton's
case, most certainly the Second Viennese School of musical composition
was another determinate source of interest. Thus *Palindrome* (1969) derives
not merely from its literary model, but just as surely from Frampton's
experience of serial composition, employed by Schoenberg and Webern.

Stan Brakhage, *Text of Light*, 1974.

Hollis Frampton, *Special Effects*, 1972.

Frampton's correspondence is, in fact, probably unique in its demonstration of interest in both the constraints of serial composition and the aesthetic of chance. One presumes that Frampton's sustained interest in mathematics and in comparative grammar grounds this openness, unusual for its time within New York's intellectual milieu. *Palindrome*, in any case, owes the complexity and solidity of its structure to the adoption of the retrograde inversion, employed by the Viennese as a variational form.

It is the period between 1968 and 1973 which has, I think, rightfully been claimed as most seminal, and I elect to concentrate upon it, though somewhat differently, here. This is the time of *Palindrome*, but more importantly of *Surface Tension*, *Zorns Lemma*, and the six films that comprise *Hapax Legomena*. These are, in fact, the films with which Frampton explores the terrain marked off, as it were, by Brakhage's uneasy intuition, in which he will bring powerfully into play that variant of the sieve, that "riddle" through which he "clarifies," confirming, redefining the position assumed within the thetic, of the American avant-garde. In so doing, Frampton initiated, in solitude—and it is this that defines his singular place within this movement—a dialogue with contemporary theory of language and of narrative.

Within the trajectory traced by *Hapax Legomena*, between *Critical Mass* and *Poetic Justice*, the image will be replaced upon the screen by text. And serial ordering of the heterogeneous is replaced by the construction of a diegetic chain in writing. If, therefore, we want profitably to read the work of this central period, we must do so along two intersecting axes:

1. that of the crystallization of the thematics of a double violence within language and the erotic;
2. that of a curiously prompt and constant response (as if in dialogue) to the developing meditation of Roland Barthes upon image, text, and the erotic.

Zorns Lemma responds to, seizes upon, that which Barthes has termed the "temptation" of the alphabet,[14] its manner of connection,

of linking fragments, and its fostering of our dependence upon what he terms "the glory of language, that 'which drove Saussure to despair'"; it is an unmotivated order, unmotivated but not arbitrary, insofar as it is a matter of general agreement and acceptance. Its way of dispensing with the necessity of planning and development renders it "euphoric." And it provides, as it were, supplementary effects of meaning that carry a charge of malice. Frampton's adoption of the alphabet as an ordering form for his work may be seen as part of that larger, more generally installed predilection for the systemic which did, indeed, infuse the efforts of the 1960s and '70s with confidence in the freshly generative power of the system. The euphoric was, in Frampton's singular case, reinforced by the appropriation of set theory as another source of systemic organization.

Three works of this period, covering two years of production, intersect in a particularly meaningful manner: *Critical Mass*, an acted sound film; *Poetic Justice*, a filmed script; a text on Muybridge (1973), subtitled "Fragments of a Tesseract," an essay, discursive, speculative. It locates the originary impulse of Muybridge's obsessive motion studies in the reenactment of his murder of his wife's lover.

Critical Mass is, principally, the enactment of a domestic quarrel, a "scene." Its title is derived, as was frequently the case, from scientific terminology, and it refers to the amount of nuclear fuel necessary to sustain a chain reaction; in the absence of sufficient fuel, an insufficiency of neutrons will cause the reaction to fade. This title's wit inheres not only in its general metaphorical aptness, but in the thoroughgoing precision of its pertinence, for this domestic quarrel, like most, does fade out from time to time in its obstinate, draining repetition; it comes apart, leaving a blank, dazzling screen. *Critical Mass* opens, in fact, with the screen black, its audible track that of the couple deep in argument in an exchange of accusation, recriminations, threats. Frampton's editing, on both parameters of this first film involving characters in dialogue, deflects the arguments of this little comedy of suspicion and infidelity, a staple of traditional genre, through interception, fragmentation, repetition, its extravagantly stuttering

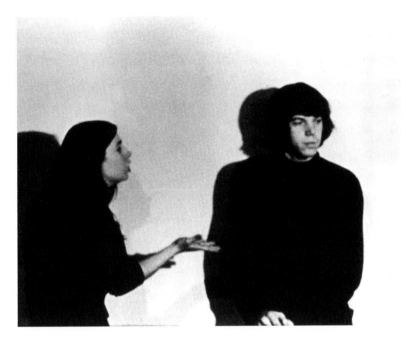

Hollis Frampton, *Critical Mass*, 1971.

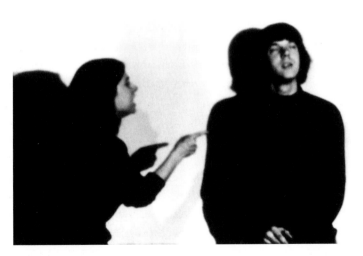

Hollis Frampton, *Critical Mass*, 1971.

pattern of gesture and sound reinforcing the hopelessly circular pattern of this transaction. Barthes has pointed out that the horror of such scenes lies in the manner in which they reveal "the cancer of language,"[15] the dynamics of such transactions tending toward an ultimate, essential violence, that of murder, never acknowledged. They are therefore propelled forward in self-perpetuation, each exchange generating yet another, like some terrible and absurd homeostatic invention of science fiction.

The imaged pieces of this film's second section remain constant in length, while the sound pieces were edited so as to expand and contract, in and out of synch. Frampton saw his task as the devising of a rigorous scheme for the organization of the material such that it would still "rhyme" in various ways with the enacted incidents. "It had to repeat, to change out of the staggering rhythm, so that each of those cries ... they really are utterances ... is handled not as part of a sentence, but as if it were a word, a kind of primal word, having exhausted absolutely the possibility of normal syntax."[16] The complex polyphony of the dissociative cutting projects the uncontrollable chain of recrimination, of violence suspended, rather than arrested, unresolved, irresolvable.

Descriptions of Hollis Frampton's films abound (for most writing about them has been primarily descriptive), and the best are certainly those offered with unflagging generosity in Frampton's recorded interviews.[17] Of *Poetic Justice*, one wants, most of all, to say that it offers the completion of the straining process, Frampton's consummate elaboration of the riddle.

Poetic Justice is, in fact, almost all text; the screen has been almost voided and is now filled with the written script of a film. "Almost all text," "almost voided," for the table upon which this script is placed and its two surrounding objects constitute the materials of a first-order film, the condition of our reading of the script. It is this first-order film which, in its pulse of projection, inscribes light as the medium of both reading and viewing. The reading enables our projection of the imaginary film structured around an apparently triangular series of erotic transactions.

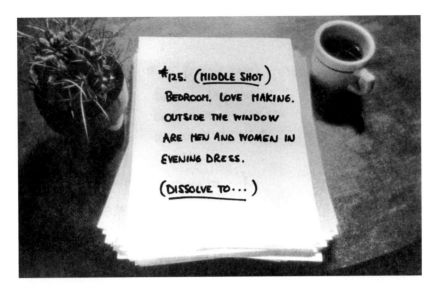

Hollis Frampton, *Poetic Justice*, 1972.

Hollis Frampton, *Poetic Justice*, 1972.

Hollis Frampton, *Poetic Justice*, 1972.

Hollis Frampton, *Poetic Justice*, 1972.

In these the architecture of a house and the presence of both camera and still photographs hold out the promise of a spatiotemporal system within which things—the narrative—may take place. It is a promise unfulfilled, however, for the confusion of coordinates and the systematic use of the pronominal shifter works to dissolve and defeat diegetic construction.

We may gauge the effects of this dislocation by recalling the nature of the shifter. "Pronouns do not constitute a single class, but are rather of different kinds according to the syntax of language; some are typical of what we call discursive instances, that is, the discrete and singular acts through which language is actualized in utterance by a speaker."[18] "These pronominal forms do not refer to 'reality' or to 'objective' positions in space or in time, but rather to a singular enunciation which contains them and reflects their proper use. The importance of their function is a measure of the problem that they serve to solve, which is none other than that of intersubjectivity."[19] It is this use of empty forms, together with the synthetic, edited spatiality of architecture which surrounds the third of the script's four "tableaux." The first of these has been constructed as a kind of didactic model of narrative script-writing, the second functions as a model of what memory in its obsession and disjunction might resemble. In the third tableau, a window near the lovers' bed becomes the frame through which, or screen upon which, a long cascade of disjunct images is viewed; they compose a kind of surrealist movie, an assertively edited stream of heterogeneous, hypnagogic images.[20] In the fourth tableau, the spatial ambiguities intensify and the author enters the narrative through the revelation that he has been photographing. With the final shot, in which an empty glove is cast upon the script, the collapse of the narrative's authorial "I" into that of the maker of the first-order film is effected, and the full range of the *mise en abîme* is disclosed.

Adorno was known to have said, "I love to go to the movies; the only thing that bothers me is the image on the screen." And we have seen why. Barthes, too, complained of the fullness of the image, of the constraints of representation which force one to receive everything

presented: "In writing, on the contrary, I don't have to see what the hero's fingernails are like, but the Text tells me, if it so wishes—and with what force!—of Hölderlin's excessively long nails."[21] It is that tact and economy, that discretion, that reservation of the linguistic signifier which Frampton offers in this film compounded of paradox and a fine malice. And the discretion is reinforced by the adoption of the shifter as its central rhetorical mechanism.

Barthes, in his later years, increasingly protested against the weight of signification, its tyranny. He dreamed of a world which might be "exempted from meaning as one is from military duty." Or of meaning which could be thought of as "tint," "quiver," "shudder," "thrill." Above all, he saw the shifter (and by extension, all operators of uncertainty in language) as a sort of "utopia," a species of subversions, conceded by language but repressed, nonetheless, by social structuring. It was the fluidity within the thetic, provisional freedom from reference, which he came to prize. Barthes was, like Adorno then, a celebrant of the ritual of filmgoing, but a most resistant spectator; there does, however, exist an imaginary cinema, constructed as if to order for them both, in the textual riddles of Hollis Frampton.

NOTES

First published as "Frampton's Sieve" in *October* 32 (Spring 1985): 151–166. Minor corrections have been made for consistency.

1. Quoted in Simon Field and Peter Sainsbury, "*Zorns Lemma* and *Hapax Legomena*: Interview with Hollis Frampton," *Afterimage* 4 (Autumn 1972): 54.

2. Brakhage's earlier work in sound includes *Desistfilm* (1967), *The Way to Shadow Garden* (1954), *In Between* (music by John Cage) (1955), and *Flesh of Morning* (1965). In 1962 Brakhage made *Blue Moses*, his dramatico-discursive analysis of film narration and film acting, and, in 1965, *Fire of Waters*.

3. Stan Brakhage, in *Film-makers' Cooperative Catalogue No. 5* (New York: New American Cinema Group, 1971), p. 40.

4. Julia Kristeva, "Place Names," *October* 5 (Fall 1978): 97–98.

5. Peter Wollen has briefly alluded to the notion of the semiotic in reference to Sharits's work in his essay "'Ontology' and 'Materialism' in Film," *Screen* 17, no. 1 (Spring 1976); reprinted in Peter Wollen, *Readings and Writings* (London: Verso, 1982). I do, however, consider that it is, in its psychoanalytic resonance, more exactly and extensively applicable to the corpus of Brakhage's films under discussion here.

6. Andrei Bely, *Kotik Letaev*, trans. Gerald Janecek (Ann Arbor: Ardis, 1971), p. 8.

7. Ibid., p. 16.

8. Stan Brakhage, *Metaphors on Vision* (New York: Film Culture, 1963), n.p.

9. Julia Kristeva, *La Révolution du langage poétique* (Paris: Éditions du Seuil, 1974), p. 24 (my translation).

10. T. W. Adorno, "Transparencies on Film," trans. Thomas Y. Levin, *New German Critique* 24–25 (Fall–Winter 1981–1982): 202.

11. Roland Barthes, *Roland Barthes par Roland Barthes* (Paris: Éditions du Seuil, 1975), p. 59 (my translation).

12. The filmmaker's statement accompanying the mention of this film in the *Canyon Cinema Cooperative's Catalogue No. 4* (San Francisco, 1976) notes, "It is the film I'd long wanted to make inspired by the sense, and specific formal possibilities of the classical English Language riddle ... only one appropriate to film and, thus, as distinct from language as I could make it."

13. See Annette Michelson, "Paul Sharits and the Critique of Illusionism: An Introduction," in *Projected Images* (Minneapolis: Walker Art Center, 1974), pp. 20–25.

14. Barthes, *Roland Barthes par Roland Barthes*, pp. 150–151.

15. Ibid., p. 162.

16. Field and Sainsbury, "*Zorns Lemma* and *Hapax Legomena*," p. 62.

17. See ibid., pp. 69–71.

18. Émile Benveniste, *Problèmes de linguistique générale* (Paris: Éditions Gallimard, 1966), p. 251 (my translation).

19. Ibid., p. 254.

20. For a discussion of other aspects of this section of *Poetic Justice*, see Annette Michelson, "Time Out of Mind: A Foreword," in Hollis Frampton, *Circles of Confusion* (Rochester: Visual Studies Workshop, 1983), pp. 18–20; reprinted in this volume.

21. Barthes, *Roland Barthes par Roland Barthes*, p. 59.

The Mummy's Return: A Kleinian Film Scenario

My movies are made by God; I was just the medium for them.

—*Harry Smith*[1]

In offering elements for a textual analysis of Harry Smith's epic collage film *The Magic Feature*,[2] I pay tribute to the men responsible for its preservation and dissemination. To them, as well, we owe the first important critical assessment of a work whose visual splendor is grounded in that artisanal mode of production that has sustained the American cinema of independent persuasion. Jonas Mekas and P. Adams Sitney, in their passionate dedication to that cinema in general and to the work of Harry Smith in particular (a dedication resistant to public indifference and to the very caprices of the author himself) retrieved this work for the corpus of the New American Cinema.

It is, moreover, Sitney's assiduous investigation of the sources of Smith's iconography that continues to provide the basis for any reading of this film-text. And we are further indebted to Sitney for something of comparable value: his ability to draw from Smith, in conversation, the phantasmatic construction of a life history. I stress the importance of this

latter element insofar as these extravagant musings demand, in my view, acknowledgment as constitutive, together with Smith's film practice, of a field that must be studied as such. Text and film-text, then, are to be considered, for the purpose of an iconological project, as reciprocally illuminating within a unified field.

My reading, its method, leads me, however, to differ with Sitney in many important respects. For Sitney, whose pioneering account of the cinema of the American avant-garde, *Visionary Film*, first published in 1974, remains a major text within its field of study, *The Magic Feature* is the narrative of a spiritual quest, sharing with the mythopoeic cinema of Stan Brakhage, Kenneth Anger, and Gregory Markopoulos "the theme of the divided being or splintered consciousness which must be reintegrated."[3]

Now this first intuition may appear sound, but only on condition that we examine the ground and nature of that division and splintering. They cannot, I believe, be understood as yet other elements of Romanticism's legacy, within which a drama of spiritual salvation and transcendence is enacted; they must be explicated in terms that are more concrete and more fully explanatory.

Noël Carroll, the other prime exegete of this film-text, has offered a reading wholly antithetical to that of Sitney and equally subject to question. He sees it as an articulation of the epistemology of British empiricism, literalizing John Locke's image of the mind as "a cabinet or closet, full of simple impressions of perception" and David Hume's notion of the mind as "a heap or collection of different perceptions united together by certain relations."[4] If, however, one is to understand this film as a whole, in the full range of its imagery, its pace and rhythm, its parametric construction, its serial repetition and permutational structure, if one is to account for its constantly postponed resolution of action, one requires an approach that is, again, more fully explanatory. One wants, as well, to consider its material aspect as collage animation. And one must confront the manner in which this form, this work, offers the

incessant fragmentation and restoration of the body, of a woman's body, in particular. Moreover, the performance of these assaults and of all other operations is of a magical character, the work of a man of singularly small stature and hyperagility. A homunculus is, in fact, the central, dominant, omnipotent protagonist of the action articulated through apparitions, transformations, and vanishing acts effected by the constant invention, supply, and deployment of magical instruments and weapons. As Smith himself remarked,

> first I collected the pieces out of old catalogues and books and whatever; then made up file cards of all possible combinations of them; then I spent maybe a few months trying to sort the cards into logical order.[5]
>
> All the permutations possible were built up: say there's a hammer in it, and there's a vase, and there's a woman, and there's a dog. Various things could then be done—hammer hits dog; woman hits dog; dog jumps into vase; so forth. It was possible to build up an enormous number of cross references.[6]

If I am led to differ from Sitney's reading of *The Magic Feature*, it is because he accepts Smith's discourse, epitomized in my epigraph, as scripture, so to speak. If it be such, one is bound to further persevere in one's hermeneutic efforts. Both readings heretofore offered confuse, as it were, the order of those principles of exegetical tradition which, deriving from Origen, read scripture through the Platonic topos of body/ soul/spirit, passing from the literal to the allegorical, and thence to the analogical register of faith. It is the median term of allegory—that of the soul which we now term the psyche—that I shall claim as the ground of a coherent reading.

Smith, talking to a group of students in 1971, advised them to look at films as discrete systems of signs, bearing in mind their character as such as against the reality effect of the motion picture. One recognizes

the stress upon the acknowledgment of persistence of vision character-
istic of a generation of American Modernists and salient in the work
and theoretical production of Hollis Frampton, Paul Sharits, Michael
Snow, and Ernie Gehr, among others. Smith, however, presses on: "You
shouldn't be looking at this as a continuity. Film frames," he declares, "are
hieroglyphs, even when they look like actuality. You should think of the
individual film frame, always, as a glyph, and then you'll understand what
cinema is about."[7]

From the time of their insertion into European discourse, Egyptian
hieroglyphs were known, as in John Florio's sixteenth-century definition,
as "mysticall or enigmaticall letters,"[8] a view that persisted into the nine-
teenth century, when they were characterized as sacred writing. And cer-
tainly Smith, in his role as divine instrument, as bearer of a gnosis, enjoins
upon us the attentive reverence owed to the hieroglyphic inscription of
that gnosis. However, we now possess the key to Egyptian hieroglyphic
writing, the Rosetta Stone. And *The Magic Feature*, presumably dictated
by God, presents itself as a mixture of pictures, visual puns, conventional
signs, that is to say, as a rebus for our deciphering. Following Thomas
Carlyle's advice, as offered in *Sartor Resartus*, I shall consequently not pro-
ceed to receive "as literally authentic what was but hieroglyphically so."[9]
It is by now most surely evident that I shall take my cue from the prime
interpreter of the rebus, that my approach, through the median term of
the psyche, is to be psychoanalytic.

Now, recent film theory has been most extensively concerned, in
its highly developed psychoanalytic register, not with the analysis of the
film-text itself but rather with the positioning of the spectator within
cinematic construction. Its work has been grounded largely in Sigmund
Freud's paper, published in 1927, in which the position of the fetishist
is described as one of disavowal. "To put it plainly," Freud writes, "the
fetish is a substitute for the woman's (mother's) phallus which the little
boy once believed in and does not wish to forego—we know why," for if
mother has lost hers, he, too, is subject to that threat of castration.[10] The

child "retains this belief"—in the woman originally endowed with a phallus—"but he also gives it up; during the conflict between the dead-weight of the unwelcome perception and the force of the opposite wish, a compromise is constructed such as is only possible in the realm of unconscious ties of thought—by the primary processes."[11] He knows, but all the same ...

Such then, as claimed by a dominant trend in contemporary film theory, will be the position of the film viewer in relation to the reality effect of cinematic representation.

In the exercise of decipherment to follow, I shall want to shift the psychoanalytic method of inquiry back to the film-text. In so doing, I shall take as my structural model a quotation not from Freud's essay on fetishism but rather from an earlier paper of 1919, entitled "Psycho-analysis and Religious Origins," that I have found helpful and suggestive when confronted with the hermeneutic task posed by singularly complex and enigmatic works:

> A little reflection was bound to show that it would be im-
> possible to restrict to the provinces of dreams and nervous
> disorders a view such as this of the life of the human mind. If
> that view has hit upon a truth, it must apply equally to nor-
> mal mental events, and even the highest achievements of the
> human spirit must bear a demonstrable relation to the factors
> found in pathology—to repression, to the efforts at master-
> ing the unconscious and to the possibilities of satisfying the
> primitive instincts. There was thus an irresistible temptation
> and, indeed, a scientific duty, to apply the research methods
> of psycho-analysis, in regions far remote from its native soil, to
> the various mental sciences. And indeed psycho-analytic work
> upon patients pointed persistently in the direction of this new
> task, for it was obvious that the forms assumed by the different
> neuroses echoed the most highly admired productions of our

culture. Thus hysterics are undoubtedly imaginative artists, even if they express their phantasies *mimetically* in the main and without considering their intelligibility to other people; the ceremonials and prohibitions of obsessional neurotics drive us to suppose that they have created a private religion of their own; and the delusions of paranoics have an unpalatable external similarity and internal kinship to the systems of our philosophers. It is impossible to escape the conclusion that these patients are, in an *asocial* fashion, making the very attempts at solving their conflicts and appeasing their pressing needs which, when they are carried out in a fashion that has binding force for the majority, go by the names of poetry, religion and philosophy.[12]

In following the Freudian model, I shall draw as well upon the theory of object relations formulated and documented for us by Melanie Klein in the psychoanalysis of young children. Klein, stressing the importance of the psyche's developments with the very earliest period of life, radically revised our view of early infancy and its consequences for later development. Given the relative neglect of Kleinian theory within the recent literature of cinema studies, I shall allow myself to retrace its account of the human subject's formation in those aspects that I judge to be pertinent for my project.[13]

The relational aspect of a primordial dyad is fundamental to her analysis of successive positions as the ground of the formation of infantile psychoses. Like D. W. Winnicott, Klein tended to believe that not babies but babies-with-mothers formed the proper object of analysis. Moreover, Klein, in strong opposition to the dominant psychoanalytic thinking, extended the trajectory of the human subject into the earliest stages of existence, laying stress upon anxieties, defenses, and relations as constituting, from earliest infancy on, the crucial factors in the development of two successive infantile positions. The first of these, known as

the paranoid-schizoid position, is operative within the first three to five months of the infant's life. The infant at this earliest stage of development relates to external reality not as a group of "whole objects" (mother, father) but rather as "part objects"—first and foremost, the mother's breast. When present to satisfy the infant's hunger, this part object functions as a "good breast," nourishing and satisfying. When absent during hunger, it acts as a "bad breast," frustrating and denying. It is consequently experienced as dual and persecutory: bent on the annihilation of the infant.

The dynamics of this relatively simple schema are nonetheless complex: the mechanism of "projective identification" is that which allows the object to become a representative of the developing ego—the identification of an object with the hated parts of the self, endowed with qualities of independence. At the same time, the infant introjects the object and its associated qualities, creating within its own psyche an internalized good breast or bad breast. The internal objects, as idealized constructs, become the prototypes of all helpful and gratifying objects, or—as in the case of the bad breast—the prototype of all external, persecutory objects. Such a process of introjection and holding of internal objects corresponds, in Kleinian thought, to the beginning of the formation of the superego. Interestingly enough, however, the splitting of the object necessarily involves concurrent splitting of the ego, as the infant attempts to separate its good and bad objects.

The bad breast comes to possess the oral-sadistic impulses deriving from the infant's own feeling of envy. Destructive phantasies of biting, devouring, and annihilating the breast and the mother's body are prevalent when the infant is in a state of such paranoid anxiety. Later psychosexual stages will bring phantasies constructed about the infant's urethral and anal-sadistic impulses. Throughout, however, consistent defense mechanisms continue to operate—splitting projection/introjection, a hallucinatory phantasy of control over the object (phantasies of omnipotence), and complete denial of the object, expressed by phantasies of annihilation.

I began this schematic exposition of Kleinian theory by remarking that its insistence upon extending the subject's psychoanalytic history back into the very earliest months of infancy met with great resistance, and I now want to stress the extreme hostility it elicited, which continues to this day. This we must understand as generated by the extreme violence of the infantile psyche's psychotic states as described in the theory of object relations. Both precocity and violence were, as we know, derived from and confirmed by Klein's extensive work over several decades in the as yet undeveloped field of the psychoanalysis of children, now shaped, nonetheless, by her pioneering efforts. In that process, she delivered to us a scenario of infantile development whose complex violence does indeed require a considerable adjustment of perspective, even from those already disabused, by Freudian theory, of the idealization of childhood so deeply embedded in our culture.[14]

I now return to the account of infantile development and its analysis of the second, crucial stage: that of the depressive position. Those physiological changes that extend the child's perceptual faculties now render it capable of establishing connections among the part objects of breast, hands, voice, gaze, so as to perceive the mother as a unified whole. The separating of good from bad which produces splitting is reduced, and the infant accedes to the depressive position through a growing awareness that the mother, embodying good and bad, is source of both love and hate, of satisfaction and frustration. It is then that the child comes to believe that it can, through projection of aggressive and destructive phantasies onto the mother, destroy and consequently lose the mother. The depressive anxieties thus generated produce a sense of loss of the good external object, a sense that the infant has, in its destructive phantasies, caused that loss. Good and bad breasts are now seen as the same object. It is this realization, and its consequent anxiety, that generates, in turn, an impulse toward reparation. The infant defends itself against those feelings of loss partly through manic defenses. For, Klein tells us, in describing the mourning that occurs during the depressive state, the ego is driven by

depressive anxiety to build up omnipotent and violent phantasies, partly for the purpose of controlling and mastering the bad and dangerous objects, partly in order to save and restore the loved ones. Omnipotence, denial, and idealization, closely bound up with ambivalence, enable the early ego to assert itself to a certain degree against its internal persecutor and against a perilous dependence upon its loved objects, and thus to make further advances in its relation with its loved objects.

Together with these defenses and in place of these, Klein tells us, the child cultivates what she holds as the primordially significant aspect of the depressive position—reparative tendencies, in which the subject actively seeks to repair the damage (the loss inflicted on the good object), thereby successfully working through the depressive position. Reparation is, however, a complex process, for it involves impulses of control and phantasies of omnipotence, and therefore is closely aligned with sadistic impulses, leading to reintroduction of manic defenses. It is only through *repetition* of reparative tendencies, through reinforcement and successful introjection of strong internal good objects, that the child comes to trust its own constructive bent, and its capacity for love. And this, finally, is of especial importance, for to Klein and to her followers the reparative impulse is the ground of creative action. Confidence in one's reparative powers appears to be important, fundamentally so, for development in general, but, more particularly, it is the generative source of artistic production.

II

Allegory dwells in a palace of transparency.

—*Antoine-Marin Le Mierre*[15]

It is by now surely evident, after this long expository excursus, that what is proposed is a reading of *The Magic Feature* as the representation of an

Harry Smith, *The Magic Feature*, c. 1957–1962.

Harry Smith, *The Magic Feature*, c. 1957–1962.

Harry Smith, *The Magic Feature*, c. 1957–1962.

elaborate working through, in the form of a prodigally generous form of reparation offered by artistic practice, of the spectrum of infantile development through paranoid-schizoid and depressive positions. And our first step toward that reading will entail an account of the initial image of the film, which I note, with more than casual interest and amusement, neither of the exegetes cited above troubled to include in his own reading: that of the homunculus who sets in motion this epic of repeated slaughter and resurrection by introducing (literally carrying onto the screen or scene) the other member of the primordial dyad, whose name we read, as in a rebus: "Mummy." She is dead, embalmed, encased Egyptian-style, imprisoned in her coffin. It is from that initial point on that one is impelled to read *The Magic Feature* as an elaborate articulation by an artist of what has come to be known as the Kleinian scenario of infantile development. It is, of course, the scenario of a horror feature, and the longest running one known to us. For it presents the narrative of the ever-recommencing struggle of the little man, endowed in phantasy with magic powers (of aggression, insemination, destruction, and restoration), constantly engaged in the repetition compulsion of murderous assault upon and fragmentation of Mummy's body and the restoration of its integrity in an act of reparation. To cite Smith:

> Then there's a graveyard scene when the dead are all raised again. What actually happens at the end of the film is everybody's put in a teacup, because all kinds of horrible monsters came out of the graveyard, like animals that folded into one another. Then everyone gets thrown in a teacup which is made out of a head and stirred up. This is the Trip to Heaven and the Return, then the Noah's Ark, then The Raising of the Dead.[16]

Sitney offers the following account of the little man, his actions, and his role:

257

Although Smith has described him as having the same function as the prop-mover in traditional Japanese theater, his continual manipulations in the alchemical context …, coupled with his almost absolute resistance to change when everything else, including the heroine, is under constant metamorphosis, elevates him to the status of a magus. According to the argument of the film, he injects her with a magical potion while she sits in a diabolical dentist's chair. She rises to heaven and becomes fragmented. The "elaborate exposition of the heavenly land" occurs while the magus attempts a series of operations to put her back together. He does not succeed until after they are eaten by the giant head of a man (Max Muller) and they are descending to earth in an elevator. Their arrival coincides with an obscure celebration, seen in scatological imagery (the Great Sewer), in which a climactic recapitulation of the journey blends into an ending which is the exact reversal of the opening shots.[17]

The reference to the "alchemical context" is clarified by reference to the phantasmatic autobiography elicited by Sitney in the interview of Smith previously cited. Additionally and most importantly, that text foregrounds an etiology of infantile aggression and phantasies of omnipotence:

Like I say, my father gave me a blacksmith shop when I was maybe twelve; he told me I should convert lead into gold. He had me build all these things like models of the first Bell telephone, the original electric light bulb, and perform all kinds of historical experiments. I once discovered in the attic of our house all those illuminated documents with hands with eyes in them, all kinds of Masonic deals that belonged to my grand-father. My father said I shouldn't have seen them

and he burned them up immediately. That was the back-
ground for my interest in metaphysics.[18]

I mostly lived with my mother. I performed what might
now be considered sexual acts with her until I was eighteen
or nineteen maybe. No actual insertion or anything, but I
would always get up in the morning and get into bed with
her because she had a long story she would tell me about
someone named Eaky-Peaky. She was a really good story
teller. My posture is derived from trying to be exactly her
height; for she was shorter.[19]

She would leave me in a theater. I saw some good films
there which I wish it was possible to locate again. I saw one,
for example, which was pretty good in which bad children
put caps into the spaghetti at a fancy Italian dinner. (That
was one of the first sound films that I ever saw.) When the
people chewed their spaghetti there was a BAAAKH that was
about all that was on the soundtrack. The mouth would fly
open and false teeth would go across the dinner table and so
forth.[20]

I saw all those Fu Manchu movies; they were some of
my favorites. There was also some serial that had a great big
spider about the size of this room, which would be chasing
Pearl White down through tunnels. That thing scared the
shit out of me, but I probably had erections during it, it was
so terrifying. I was very interested in spiders at about the age
of five.[21]

Klein, in characterizing infantile sexuality between the ages of
three and five, tells us that it is in this phase that we can locate the origin
of the unconscious equation of breast, penis, feces, child. The infant's
phantasies at the polymorphous stage of instinctual development, when
excitations form all bodily zones, and libidinal and destructive aims rival

one another, produce the theory of parental intercourse as a feeding or an excretory act, of conception through the mouth and birth through the anus: in them are superimposed oral, excretory, and procreative urges and phantasies. And, indeed, the film's little man alternates his destructive acts with a spectrum of actions of insemination of the maternal figure. Adolescence normally shows the reemergence of early infantile sexuality. When the adolescent in horror turns away from his impulses, it is not only because he discovers his incestuous object choice, the wish to sleep with his mother, but also because he becomes aware that he is attracted and excited by perverse and cruel phantasies.

Textual analysis of *The Magic Feature* requires, however, the unveiling, as it were, of the scenario's third leading actor, for the Baby/Mummy dyad is, of course, extended into a trio, completed by Daddy. Our scenario's Baby, is, naturally, a homunculus, or little man, formed in Daddy's very image and wielding that same powerful instrument as Daddy, the secret of his power over both Mummy and Baby, and over all things in general. Represented by syringe or by hammer, it is the instrument of destruction, vivification, transformation; it is magical, the source of the homunculus's omnipotence.

But the homunculus of *The Magic Feature*, this protagonist of the Kleinian scenario, is not just any anonymous little man; he is a very particular one. Mummy's chic and dainty avatars have been culled from the nineteenth-century fashion plates of *Godey's Lady's Book*, cut, dismembered, placed on pedestals, encased, entombed, revived, framed, and elevated. But the homunculus is taken from the illustrations for the volume *Kallipädie* (1858)—the subtitle of which translates, in part, as *Education to Beauty through Natural and Symmetrical Promotion of Normal Body Growth, Functional Health, and Mental Refinement*—by Dr. Daniel Gottlob Moritz Schreber.[22] This celebrated German pedagogue of an earlier century has now receded into the past, eclipsed by the celebrity of his son, Daniel Paul Schreber (1842–1911), the presiding judge of a division of the court of appeal in Dresden, whose *Denkwürdigkeiten eines*

Nervenkranken, or *Memoirs of a Mental Patient,* first published in Leipzig in 1903, narrated in great detail his stays in various mental institutions as well as the excruciating periods of disturbance that preceded them.[23] These crises were described with a candor that led the Schreber family to buy up and destroy the book after publication. The few copies that remained attracted, as we know, considerable and enduring interest in psychiatric circles. One of these copies came into Freud's possession in Vienna, in 1910; the eventual result was Freud's penetrating analysis of the case, published in 1911, the only major case study he undertook and published without direct contact with the patient, on the basis of this admittedly abundant documentary evidence.[24] Generally considered a seminal text, and the forerunner of numerous related studies in the area of paranoia, Freud's analysis has, since the 1970s, been subject to a widespread renewal of interest and to intensive revision of approach to the case. I shall in what follows draw upon the pioneering work of William G. Niederland, whose investigation extends to analysis of Schreber's family history and research into the father's biography.[25]

Schreber's long phantasmatic narrative presents all the density of and obsession with detail and all the "invented logic" that characterize the discourse of the paranoiac. Schreber invents special terminology, which he calls *Grundsprache* ("ground language" or "root language") and which he attributes to God or to divine rays emanating from God. These were the means of communication between himself and the divine source of his mission.

His delusional system, as revealed in the *Memoirs,* has been summarized *briefly* by Niederland as follows:

He felt he had a mission to redeem the world and to restore it to its lost state of bliss.

This mission must be preceded by the destruction of the world and by his personal transformation into a woman.

Ancestral Reality	Delusional Formations
Grandfather Johann GOTThilf Daniel Schreber	Abraham FürchteGOTT
Father Daniel GOTTlieb Moritz Schreber	Daniel FürchteGOTT
Patient Daniel Paul Schreber	
Physician Paul THEOdor Flechsig	Administrator of GOD in Germany
	SUN Flechsig
	SOUL Flechsig
	GOD Flechsig

Daniel Paul Schreber's delusional use of the presence of God in personal names for the deification of his ancestors and his physician. From William G. Niederland, *The Schreber Case: Psycho-analytic Profile of a Paranoid Personality* (New York: Quadrangle/New York Times, 1974), p. 47.

Transformed into a female, he—Schreber, now a woman—would become God's mate, and out of such union a better and healthier race of men would emerge.[26]

Schreber, whose sleep depended "totally on the celestial constellations," claimed: "A *force of attraction* emanating ... from [my] single human body over such enormous distances ... may appear quite absurd. Nonetheless, the action of the force attraction is a fact that for me is absolutely unquestionable."[27]

He, Schreber, was awakened by rays to a new heavenly life, "a *state of bliss* ... for God ... only pure human nerves were usable, because they were destined to become attached to God himself and finally to turn into parts of God as 'forecourts of heaven,'"[28] as he termed them.

A male state of bliss occupied (Schreber speaking) an even "higher level than the female state of bliss; the latter seems to have consisted of an uninterrupted sensation" that "it was the ultimate goal of all souls, merged with other souls, to coalesce into higher entities and to feel themselves as parts of God ('forecourts of heaven')."[29]

Schreber's discourse on the omniscience and omnipresence of God stresses, as well, the importance of the connection, preestablished, in his view, more than a century before, between the names of Flechsig, his doctor, and Schreber—a connection that was not, as we shall see, limited to himself as a merely individual member of one of those families.[30]

The undergoing, at the hands of the doctor, of a "soul murder" is woven into the narrative of Schreber's feminization, a process involving unutterable pain and issuing in ecstatic surrender. Schreber eventually developed the delusion that he actually was a woman, declaring that he had the breasts of a woman and experienced the "soul voluptuousness" of a female being. He was, in fact, "the last real person left," whereas others, including Dr. Paul Emil Flechsig, attendants, and other patients were merely "miracled-up," cursorily sketched, many-headed little men.[31] We know that Freud was particularly interested in the psychopathological

process that led or ascended from Flechsig, Schreber's persecutory physician, to the figure of God. A partial family tree shows the various steps in the production of the delusional system that culminates in the Flechsig-father-God identification. The diagram shows the patient's delusional use of the presence of *Gott* (God) in his father's and grandfather's names and of *Theo* (the Greek root meaning "God") in his physician's name.[32] It presents, we are told, the linguistic basis for the deification of the ancestors and, via psychotic transference, of Flechsig. It also illustrates Schreber's statement: "I have parts of their souls in my body." Freud analyzed the patient's psychotic thought process as an "attempt at restitution." One of the characteristic manifestations of this attempt consists of an effort to regain lost libidinal objects by reinforcing the cathexis of the verbal representations standing for the lost objects. The outstanding libidinal object in Schreber's case was the father. The verbal representation of his father—his given name, Daniel Gottlob—is recathected, and in all the variations of the delusional names, "God" (*Gott* or *Theo*) occurs. *Fürchtegott* (fear God) is of especial interest, revealing the patient's ambivalence, his fear of God as well as the threat he addresses to God. And the patient, as we see, shared the name of Daniel with his father and the name of Paul with his physician.[33] Considering the photographic portrait of Flechsig installed behind his desk, with the contextual confirmation of his professional capacity and status, the huge map of his domain of sovereignty, the brain, one wonders, indeed, how his patient could not take him for that omniscient, omnipotent object of veneration and of fear?[34] Benefiting from Niederland's research offering a more precise identification of the father figure in the case, we learn that Dr. Daniel Gottlob Moritz Schreber (1808–1861) was a celebrated social, medical, and educational reformer, who taught in the medical school of the Universität Leipzig. He wrote and published close to twenty books on health and pediatric care. He was described in his obituary as "physician, teacher, nutritionist, anthropologist, therapeutic gymnast and athlete, and above all as man of action, of tremendous enthusiasm and endurance."[35]

Kopfhalter and its use. From Daniel Gottlob Moritz Schreber, *Kallipädie; oder, Erziehung zur Schönheit* ... (Leipzig: Friedrich Fleischer, 1858), figs. 71, 72.

Among the twenty books mentioned was the *Kallipädie*, the popular guidebook for parents and educators, which after his death was reissued, in expanded form, as *Das Buch der Erziehung an Leib und Seele* (Book for the education of body and soul). And it was an especial and important point of pride with Dr. Schreber that his methods, theoretically derived, were, nevertheless, "regularly, actively, and personally applied by him in the rearing of his own children."[36] His educational system, as set forth to his readership of parents and educators, was based on the application of firm discipline, control, pressure, in the expectation that an early discipline will establish, in the malleable years of childhood, a moral discipline and a physical, muscular control that will ensure bodily health and mental soundness. He invented for this system a set of exercises and physical controls that were to be applied to children and were certainly applied to his own children, including young Daniel Paul. He seems to have been particularly concerned about the development of upright, straight posture.[37] In this he was not alone, certainly, in Germany, but he was singular in his construction of varied and elaborate apparatuses for the training in question, as illustrated by his recommendations for application of the following elements of his orthopedic apparatus:

> *Geradhalter* (upright brace) designed to ensure a rigidly erect sitting posture.
> *Kopfhalter* (head belt) designed to correct the alignment of the jaws.
> Braces designed to straighten the legs.
> Apparatus designed to maintain perfect posture in sleep.

The pedagogue's *pangymnastikon* offered an entire gymnastic system condensed into one apparatus—consisting of two large rings suspended from the ceiling—the construction and application of which are described in his book of the same name.[38] This device, ensuring that all gymnastic exercises were brought within the compass of a single piece of equipment, was viewed as the simplest means for achieving the fullest development of muscular strength and endurance.[39]

Apparatus for maintaining perfect posture while asleep, and its use. From Daniel Gottlob Moritz Schreber, *Kallipädie; oder, Erziehung zur Schönheit* … (Leipzig: Friedrich Fleischer, 1858), figs. 25, 26.

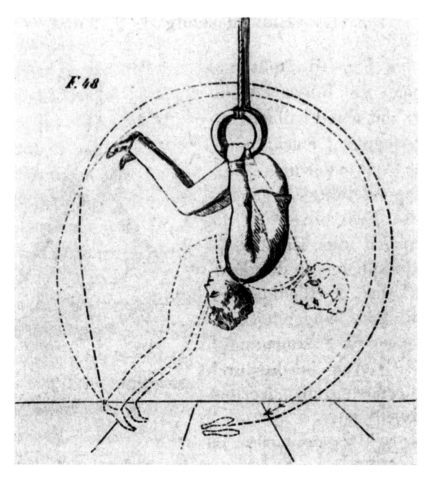

Exercise on the *pangymnastikon: Umschlag mit Auffussen* (Turn over with kick). From Daniel Gottlob Moritz Schreber, *Das Pangymnastikon; oder, Das ganze Turnsystem an einem einzigen Geräthe ohne Raumerforderniss ...* (Leipzig: Friedrich Fleischer, 1875), fig. 48.

It is from this book's set of illustrations, no doubt, that Schreber derived his own images of cursorily sketched little men with multiple heads.[40] And indeed, Schreber's entire delusional system can be seen as the projection of the system of constraints imposed upon the body and the psyche of the child of this extraordinary, totally controlling, Godlike father. As Schreber put it, "a miracle *directs the movements of my eyes*. I have not mentioned this miracle before, but it has been regularly enacted for years. Rays [father], after all, want constantly to see what pleases them. ... My eye muscles are therefore influenced to move in that direction toward which my glance *must* fall on things just created or else on a female being."[41]

Although an iconological study of *The Magic Feature* hardly requires that we situate the operation of the family triad more exactly within its text, we will want, however, to recall that Smith received, at the age of puberty, the command from his own father, of a task impossible to fulfill: "You must perform that magic feat which no one in the history of the world has yet performed: the conversion of lead into gold." (And Smith, in a spontaneous articulation of the accepted relation between gold and stool, speaks of his works as "excreta.")[42] Smith has offered us, in the visual splendor of his magic feature, the reparative offering in which the grief and anger of infantile psychosis are rehearsed and resolved. Out of the existing body of nineteenth-century illustration he cut, tore, then restored by collage and montage the turbulent saga of a passage from schizoid paranoia to depression. Smith's claim that his films were made by a force speaking through him has only to be translated from the rhetoric of transcendence. It was the force of the little man, the homunculus, acting through him that converted that grief, that anger, those leaden directives of fashion and of pedagogic control into the reparative gold of *The Magic Feature*.

NOTES

First published in *Meaning in the Visual Arts: Views from the Outside: A Centennial Commemoration of Erwin Panofsky (1892–1968)*, ed. Irving Lavin (Princeton, N.J.: Princeton University Press, 1995), pp. 335–350, and slightly revised for publication in *Harry Smith: The Avant-Garde in the American Vernacular*, ed. Andrew Perchuk and Rani Singh (Los Angeles: Getty Research Institute, 2010), pp. 85–101.

1. See, for instance, Harry Smith, book page doodle, ca. 1970; reproduced in *American Magus Harry Smith: A Modern Alchemist*, ed. Paola Igliori (New York: Inanout, 1996), p. 2.

2. The alternate title for this work is *Film #12: Heaven and Earth Magic.*

3. For a comprehensive survey and interpretation of Smith's oeuvre, see P. Adams Sitney, *Visionary Film: The American Avant-Garde* (New York: Oxford University Press, 1974), pp. 270–300; *The Magic Feature* is described on pp. 287–299.

4. Noël Carroll, "Mind, Medium and Metaphor in Harry Smith's *Heaven and Earth Magic*," *Film Quarterly* 31, no. 2 (1977–1978): 39.

5. Harry Smith, "Harry Smith Interview," interview by P. Adams Sitney, *Film Culture* 37 (Summer 1965): 11; cited in Sitney, *Visionary Film*, p. 287, n. 3.

6. Smith, "Harry Smith Interview," 10, n. 5; cited in Sitney, *Visionary Film*, 294, n. 3.

7. Harry Smith in 1971; as cited in Sitney, *Visionary Film*, p. 299, n. 3.

8. John Florio, *A Worlds of Wordes; or, Most Copious, and Exact Dictionarie in Italien and English* (London: printed by Arnold Hatfield for Edw. Blount, 1598), p. 146, s.v. "geroglifico."

9. Thomas Carlyle, *Sartor Resartus: The Life and Opinions of Herr Teufelsdröckh*, rev. ed. (Boston: James Munroe, 1840), p. 205.

10. Sigmund Freud, "Fetishism" (1927), trans. Joan Riviere, in *Collected Papers*, vol. 5, *Miscellaneous Papers, 1888–1938*, ed. James Strachey (New York: Basic Books, 1959), p. 199.

11. Ibid., p. 200, n. 10.

12. See Sigmund Freud, "Psycho-analysis and Religious Origins" (1919), trans. James Strachey in *Collected Papers*, vol. 5, p. 94. For a demonstration of its explanatory power in the construction of the semiotics of the oeuvre of Marcel Duchamp, see my "Anemic Cinema: Reflections on an Emblematic Work," *Artforum* 12, no. 2 (October 1973): 64–69; reprinted in this volume.

13. For the following exposition of Kleinian theory, I have drawn upon Melanie Klein, *Contributions to Psycho-analysis, 1921–1945* (New York: McGraw-Hill, 1964); and Melanie Klein, *Envy and Gratitude and Other Works, 1946–1963* (New York: Dell, 1977).

14. A recent example would be the extraordinary statement by Sally Mann, the remarkable photographer of children whose work has been the subject of much critical debate: "I think childhood sexuality is an oxymoron"; cited in Richard B. Woodward, "The Disturbing Photography of Sally Mann," *New York Times Magazine*, September 27, 1992, p. 52.

15. Antoine-Marin Le Mierre, *La peinture: Poéme en trois chants* (Paris: Le Jay, 1769), p. 60: "L'allégorie habite un palais diaphane."

16. For this description and that of the larger conception and realization of *The Magic Feature*, see Smith, "Harry Smith Interview," p. 10.

17. Sitney, *Visionary Film*, p. 292.

18. Smith, "Harry Smith Interview," p. 5.

19. Ibid., p. 6.

20. Ibid.

21. Ibid., p. 7.

22. Daniel Gottlob Moritz Schreber, *Kallipädie; oder, Erziehung zur Schönheit durch naturgetreue und gleichmässige Förderung normaler Körperbildung, lebenstüchtiger Gesundheit und geistiger Veredelung und insbesondere durch möglichste Benutzung specieller Erziehungsmittel: Für Aeltern, Erzieher und Lehrer* (Leipzig: Friedrich Fleischer, 1858). Note that various authors (including Freud and Niederland) and other authorities mistakenly spell his second given name as "Gottlieb."

23. Daniel Paul Schreber, *Denkwürdigkeiten eines Nervenkranken: Nebst Nachträgen und einem Anhang über die Frage: "Unter welchen Voraussetzungen darf eine für geisteskrank erachtete Person gegen ihren erklärten Willen in einer Heilanstalt festgehalten werden?"* (Leipzig: O. Mutze, 1903).

24. See Sigmund Freud, "Psychoanalytic Notes upon an Autobiographical Account of a Case of Paranoia (*Dementia Paranoides*)" (1911), in *Three Case Histories*, ed. Philip Rieff (New York: Collier, 1966), pp. 103–186.

25. William G. Niederland, *The Schreber Case: Psycho-analytic Profile of a Paranoid Personality* (New York: Quadrangle/New York Times, 1974). For quotations from Schreber's text, I have drawn upon the translations in Niederland. For an English translation of the entire text, see Daniel Paul Schreber, *Memoirs of My Nervous Illness*, trans. Ida Macalpine and Richard A. Hunter (London: Wm. Dawson, 1955).

26. Niederland, *The Schreber Case*, p. 10.

27. Schreber, as translated in ibid., pp. 18, 11.

28. Schreber, as translated in ibid., p. 11.

29. Schreber, as translated in ibid., pp. 11–12.

30. Niederland, *The Schreber Case*, p. 12.

31. Ibid., pp. 16–17, 44–45.

32. "Paul Theodor" was a delusional construct too, apparently, as the doctor's given names were "Paul Emil." See Schreber, *Denkwürdigkeiten*, pp. 23–25.

33. Niederland, *The Schreber Case*, pp. 46–47.

34. See ibid., pp. 29, 105.

35. Ibid., pp. 49–50.

36. Ibid., p. 50.

37. Ibid., pp. 50–51.

38. Daniel Gottlob Moritz Schreber, *Das Pangymnastikon; oder, Das ganze Turnsystem an einem einzigen Geräthe ohne Raumerforderniss ... für Schulanstalten, Haus-Turner und Turnvereine* (Leipzig: Friedrich Fleischer, 1862). Three editions of the English language translation of this work were published that same year by Ticknor and Fields in Boston in Dio Lewis, *The New Gymnastics for Men, Women, and Children, with a Translation of Prof. Kloss's Dumb-bell Instructor and Prof. Schreber's Pangymnastikon*, with over twenty editions to follow.

39. Niederland, *The Schreber Case*, p. 51.

40. Ibid., pp. 94–95.

41. Ibid., p. 79 (brackets in Niederland's text; italics in Niederland's text and Schreber's original).

42. Cited in Smith, "Harry Smith Interview," p. 5. The reference to "my cinematic excreta" opens the detailed description of his films that Smith prepared for the *Film-Makers' Cooperative Catalogue No. 3* (1965), p. 57.

SOLVING THE PUZZLE: MARTHA ROSLER

"The familiar is not necessarily the known," said Hegel. Let us go further and say that it is in the most familiar things that the unknown—not the mysterious—is at its richest, and that this rich content of life is still beyond our darkling consciousness, inhabited as it is by imposters and gorged with the forms of Pure Reason, with myths and their illusory poetry.

—*Henri Lefebvre,* The Production of Space

FIRMINY

In 1993, Martha Rosler was invited to join a group, internationally composed, of forty artists in reflection on and documentation of a major housing project, the last and largest of Le Corbusier's Unités d'Habitation, completed in 1967, two years after his death. Their work was to form an exhibition, conceived and curated by Yves Aupetitallot, presenting their individual views of a project that had become the focus of intense debate and struggle. Within and around its precincts, since accorded the status of an officially designated monument, a drama of utopian theory and social

praxis had been played out with results and implications that were drastic for its inhabitants and more generally of concern to a wide range of economists, urban planners and developers, architects and social theorists.

Firminy, the small town near the mining center of Saint-Étienne in central France, once the site of developmental ambition, had not fulfilled the hopes and promise of the previous decade. This Unité had been designed as part of a larger plan for development of the hillside on which it was set. The plans for housing included a school and a church. Launched by its liberal mayor, Eugène Claudius-Petit, with the hope of attracting industrial production that would provide employment for a depressed mining community, the project did not elicit the anticipated response, and the change of administration that came with new local elections initiated debates as to the future viability of the Unité. Rosler's response to the curatorial invitation took the form of documentation in a video work: *How Do We Know What Home Looks Like? The Unité d'Habitation de Le Corbusier at Firminy, France* (1993). At the time of shooting, the northern half of the project had been closed for about ten years. The group commission was the occasion for a critical reappraisal of Le Corbusier's project, and of the notion of large, low-cost housing projects altogether.

In 1965 Jean-Luc Godard had begun his meditation on the urban development then taking off in France. It was to culminate in two films that were exactly contemporary with the construction of Firminy's Unité d'Habitation: *Alphaville* (1965) and *Deux ou trois choses que je sais d'elle* (*Two or Three Things I Know about Her*, 1967). In the first of these works, his densely structured allegorization of a future already inscribed within the present was extended to both the location in which it was shot—a Paris moving, as Godard saw it, toward the desolate future of cultural and social deep freeze—and to its very language. Speeding through the "outer regions" of the City of Dreadful Night that this Paris has become, the protagonist's guide (Eurydice) explains to him that the large stretches of building passed en route to the Center are *hôpitaux des longues maladies*

Martha Rosler, *How Do We Know What Home Looks Like? The Unité d'Habitation de Le Corbusier at Firminy, France*, 1993. Courtesy the artist and Mitchell-Innes & Nash, New York.

(hospitals for incurable diseases), a very play on the *Habitations à loyer modique* (low-cost housing projects) known as the HLMs, construction of which had begun in the late 1950s in an effort to solve the housing crisis of the postwar period, the gravest of the century. An entire emerging generation of young adults was condemned to two decades of life in cramped and shabby hotel rooms or servants' quarters, to the cuisine of the Bunsen burner, and the personal hygiene of the public bath.

In the second of these two films, Godard resumed and extended the thematics of prostitution[1] that were to become central to his filmic enterprise: locating its generalized practice within the structure of the HLM as necessarily and radically emblematic of the condition of the consumerist dynamic of French capitalism's accelerated drive toward modernization through hyperindustrialization.

The struggle to maintain the Unité of Firminy, the attachment of its remaining inhabitants to the ideas of a large, communally conceived project, are documented in Rosler's exploration of both the abandoned apartments and the remaining inhabited quarters of the project. Her documentation of the empty apartments—of the modest decoration of their poster-filled walls[2]—precedes a tour of the halls and corridors that provided play spaces and tricycle paths for children, her interviews with tenants—with mothers and children, with activists fighting to maintain the life of the Unité.

To outsiders, such as many of the artists commissioned, the project appeared constraining in a number of ways, and most certainly acoustically oppressive in its lack of soundproofing. Listening, one recalls the savage attack on Le Corbusier launched from the Left by the Lettrist International, which began with the following invocation:

> In these times of growing repression, there lives a singularly repellent man, of clearly more than average cop mentality. He builds cells that are housing units, he builds a capital for

Martha Rosler, *How Do We Know What Home Looks Like? The Unité d'Habitation de Le Corbusier at Firminy, France*, 1993. Courtesy the artist and Mitchell-Innes & Nash, New York.

the Nepalese; he builds vertical ghettos, morgues for an age
that puts them to good use, *he builds churches*.

The Protestant modulor, the neo-cubist dauber runs
"the machine for living" for the greater glory of that God
who has created corpses and corbusiers in his own image.[3]

And Henri Lefebvre had observed, somewhat more temperately,
that "it is arguable, for instance, that Frank Lloyd Wright endorsed a
communitarian representational space deriving from a biblical and Prot-
estant tradition, whereas Le Corbusier was working towards a technicist,
scientific and intellectualized space," which is to say an abstract space.[4]
Lefebvre, whose meditation on urban planning was undertaken in the
immediate aftermath of World War II, had gone on to offer a critique
of Modernist architecture's "abstract space" as a "tool of domination."[5]

To the tenants of Firminy, however, *l'Unité* appears to be, generally
if not entirely, a place of comfort and community. And it is the context
of the housing shortage into which this generation had first emerged
into maturity that must be kept in mind. To none of those interviewed
by Rosler did it seem truly oppressive. The sense of constraint, when
expressed, was tempered by a certain pride in the nature and prestige of
the project, expressed in two touching forms of testimony, among others:
a striking inscription among the graffiti: *Nous aimons vivre au Corbu* ("We
like living in the Corbu") and the refutation by one woman of the accu-
sation of "terrorism" leveled against Le Corbusier: rather, he "prevents
you from consuming like idiots." One gathers, moreover, that the sense
of community had been reinforced by the common struggle to preserve
their homes.

Rosler's work on Firminy appears, at first viewing, neither typi-
cal nor representative of the full scope of her enterprise. In this tape
she is silent, neither performer nor narrator. It lacks the frontally shot,
discursive address to the viewer; it does not have the openly and admit-
tedly didactic character of her videography. Its rather unusual soundtrack

opens with fragments of Satie's score for *Mercure* (1924).[6] I shall want, however, to claim that this somewhat eccentric work does nonetheless provide one with a fresh and feasible path of entry into Rosler's efforts as a whole, that its documentation of a struggle for the preservation of conditions of possibility for community issues from a sense of an unachieved totality that informs her enterprise. I understand this sense as a center, the axis about which her work revolves, and shall try to indicate some of the ways in which those conditions of possibility are articulated through a critique that establishes the continuum, the network of interpenetration between the facts of the individual quotidian, the domestic, and the issues of international capital in crisis.

THE FOOD CHAIN

Rosler's work first gained attention in the 1970s through its especially forceful presentation, in both performance and videomaking, of a feminist thematics of the period: domestic servitude, anorexia, the especial demands and constraints imposed upon women through the dynamics of the fetishism of commodities. The intensity of an informing rage, heightened by the strength of her own presence as performer, was very quickly transformed into the analytic sharpness of attack, a thinking through of the sources and the dynamics of domination.

Between 1974 and 1977 she produced three works that we might group under a rubric that I shall call "The Food Chain": *A Budding Gourmet* (1974), *Semiotics of the Kitchen* (1975), and *Losing* (1977). The axis around which these works turn is that of consumption of food and the way in which it engages, metonymically and metaphorically, varied registers of feminist protest and claim. The work of 1975, although offered as an exercise in semiotics, has rather the form of a lexicon. It does not involve the order, the diachronic and synchronic axes, along which a "system of objects" or utensils might be employed, nor does it establish a functional syntax. Rather, Rosler presents a lexicon of cooking utensils,

recited in alphabetical order and in frontal position in the manner of a store demonstration or television program. But this is a demonstration with a difference, that of utensils as instruments of domestic servitude, each one converted by the force of the presenter's gesture and demeanor into an instrument of aggression.

Rosler was from the first, however, concerned with the fuller range of repression, with the manner in which a critique of everyday life within capitalism, of the fetishism pervading every register of existence within the capitalist social formation, can be seen as part of a continuum involving the larger spectrum of repression of needs, wants, desires. Thus, for example, *A Budding Gourmet* is the mercilessly witty bourgeois housewife's monologue on "self-enhancement" and upward mobility through consumption of "the finer things of life," through the consumption of foreign and exotic cuisine. The notion, advanced by the speaker, of the chef as analogous to the orchestra conductor heightens the sense of an enabling class distinction, and of cuisine as a pathway to social mobility. Here in this parable on colonialism as ingurgitation, the *bourgeoise* sees herself as the possessor of a truly international culture, as a citizen of the world. A discourse of cultural bulimia presented as a policy of "creativity"[7] celebrates the manner in which "in the USA we can take the best of all times and places and make them our own."

Losing: A Conversation with the Parents is the scripted performance by professional actors of the work of mourning for a dead, anorexic daughter.[8] One might say that *Semiotics of the Kitchen* forms a mean register of discourse between *A Budding Gourmet* and *Losing*. The anorexic child, who had been in all respects "perfectly normal," well brought up, and "eager to please," and the culturally bulimic housewife define the limits of woman's servitude within which both self-imposed privation and excess of appetite must be seen in relation to a hungering elsewhere, that of mass famine in what is known as the Third World.

Losing is cast in the form of conversation similar to that of an interview or counseling session. The picture of the dead girl projected is one

of the adolescent, instructed by the media in the requirements of the canon of beauty as to height and weight, not, like her brother, "pushed" by parental ambition into a college education, eager to please, envisioning a possible future as a photographic model (pleasing as profession), and no doubt convinced, like her parents, that "every goal in life involves some sacrifice." It does occur to the bereaved and mourning protagonists that feminine rage, unlike that of the adolescent boy, may be projected against the self, that the criteria of ideal femininity involving standards of weight and height as defined and propagated by the media might serve as conditions of possibility for the self-inflicted deadly dialectic of bulimia and anorexia.

And it is borne in upon one that if food and its deprivation can figure as a self-inflicted weapon, then we must, indeed, consider its aggressive potential in other contexts: that of the politically motivated hunger strike, or that of a politics of deprivation, as directed, for example, through the restriction of a diet of 300 calories a day of the Jews of the Warsaw ghetto. And there is finally the concrete and drastic sense in which hunger is a massively deployed political weapon in the subjugation of whole populations through starvation.

DISMEMBERMENT

It is this sense of the manner in which an issue whose consideration originates in the local requires extension to the analysis of its further, more general implications that characterizes Rosler's method. As we shall see, it is the woman's body as site of domination from which the larger, fuller range of domination emerges clear to the view. And central to the way in which Rosler develops the theme of the woman's body as the site of domination is what we might term its *dismemberment*, the multiple procedures by which representation of the female body is defined as composed of parts. This violation of the living body's experience of itself as a whole entity is the core and the foundation of the problematic

Martha Rosler, *Vital Statistics of a Citizen, Simply Obtained*, 1977. Courtesy the artist and Mitchell–Innes & Nash, New York.

of fragmentation/totality that runs through her work, and it leads, in a manner characteristic of her method, to the analysis of the quotidian as implicated in the larger fetishistic determinations of human agency and condition within the capitalist social formation.

One divines this thinking behind the inquiry into the idealizing analytic of the body that impels the adolescent's mortal struggle to conform to the standards of fashion. Rosler's most developed inquiry is, however, *Vital Statistics of a Citizen, Simply Obtained* (1977). This complex and major tripartite work has been excellently described and analyzed by Amy Taubin with a meticulousness that befits the structure and texture of the obsessive character of its theme.[9] I shall therefore confine my remarks to a few of its salient conceptual aspects. The video centers on presentation of the technique of measurement as applied to the woman's body *in its every part*, down to the joints of fingers and toes. (That this obsessive preoccupation with the female body is not limited to our single culture we know from the description of the cleansing and purification of women as required and performed in the ritual bath of the *mikveh* within the Jewish Orthodox tradition. This procedure, following the menstrual period, entails the cleansing and inspection of every part and orifice.)

In *Vital Statistics* we find the development of Rosler's premises and the guiding principles of analysis: the notion of measurement as informative of a truth of the self, the imposition of measurement as technique of normalization and subjection, the subject's internalization of imposed standards.

The contexts, implications, and concrete results of these premises involve the questioning of testing procedures and the training of individuals to conform to places and positions decreed as proper, of the socialization and integration of working populations within the framework decreed by the scientificity of design and of planning.

Since the process requires that the female subject internalize the processes involved in domination, she "learns to think of her body as having parts." Here we touch on a conceptual root of Rosler's work:

the awareness of a fracturing that begins with a body in pieces, with the loss of a sense of intimate wholeness of the body, and extends to the fracturing of the social body. It is, in fact, the technique of domination that requires and forces, on every parameter of existence, the fracturing of the sense of wholeness. The subjection of women—a multicultural phenomenon indeed—is characterized by Rosler through a long litany of its forms; it includes, among many others, immolation, infibulation, clitoridectomy, prostitution, slavery, sterilization, illegal abortion. And in *Vital Statistics*, we can indeed follow the working of a strategy of radical dismemberment of the female body through measurement that becomes increasingly prevalent in the dissemination by the print and electronic media. Henri Lefebvre has remarked that in the space of abstraction "an anaphorization occurs that transforms the body by transporting it outside itself and into the ideal/visual realm." It is there that we also encounter a strange "substitution":

> The space where this substitution occurs, where nature is replaced by cold abstraction and by the absence of pleasure, is the mental space of castration (at once imaginary and real, symbolic and concrete): the space of a metaphorization whereby the image of the woman supplants the woman herself, whereby her body is fragmented, desire shattered, and life explodes into a thousand pieces. Over abstract space reigns phallic solitude and the self-destruction of desire. The presentation of sex thus takes the place of sex itself, while the apologetic term "sexuality" serves to cover up this mechanism of devaluation. ...
>
> Confined by the abstraction of a space broken down into specialized locations, the body itself is pulverized. The body as represented by the images of advertising (where the legs stand for stockings, the breasts for bras, the face for makeup, etc.) serves to fragment desire and doom it to anx-

ious frustration, to the nonsatisfaction of local needs. In abstract space, and wherever its influence is felt, the demise of the body has a dual character, for it is at once symbolic and concrete: concrete, as a result of the aggression to which the body is subject; symbolic on account of the fragmentation of the body's living unity. This is especially true of the female body, as transformed into exchange value, into a sign of the commodity and indeed into a commodity per se.[10]

Thus, the protagonist of Godard's *A Married Woman* (1964) has indeed internalized the sort of standards portrayed in *Vital Statistics* as she measures her breasts (and their distance from each other) against the norms provided by the magazines and billboards that had increasingly come to dominate the images of the Fifth Republic, even as her lover keeps count, with a pedometer, of his ambulatory mileage.

THE PUZZLE

Born to Be Sold: Martha Rosler Reads the Strange Case of Baby S/M (1988) is Rosler's vivid and trenchant analysis of the overdetermination of surrogate pregnancy's most highly publicized case history. This is an analysis that, through a videographic collage of TV documentation, interviews, and performance by Rosler, whose satiric intensity recalls the style of American television's celebrated program *Saturday Night Live*, does justice to the complexity of a problematic that compounds issues of gender and class. The battle waged around the womb for hire generates further consideration of the concentration upon body parts and the way in which they produce "a vision of the world as made up of incommensurabilities, a puzzle whose pieces can't fit together to make a whole." This mystified belief will, of course, most generally and effectively impede analysis of conflicts of class, race, and gender, and it will block efforts to resolve or eliminate them. Recognition of this and of a body in pieces as the locus of domination has

implications whose analysis provides the force and the especial clarity of Rosler's work, haunted throughout by a vision of totality.

The works on tape which I select as illustrative in this regard (others are possible) span two decades of Rosler's production: *Domination and the Everyday* (1978) and *Chile on the Road to NAFTA, Accompanied by the National Police Band* (1997). As this volume goes to press [1998], we commemorate the defeat in Chile of the progressive Allende regime by the fascist coup d'état of 1973. *Chile on the Road to NAFTA*, made twenty-four years later, offers the image of a pacified populace as audience at a public concert of a medley of John Williams's *Star Wars* suite, offered by the Police Band, to the music of which a small boy in shorts, son of a band member, dances. And the image track cuts repeatedly to the lone salience along the highway to Chile: the emblem of economic and political hegemony, the monumentally scaled arm and hand grasping the ubiquitous Coca-Cola bottle. The role of the United States in the coup of '73, its complicity with the insurgent forces of fascism supported by an international bourgeoisie, had been documented in detail by Patricio Guzmán's film *The Battle of Chile* (1978). Rosler evokes the passing of the "Free Trade" Act under the Clinton administration, and of the United States' projected relocation of industry to areas of "cheap labor" that was contested by the American labor movement. It is emblematized, as it were, by the scale and dynamism of the horrific object emerging from the flat terrain of the highway along which the car-mounted camera travels to reach the performance in the heart of Chile.

Domination and the Everyday, made almost two decades before, which is to say, in the immediate wake of the fascist coup, is in its form a literalization of the intersection, or rather the conjunction, of the political and the everyday. Its structure is one of a thoroughgoing superimposition, on image and soundtrack, of three parameters: that of the image track, involving continuity of textual analysis, and two-track sound, involving a radio or TV interview with the director of an art gallery and the dialogue of mother and child involved in the chatter of daily routine. The acoustic

Martha Rosler, *Domination and the Everyday*, 1978. Courtesy the artist and Mitchell-Innes & Nash, New York.

level of mother and child dominates that of the interview, which takes on the quality of a continuous vague patter, continuing even over a temporarily vacant screen preceding the display of stills of Chilean fascists and titles. The layering of sound and image tracks establishes, nonetheless, in its juxtaposition of the child's voice and the textual declaration, the complicity of the United States with an international bourgeoisie which sanctioned the repression through torture, starvation, and death. This attitude is crystalized in the statement, culled from a Chilean TV address: *Remember, you can be replaced.* And the truth of the statement is validated, as it were, by a situation in which the issue is that of domination of a single class.

Rosler's project in this particular work was not to articulate the conjunction of personal, daily regimens of existence with the political, but to invent the multilayered structure that would allow her to affirm that in the United States, "where there are layers of illusion masquerading as fact," we forget about domination and its control of culture, our knowledge of the world, and other products of the marketplace. "When we raise our eyes from the smallest routine of the home and family life, we find an already prepared world. …We are sleeping and dreaming with our eyes open, imagining that the layer upon layer of facts, truths, explanations … are … adequate to explain all the important truths about ourselves." There follows a still photograph of the central totalizing group, the family, admissible within the already prepared and fragmented world of human labor. Its caption reads, "We like to think of you as a corporation."

Marx's term for this register of discourse was that of the "hieroglyphic." Rosler's videography works toward its decoding, toward the solving, the restoration of coherence, to the puzzle of the social text.

NOTES

First published in the exhibition catalog *Martha Rosler: Positions in the Life World* (London: Ikon Gallery/Cambridge, Mass.: MIT Press, 1999), pp. 180–192. Minor corrections have been made for consistency.

1. Prostitution is the theme first explored, in both fictional and documentary mode, in his film *Vivre sa vie* (1962).

2. The vogue for posters of Vasarely's "Op Art" was noted in the French press.

3. My translation. For the full text of this excoriation, see "Les gratte-ciel par la racine," signed collectively by the Internationale Lettriste, in Guy Debord, ed., *Potlatch 1954–1957* (Paris: Gallimard, 1996), pp. 37–38.

4. Henri Lefebvre, *The Production of Space*, trans. Donald Nicholson-Smith (Malden, Mass.: Blackwell, 1991), p. 43.

5. Ibid, p. 370.

6. *Mercure*, the ballet commissioned by Diaghilev, was the collaborative work of Satie, Picasso (for the decors), and Massine (for the choreography). Its curious history of attack from the Surrealist Left and subsequent apologetic withdrawal is recounted in Anne Rey, *Erik Satie* (Paris: Seuil, 1974), pp. 143–148.

7. The subtle accuracy and wit of this monologue is comparable to the more recent performance work by Anna Deavere Smith. One wonders, however, if it might possibly have been inspired by the effort of gracious acknowledgment made by Mrs. Richard Nixon to the head chef responsible for the sumptuous banquet served in the Great Hall of the People on the occasion of the presidential visit to Peking. Mrs. Nixon's words, reported in the *New York Times*, were: "I like Chinese food anywhere in the world, but it's especially good here in China" (February 22, 1972).

8. The soundtrack carries quotations from the movement of Schubert's String Quartet in D Minor, constructed as a series of variations upon the theme of his song "Death and the Maiden."

9. Amy Taubin, "And What Is a Fact Anyway? (On a Tape by Martha Rosler)," *Millennium Film Journal* 4/5 (Summer–Fall 1979).

10. Lefebvre, *The Production of Space*, pp. 309–310.

"WHERE IS YOUR RUPTURE?": MASS CULTURE
AND THE *GESAMTKUNSTWERK*

And if the body were not the soul, what is the soul?

—*Walt Whitman*

A specter haunts the theory and practice of the arts: the specter of the *Gesamtkunstwerk*, a notion born of late Romanticism, nurtured and matured within the Modernist moment, and never wholly exorcised in the era of Postmodernism and digital reproduction. To Adorno, writing in 1944, television promised a synthesis of radio and film which would so impoverish artistic production that "the thinly veiled identity of all industrial products" would reveal itself,

> derisively fulfilling the Wagnerian dream of the *Gesamtkunstwerk*—the fusion of all the arts in one work. The alliance of word, image and music is all the more perfect in *Tristan* because the sensuous elements which all approvingly reflect the surface of social reality are in principle embodied in the same technical process, the unity of which becomes its distinctive content. This process integrates all the elements of the produc-

tion, from novel (shaped with an eye to film) to the last sound effect. It is the triumph of invested capital, whose title as absolute master is etched deep into the hearts of the dispossessed in the employment line; it is the meaningful content of every film, whatever plot the production team may have selected.[1]

To the specter of the *Gesamtkunstwerk*, already somewhat faint and failing, Moholy-Nagy had delivered, in 1925, a telling, though not fatal, blow. In *Painting, Photography and Film*,[2] he says, when speaking of the project of Cubism and Constructivism, that they attempted a purification of the expressive component of "art" (one notes the quotation marks), that they led an attack upon the subjectivism of a previous generation, whose relegation of art to preoccupations of leisure-time activity went hand in hand with an excessively sublimated notion of artistic production, issuing in an art that was trivial and derivative, severed from its roots in social collectivity. He then evokes, as a second line of protest, "the attempt to bring together into one entity, singular works or separate fields of creation that were isolated from one another. This entity was to be the *Gesamtkunstwerk* in the form of architecture as the sum of all arts."[3] Such was the project of de Stijl and of the Bauhaus in its first period. But this project Moholy defines as produced within a specific historical moment, that of the triumph of specialization. And this we retrospectively understand as the consequence of the division of labor through the dynamic of the industrial revolution. It is with characteristic acuteness that Moholy perceives this ideal as a compensatory reaction to a general fragmentation of existence and therefore incapable of providing the ground for an art of social collectivity, an art of necessity.

For it provides, as it were, merely an addition to the present state of things, an increment. "What we need," he says, "is not the *Gesamtkunstwerk* alongside and separate from which life flows by, but a synthesis of all the vital impulses spontaneously forming itself into the all embracing *Gesamtwerk* (life) which abolishes all isolation, in which all individual

accomplishments proceed from a biological necessity and culminate in a universal necessity."[4]

There would seem to have been two major, antithetical programs for the achievement of this radically utopian aesthetic in our century. One might call them, roughly speaking, those of the Yogi and the Commissar, casting Moholy as Commissar and recasting (with the respect and apologies due a Zen Master) John Cage as the Yogi. I wish, however, to consider a third attempt of the recent past, one whose deviant logic was preeminently of our time, producing a mediated or degraded version of this project. I have in mind a site of artistic production exempted, if only for a brief period of time, from industrial criteria of production, modes of distribution, and commoditization. It was, as it happens, a film studio. I shall not, however, be proposing, in the manner of Moholy's contemporaries, the cinema as the ultimate *Gesamtkunstwerk*. Rather, I shall consider the structure and dynamics of this site of production as a late variant upon Moholy's model, subject, however, to the powerful constraints and perversions of its particular moment within late capitalism.

The site and period, then, are those of Andy Warhol's old Factory described by Warhol himself as those in which "we made movies just to make them" rather than that in which he was producing "feature-length movies that regular theaters would want to show." It is the shot from Valerie Solanas's gun in 1968 that marks the boundary between two sites and modes of production, the moment of replacement by a systematic division of labor of a previous artisanal mode of production. When, as has been noted, Warhol began increasingly to delegate authority, as in the later films, his participation was limited to the work of finance and publicity. *The Chelsea Girls* is the major work that concludes the first period. After 1968, Warhol assumed the role and function of the *grand couturier*, whose signature sells or licenses perfumes, stockings, household linens manufactured elsewhere.[5] Warhol's "business art" found its apogee in the creation of a label that could be affixed to the feature films made under the direction of Paul Morrissey. And Morrissey's role in the suppression

of films made prior to his accession to power is linked to the marketing of the new product, coded with an eye to industrial norms.

<center>*</center>

Consider, then, the image that provides the title of this text. Dated 1960, numbered 83 in the catalog of the 1989 Museum of Modern Art retrospective exhibition, it is, of course, the rendering of an advertisement for surgical trusses, an early instance of Warhol's deployment of the found image; he was to rework it more than once. It is, as well, an image of poignantly proleptic resonance, and we may therefore quite appropriately juxtapose it with *Andy Warhol, Artist, New York City*, Richard Avedon's portrait, made in 1969, in which the artist displays the surgical scars that memorialize the assault upon his life made the preceding year by Valerie Solanas, executor-in-chief of the Society to Cut Up Men.

In what follows, however, I shall be rehearsing neither the Orphic nor the hagiographic iconography that this juxtaposition may appear to generate. More significantly, these two images mark the limits of Warhol's intervention as a major and pivotal force within the American Independent cinema. And it is through that intervention that one may trace the passage, within that cinema, from the body's analytic representation to one of synthetic incorporation.

Most simply put, the notion of rupture will center on the break within the American cinema of independent production and persuasion in the representation of the body as effected by Warhol and its consequences: the passage from a cinema postulated on the primacy of the part object to that of the whole object, in its parallel passage from one of assertive editing to one of long shot/*plan séquence*.[6] What later followed was the development of a cinema tending toward incorporeality, as in the work of Michael Snow and Hollis Frampton—to "the taste's quick glance of incorporeal sight," a cinema of literal textuality.

<center>294</center>

Andy Warhol, *Where Is Your Rupture?*, 1960. © Warhol Foundation / Artists Rights Society (ARS), New York.

Willard Maas, *Geography of the Body*, 1943. Courtesy Anthology Film Archives.

If it may be claimed that the desire for the mode of representation which came to be that of cinema is grounded in the phantasmatic projection of the female body,[7] we may see confirmation of that claim in a founding myth of cinematic practice, that of Kuleshovian montage. One of its powerfully constituent elements posits the desiring gaze of the male subject, directed at the female object as inferred, synthesized by, the spectator from the sequence of shots of the actor, Ivan Mosjoukine, and a presumably anonymous female. We have, however, an even more impressively demonstrative instance of cinema's synthetic properties, its construction of the female body, the ideal object of desire as synthesized, once again, by the viewer, as if inevitably, from the juxtaposition of part objects.

This founding moment, is, however, inscribed within a tradition of Russian literature which extends from Gogol to Bely. Indeed, in Bely's *Petersburg* (1912), we find the following: "Alexander Ivanovich was thinking that features of Zoya Zacharovna's face had been taken from several beautiful women: the nose from one, the mouth from another, the ears from a third beauty. But all brought together, they were irritating."[8] In this passage Bely anticipated, as well, the early spectator's uneasy reaction to assertive editing and the extreme close-up.

In the United States, a new era in the representation of the body begins in the period following the Second World War, with the early films of Maya Deren, to be sure, but perhaps more pertinently for present purposes, in the work of collaboration between the filmmaker Willard Maas and the British poet George Barker, at that time resident in New York. *Geography of the Body*, produced, like *Meshes of the Afternoon*, in 1943, develops the grand metaphor of the body as landscape through the succession of extreme close-ups in which skin, fold, membrane, hair, limb, and member are transformed into plateaux, prairies, pools, caves, crags, and canyons of uncharted territory. The body, estranged, then does appear as an "America," a "Newfoundland," its lineaments suffused with the minatory thrill of exploration. This film works, through close-up, magnification, and its editing patterns, to disarticulate, to reshape and transform, the

body into landscape, thereby converging, in a manner that is both curious and interesting, with that filmic microscopy which now offers us passage through the canals of the reproductive and cardiovascular systems.

It was the project of Stan Brakhage to chart this landscape, and, through hyperbolization of montage, radical suppression of the establishing shot, and systematic use of close-up, to expand, with a view to its cosmic extrapolations, the disarticulated body's analogical virtuality, as in *Prelude: Dog Star Man* (1961). And we can now clearly see that the trajectory initiated in *Window Water Baby Moving* (1958), the early masterwork produced to document the birth of his first child, culminates in *The Act of Seeing with One's Own Eyes* (1974), filmed in the Pittsburgh morgue. Brakhage now offered the autopsist's literal, manual dismembering of the human cadaver: the cutting up of men and women.

There is a dominant trend toward the representation of a body-in-pieces, of what is in Kleinian theory termed the part object, that runs, like an insistent thread, a sustained subtext, through much of American artistic production (and through its painting and sculpture, in particular) in the decades of the 1950s and 1960s. Art objects as part objects, then. Locating the sources, we encounter, once again, in a surprisingly wide range of work, the haunting and seminal presence to whom artists of that period paid, in varying forms and degrees of intent, a steadily intensifying tribute: that of Marcel Duchamp. This effort of location entails consideration of a few works of emblematic import.

The first of these is *11, rue Larrey* (1927), that door which, in defiance of the apothegm, stands both open and closed, at one and the same time. Reflecting now upon the old Factory, one recalls that site whose threshold was indeed marked by a door both open and closed: the space in which one could "swing both ways," where stern imperatives of choice, the strict polarity of either/or, reified in the austere ethos of Abstract Expressionism, were abrogated, displaced by what is currently termed "sexual preference." In this arena, whose ecumenicity accommodated homosexuality, heterosexuality, bisexuality, asexuality, *MARiée* and

Marcel Duchamp, *11, rue Larrey*, 1927. © Estate of Marcel
Duchamp / Artists Rights Society (ARS), New York.

CELibataire were daily conjoined, and frequently within the prototypical single body, single persona.

Duchamp has offered us, however, in addition to this emblem of indifference, another set of images, representations of that supreme part object, the prime object of infantile identification and projection: the breast. *Prière de toucher* (1947) was to be followed by the sculptural renderings of the male and female sexual parts, *Feuille de vigne femelle* (1950) and *Objet-dard* (1951). And we are, I shall want to claim, justified in seeing *Rotary Demisphere (Precision Optics)* (1925) as a prototype of *Anemic Cinema* (1927), which conflates, in its spirals' alternately receding and projecting movement, penis and breast—often identified by the infant as one and split off in impulses of rage and/or love. I refer, of course, to the theorization of the part object by Melanie Klein, as founded upon that of Karl Abraham in his attribution of the importance for the child of the relation to part objects such as the breast (or feces) in his work on melancholia. Klein later posits the initial introjection, by the child, of the mother's breast and a constant splitting of its good (giving) and bad (rejecting) aspects, aimed at introjection of a good breast and the projection and annihilation of a bad one. Moreover—and this will have bearing upon one's readings of Duchamp and of other artists whose work concerns us—the cannibalistic relation to the breast is, during the second oral stage, transferred to the penis as well; both are revealed, in significant case histories, as the objects of deepest oral desires. Klein was to go on to observe that the sadistic, cannibalistic fantasies and anxieties aggravated by weaning would lead the child to displace its interest onto the whole of the mother's body, so that a primitive Oedipal envy and jealousy is thereby added to the oral sadism. And a urethral and anal sadism, added to the oral, would lead to the stage described by Melanie Klein as the stage of maximum sadism:

> Every other vehicle of sadistic attack that the child employs,
> such as anal sadism and muscular sadism is, in the first in-

300

Marcel Duchamp, *Prière de toucher*, 1947. © Estate of Marcel Duchamp / Artists Rights Society (ARS), New York.

Eva Hesse, *2 in 1*, 1965. © Estate of Eva Hesse, Hauser & Wirth.

stance, leveled against its mother's frustrating breast, but it is soon directed to the inside of her body which thus becomes at once the target of every highly intensified and effective instrument of sadism. In early analysis, these anal-sadistic, destructive desires of the small child constantly alternate with desires to destroy its mother's body by devouring and wetting it, but their original aim of eating up and destroying her breast is always discernable in them.[9]

The Kleinian scenario of infantile development is rather like that of a horror feature, the longest-running one known to us. Klein and Hanna Segal were to go on to elaborate upon the notion of children's art and art in general as involving the desire to repair and make restitution to the object of destructive fantasies.

Our best point of entry into the consideration of the role of the part object within the art of the mid-1950s through the 1960s is to be found in the work of Eva Hesse. This choice is dictated by the conviction that it was the major achievement of a woman artist to have made, through her obsessive constitution of a repertory of part objects (and this within the Minimalist moment), the elements of a radical renewal of sculptural enterprise, of its grammar and its materials. It is this primal image, the archetypal part object, that is more generally inscribed within the broadest range of American artistic production in the late 1950s through the 1960s in forms and variations so diverse as almost to defy inventory. Its presence was, of course, effectively masked by the dominant critical and theoretical discourse of the period, even as it ranged from the work of Kenneth Noland to that of Jasper Johns. And in reading Johns's celebrated and enigmatic *Target with Plaster Casts* (1955), in addition to the part objects cast and placed in the upper-level compartments, we may discern the image of the main panel as significantly more than a representation of "surface," as "flatness, itself."

Jasper Johns, *Target with Plaster Casts*, 1955. © Jasper Johns/Licensed by VAGA, New York.

It is therefore interesting to consider the reading of this work offered, in 1963, by Leo Steinberg, then engaged in a pioneering critique of the claims of "formalist" criticism. Remarking on the manner in which Johns's subjects tend to be "whole entities" or complete systems, seen from no particular angle, Steinberg infers a refusal to manifest subjectivity. He then remarks, however, upon *Target* (1955) of which Nicolas Calas had written, "One-ness is killed either by repetition or fragmentation." Having described the inserted anatomical fragments and recorded Johns's explanation of their insertion as the casual adoption of readymades (they "happened" to be around in the studio), Steinberg then goes on to remark that "these anatomical parts are not whole," that "only so much of them is inserted as will fit in each box," that "they are clipped to size," and he concludes that "the human body is not the ostensible subject. The subject remains the bull's eye in its wholeness for which the anatomical fragments provide emphatic contrast."[10] What then follows is the account of a verbal jousting between Steinberg and Johns, with Johns characteristically insisting on the absence of either overt or implicit emotional content, on his desire (as seen by Steinberg) to excise meaning from them.

But Steinberg is uncomfortable, characteristically so, with this position, for "when affective human elements are conspicuously used, and yet not as subjects, their derogation becomes a subject that's got out of control. At any rate, no similar fracturing of known wholes has occurred since in Johns's work."[11] And "the assumption of a realism of absolute impersonality always does fail—if taken literally. That assumption is itself a way of feeling; it is the ascetic passion which sustains the youthful drive of a youthful Velázquez, or a Courbet, while they shake the emotional slop from themselves and their models."[12]

Against Steinberg's readings of his paintings as works of absence, Johns's contention leaves Steinberg with a feeling of almost palpable dissatisfaction. He has certainly circled in closer to these elusive works, but he has not, as it were, quite grasped them. But hasn't he passed too rapidly

over the central panel, that of the target, the bull's eye? For the target is surely another conventionalized variant of that primal object whose interest is, in this instance, heightened for us in that it is represented as the explicit object of aggression.

Bearing in mind this consideration of the part object, epitomized in a range of practices—in those, among others, of Duchamp, Johns, Noland, Hesse, and in the editing patterns of Brakhage, as inheritor of the "classical" or postrevolutionary tradition of montage—I return to consideration of the Factory, reentering through that swinging door. I do so, however, by way of a detour.

<div style="text-align:center">*</div>

There is a story—apocryphal perhaps—of Verlaine's impoverished last years, of the Paris garret and its meager furnishings, entirely covered in gilt paint. To the visitor, bewildered as to the how and why of this fancy, Verlaine's reply was, "But this is how poets should live!" Grandeur, as tribute to and warrant of, the artist's vocation was not, one imagines, the point of Billy Linich's decoration of Warhol's studio walls. That would, in fact, have been distinctly at odds with the Aesthetic of the Tacky which prevailed in this latter-day version of Bohemia. Rather, tin foil bestowed, as gold would not, the minimal reflective potential upon surfaces which could transform the Factory into a dim Hall of Mirrors, redoubling in its confusion of actor and audience the narcissistic dynamic of the site's theatrical economy.

Here was a factory located outside the codes and standards that govern and sustain industrial labor. To understand the old Factory is to absorb that paradox and to reconstruct a world in which the prohibitions and restrictions that determine and sustain the structures and order of production are bracketed.

We reconstruct, then, a milieu in which, as well, the prohibitions and restrictions that govern the structure and order of everyday life are

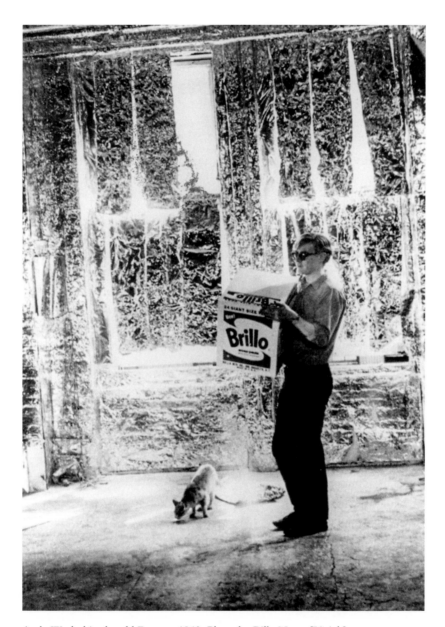

Andy Warhol in the old Factory, 1963. Photo by Billy Name [Linich].

suspended, together with the decorum which underwrites traditional forms of social hierarchy. From this world are excised the pity, piety, and etiquette linked to those forms. Here distances between persons are abrogated and eccentricity is exalted. Parodistic expression forms the center, the core of a continuous representation governed by a principle of inversion. Here the world is seen in reverse, as it were, or askew, or upside down. Travesty and humiliation are central tropes of representation. And through this place, from time to time, came the sound of laughter, shrill and ambivalent, both mordant and revitalizing, both aggressive and self-destructive.

Such was the milieu of the old Factory in its prelapsarian era (1960–1968), the site of Warhol's most productive period. In that world, choice, risk, transgression had lost their ground; the enveloping air breathed, sanctioned, and enabled the abolition of those interdictions that constitute their ground. The old Factory of East Forty-Seventh Street was, then, in the expansionist climate of the early 1960s, preeminently the site upon which Duchamp's door of *11, rue Larrey* opened to reveal the din and clutter, the revelry and theatrics of Bakhtinian Carnival, as described in the great works on Rabelais and Dostoyevsky. The old Factory, the site of Warhol's recasting of the *Gesamtkunstwerk*, solicits analysis in terms of Bakhtin's master category, defined as "the sum total of all diverse festivities of the carnival type."[13]

One recalls, then, the manner in which carnival, in its most general form, is defined as syncretic pageantry of a ritualistic sort, producing variants and nuances which vary with period and with differences of cultic origin and individual festivity. Carnival has, as Bakhtin puts it, "worked out an entire language of symbolic concretely sensuous forms—from large and complex mass actions to individual gestures." And most significantly, of course, "As theatrical representation, it abolishes the dividing line between performers and spectators, since everyone becomes an active participant and everyone communes in the carnival act, which is neither contemplated nor, strictly speaking, performed; it is lived."

Within this life, several particular modalities are distinguished. Those of especial relevance to our present consideration are abolition of distance and establishment of free and familiar contact and exchange; eccentricity; *mésalliance*; and profanation. In Carnival, behavior and discourse are unmoored, as it were, freed from the bonds of the social formation. Thus age, social status, rank, property lose their powers, have no place; familiarity of exchange is heightened.

Linked to this is the possibility of "carnivalistic *mésalliances*": "All things that were once self-enclosed, disunified, distanced ... are drawn into carnivalistic contacts and combinations. Carnival brings together, unifies, weds, and combines the sacred and profane, ... the great with the insignificant, the wise with the stupid." And, of course, the high with the low.

It thus becomes that nexus within which *mésalliances* are formed. As Kathy Acker has pointed out in a recent account of the Factory, "the uptown world of society and fashion" here joined that of prostitution and the general "riff raff of Forty-Second Street," a group "who at the same time no decent person, even a hippy, would recognize as being human."[14] It was in this social nexus that Edie Sedgwick (among other "girls of good family") enjoyed her brief celebrity. Here the hustler could play Tarzan to Jane, "sort of."

And since in carnival, parodistic images parody one another, variously and from varying points of view, Roman parody is described as resembling "an entire system of crooked mirrors, elongating, diminishing, distorting in various directions and to various degrees."[15] We may say that the tin-foiled studio literalized this practice. More than that, however, it was Warhol's strength to have revised the notion of the *Gesamtkunstwerk*, displacing it, redefining it as site of production, and recasting it in the mode of Carnival, thereby generating for our time the most trenchant articulation of relation between cultures, high and low. In the picture of carnival as a system of representation, we can recognize the old Factory, that hall of mirrors whose virtual space generated improbable encounters, alliances, eliciting the extravagant acts, gestures, "numbers" that

composed the serial parody of Hollywood production that overtakes the Warholian filmography of 1960 to 1968.

It is, however, Bakhtin's definition of the essential and defining carnivalistic act which completes and confirms one's characterization of the Old Factory as carnivalistic system. That act is "*the mock crowning and subsequent decrowning of the carnival king.*" Italicizing the phrase, Bakhtin insists upon its presence in all festivities of the carnival type, in the saturnalia as in European carnival and festival of fools:

> Under this ritual act of decrowning a king lies the very core of the carnival sense of the world—*the pathos of shifts and changes, of death and renewal.* Carnival is the festival of all-annihilating and all-renewing time. Thus might one express the basic concept of carnival. But we emph asize again: this is not an abstract thought but a living sense of the world, expressed in the concretely sensuous forms … of the ritual act.

The crowning ritual is, however, invested with a dualism, and ambivalence; its shifts celebrate the "joyful relativity of all structure and order, of all authority." For

> Crowning already contains the idea of immanent decrowning; it is ambivalent from the very start. And he who is crowned (and it is by popular demand or by election that he is so crowned), is the antipode of a real king, a slave, or a jester; this act, as it were, opens and sanctifies the inside-out world of carnival. In the ritual of crowning … the symbols of authority that are handed over to the newly crowned king and the clothing in which he is dressed—all become ambivalent and acquire a veneer of joyful relativity; they become almost stage props. … From the very beginning, a decrowning glimmers through the crowning.

Bakhtin stresses the manner in which, for the medieval festival of fools, mock priests, bishops, and popes were chosen *in place of* a king. And it is, indeed in the climactic sequence of *The Chelsea Girls* (1968)—the crowning work of Warhol's significant film production—that the Factory, which generated the continuous parodistic procession of divas, queens, and "superstars," produces like the world of the medieval carnival, as its culminating ritual, its own *parodia sacra*: the election of a pope. Ondine, the virtuoso performer at the center of the film's most brilliantly pyro-technical sequence, does indeed insist that he has been *elected* Pope. He comes on with his paper bag,

> from which (with much noisy crinkling on the soundtrack) he extracts a syringe. Using his belt to tie his arm, he proceeds through the ritual of giving himself a shot of methadrine [sic]. … Ondine then turns to the camera and asks if he should be-gin. "Okay? Okay. Well now, let's see." He arranges himself more comfortably. "As you are all well aware, uh, I am the Pope. And, uh, the Pope has many duties. It's a crushing job. I can't tell you. And—uhhh—I've come down here today in order to give you all some kind of inside view of my life, and what I've been doing with my uhhhhh"—there is a long tracking pause—"Popage? Right, my Popage. Not just the Pope as Pope, but the Pope as a man. Right? First of all, you will undoubtedly want to know who, or what, I am Pope of. Well, uhhhh," a mock faggot groan, running his fingers through his hair. "Jesus! There's nobody left. Who's left?"
>
> Time is being filled. … But now, back on the left, a woman walks on; somebody new has come to give her con-fession to Ondine, as Ingrid Superstar did at the beginning of the film. As she sits down and begins to talk, something seems wrong, slightly off … somewhat smirkily, she sets out to question the Pope's spiritual authority. She announces that

she is hesitant to confess. Exactly Ondine's meat. "My dear, there is nothing you cannot say to me. Nothing. Now tell me, why can't you confess?" The inattentive ear hears the remark fall: "I can't confess to you because you're such a phony. *I'm* not trying to be anyone."

Ondine replies,

> "Well, let me tell you something, my dear little Miss Phony. You are a phony. A disgusting phony. May God forgive you," and Ondine slaps her again, more violently, then leaps up in a paroxysmic rage. With his open hands he begins to strike the cowering bewildered girl around the head and shoulders. "You Goddamned phony, get the hell off this set. Get out."

Ondine then breaks down and

> circles the room, hysterical—"I'm sorry, I just can't go on, this is just too much, I don't want to go on"—it is the longest camera movement in the film. Her husband is a loathsome fool, she is a loathsome fool, and so it goes. Phase by slow, self-justifying phase, Ondine, who has been beside himself, slowly returns to himself—that is, to the camera. And as he calms himself, the camera reasserts its presence.[16]

Ondine's interlocutor, in questioning his papal authenticity, has transgressed the limits, violated the canon, opened a breach, in the regime of Carnival, the ground of Ondine's papal incarnation. If Ondine cannot go on, it is because that breach is, indeed, a grave one, involving not merely an error of style, a *faux pas*, a loss of "cool," but a radical assault upon the Factory's regime of representation and, by implication, upon its spatiotemporal axes.

The time of carnivalistic representation is that of the undifferenti-
ated distension. This carnivalistic Factory constructed, enclosed within a
world where time is indeed money, suspended, annulled, in turn, the spa-
tiotemporality of productivity's *ratio*. Carnival time is indeed expended,
not clocked or measured. Day and night succeeded each other in scarcely
visible sequence within the tin-foiled precinct of the Old Factory. And
this was fundamental to the sense in which its production had introduced
a rupture within filmic practice, as well.

The cinema of part objects, epitomized in the hyperbolic montage
of Brakhage had, as we know, been that of aspiration to a continuous
present, one image succeeding another at a pace that allows no space
or time for recall or anticipation. The spectator is positioned within a
hallucinated *now*. Warhol's films, as we know (including many who have
not even seen them), generate another kind of temporality, for they take,
as it were, their time, the distended time of contemplation and expecta-
tion: Robert Indiana slowly, slowly eating what appears to be a single
mushroom; a man receiving a blow job, John Giorno sleeping; the light
changing on the Empire State Building. That time, punctuated only by
the flares of successive reel endings, is also time in which to wonder:
"What's going to happen? Do I have time to go and buy some pop-
corn or to go to the bathroom without missing anything? How long, oh
Lord, how long?" In an industrial film—say Douglas Sirk's *Written on the
Wind*—the gap is not irreparable; in *Window Water Baby Moving* it is; for
Brakhage's categorical rejection of the narrative code has, in fact, as one
of its primary purposes, to insure that irreparability.

Brakhage saw in Warhol's work an elimination of subjectivity. Brak-
hage had insisted on the subjectivity which required a radical assault
upon the space of representation, upon the radical separation of signifier
and signified. Not simply the suppression of objects, actor, and actions,
but the radical transformation of the spatiotemporality which was their
precondition: the elision of their determinant coordinates. In his filmic
perpetual present, inspired by the poetics of Gertrude Stein, images and

313

sequences thus follow in the most rapid and hyperbolic fluidity of edit-ing, eliminating anticipation as vector of cinematic construction. Both memory and anticipation are annulled by images as immediate and fugi-tive as those we call hypnagogic, that come to us in a half-waking state. Like them, Brakhage's films present a nonstop renewal of the perceptual object which resists both observation and cognition. The hypnagogic, as Sartre had noted, can excite attention and perception; "one sees some-thing, but what one sees *is* nothing."[17] This is a vision that aspired to a pure presence, in which the limits separating perception and eidetic imagery dissolve in the light of vision as Revelation, uncorrupted by the Fall that is called the Renaissance, and perpetuated in the very construc-tion of the camera lens.

Brakhage is known to have uttered a howl of rage at the emergence of Warhol's film work—largely, one surmises, because *it seemed not to work*. But surely, mainly because the old Factory regenerates, as it were, through the celebrated unblinking voyeuristic state of Warhol's camera, the time, the temporal axis of expectation along which narrative can be reinstated. What Brakhage foresaw, no doubt (with an anticipatory shudder, rather reminiscent of Eisenstein's, just three decades before, at the approach of sound), was that along the temporal axis, the narrative syntagma could be restored, and with it the space of the whole body as erotic object of narrative desire.

Warhol's parody of the film factory stands, nevertheless, as a pow-erful gloss on the Frankfurt School analysis of the culture industry. To reread that text is to recall to what degree it focuses upon film produc-tion as the paradigmatic mode of the culture industry, and how sharply its critique is directed at what we now see as the construction and posi-tioning of the spectator.

For the last decade and a half the discipline of cinema studies has worked to analyze and theorize that positioning. There is, however, a sense in which the recent ascension of cultural studies begins to work against this theorization through its determination to valorize the

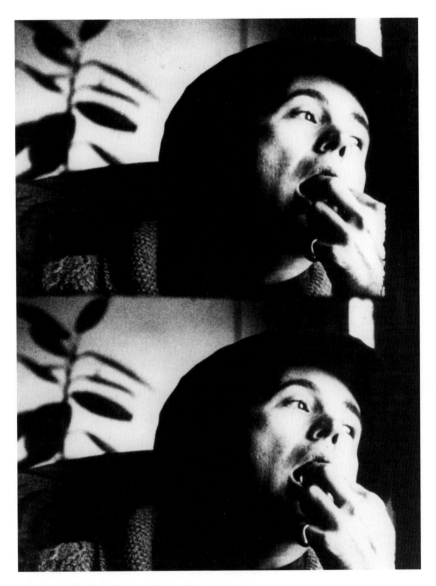

Andy Warhol, *Eat*, 1964. © Warhol Foundation.

spectator, now cast as resistant. (One thinks of a recent characterization of Madonna's body as "site of semiotic struggle.") For Warhol, stars were, in Horkheimer and Adorno's phrase, "a pattern around which the world-embracing garment is cut," a pattern they warn us "to be followed by those shears of legal and economic justice with which the last projecting ends of thread are cut away." For, as they put it in the note entitled "Mass Society,"

> The opinion that the leveling-down and standardization of men is accompanied on the other hand by a heightened in-dividuality in the "leader" personalities that corresponds to the power they enjoy, is false and an ideological pretence. [Rather they are] focal points at which identical reactions of countless citizens intersect … a collective and overexagger-ated projection of the powerless ego of each individual.
>
> They look like hairdressers, provincial actors, and hack journalists. Part of their moral influence consists precisely in the fact that they are powerless in themselves but deputize for all the other powerless individuals, and embody the fullness of power for them, without themselves being anything other than the vacant spaces taken up accidentally by power. They are not accepted from the break-up of individuality; all that has happened is that the disintegrated form triumphs in them and to some extent is compensated for its decomposition. The "leaders" have become what they already were in a less developed form throughout the bourgeois era: actors playing the part of leaders.[18]

It is the supposedly resistant spectator of cultural studies, "glued," as they say, to the television, who, having somehow converted the family living room into a site of resistance, elected—not once, but twice—just such an actor to the presidency of the United States of America.

———

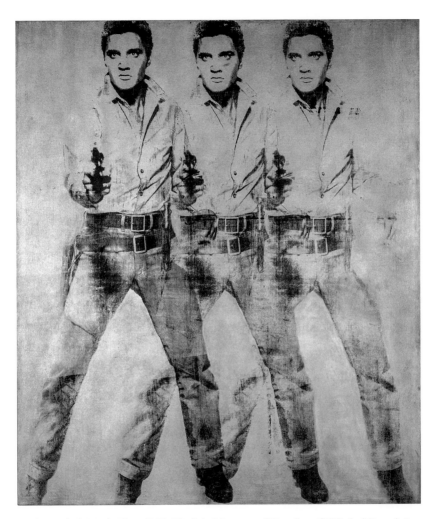

Andy Warhol, *Triple Elvis*, 1963. Virginia Museum of Fine Arts, © Warhol Foundation / Artists Rights Society (ARS), New York.

NOTES

First published in *October* 56 (Spring 1991): 43–63. Minor corrections have been made for consistency.

1. Max Horkheimer and Theodor W. Adorno, *Dialectic of Enlightenment*, trans. John Cumming (London: Allen Lane, 1973), p. 124.

2. László Moholy-Nagy, *Painting, Photography, Film*, trans. Janet Seligman (Cambridge, Mass.: MIT Press, 1969).

3. Ibid., p. 17.

4. Ibid.

5. Warhol is known to have placed the following advertisement in the *Village Voice* in 1966: "I'll endorse with my name any of the following; clothing, AC-DC, cigarettes, small tapes, sound equipment, Rock 'N Roll records, anything, film and film equipment, Food, Helium, WHIPS. Money; love and kisses Andy Warhol. EL 5-9941." This text is reproduced in Patrick S. Smith, *Andy Warhol's Art and Films* (Ann Arbor: UMI Research Press, 1986), p. 167.

6. The increasingly sublimated erotics of avant-garde film practice in the 1970s and 1980s culminates in the production of Hollis Frampton's *Poetic Justice* and Michael Snow's *This Is*, both films composed entirely of text to be read from the screen.

7. I advance this claim in "On the Eve of the Future: The Reasonable Facsimile and the Philosophical Toy," *October* 29 (Summer 1984): 3–20; reprinted in this volume.

8. Andrei Bely, *Petersburg*, trans. Robert Maquire and John Malmsted (Bloomington: Indiana University Press, 1978), p. 210.

9. Melanie Klein, *The Psycho-Analysis of Children*, trans. Alix Strachey (London: Vintage, 1975), p. 129.

10. Leo Steinberg, "Jasper Johns: The First Seven Years of His Art," in *Other Criteria* (New York: Oxford University Press, 1972), p. 37.

11. Ibid.

12. Ibid., p. 52.

13. Mikhail Bakhtin, *Problems of Dostoevsky's Poetics*, trans. Caryl Emerson (Minneapolis: University of Minnesota, 1984), p. 122. The quotations in the following paragraphs are drawn from ibid., pp. 122–124.

14. Kathy Acker, "Blue Valentine," in *Andy Warhol Film Factory*, ed. Michael O'Pray (London: BFI, 1989), p. 65.

15. Bakhtin, *Problems of Dostoevsky's Poetics*, p. 127. The quotations that follow are from p. 124.

16. This account of the climactic sequence of *The Chelsea Girls* is drawn from Stephen Koch's exceptionally fine study, *Stargazer: Andy Warhol's World and His Films* (New York: Marion Boyers, 1985), pp. 94–96.

17. For the discussion of the hypnagogic image, see Jean-Paul Sartre's *L'Imaginaire* (Paris: Gallimard, 1948), pp. 58–76.

18. Horkheimer and Adorno, *Dialectic of Enlightenment*, pp. 236–237.

Index

Page numbers in boldface indicate illustrations.